19.99

*The Practical Director*

# The Practical Director

*Mike Crisp*

Focal Press
An imprint of Butterworth-Heinemann Ltd
Linacre House, Jordan Hill, Oxford OX2 8DP

ℛ A member of the Reed Elsevier plc group

OXFORD   LONDON   BOSTON
MUNICH   NEW DELHI   SINGAPORE   SYDNEY
TOKYO   TORONTO   WELLINGTON

First published 1993
Reprinted 1994

**British Library Cataloguing in Publication Data**
Crisp, Mike
  The practical director
  I. Title
  791.430233

ISBN 0 240 51341 X

**Library of Congress Cataloguing in Publication Data**
Crisp, Mike
  The practical director/Mike Crisp.
  p.      cm.
  Includes index.
  ISBN 0 240 51341 X
  1. Cinematography.    I. Title.
  TR850.C75   1993
  778.5'3–dc20                                          92–37228
                                                            CIP

Photoset by Deltatype Ltd, Ellesmere Port, Cheshire
Printed and bound in Great Britain by
Redwood Books, Trowbridge, Wiltshire

# Contents

# Preface

More and more people come into television and film making from outside the industry. They are usually highly intelligent and burning to communicate but, with little or no knowledge of film technique or visual language, their work is bedevilled by visual impotence. For years the various television companies were happy to throw such young talent in at the deep end, as there was a bedrock of professionalism amongst the cameramen, recordists and editors with whom the rookie director worked. This was never a very satisfactory situation as it allowed production heads to become contemptuous of craft skills, and led directors to believe that they had learned all that was necessary as soon as they were able to deliver products that had the house style of whatever programme they represented. If they were not very wary the firebrands fell victim to their own ignorance and the lack-lustre formulae of the departmental heads. Today, as more and more inexperienced directors work with inexperienced crews, the situation has become more serious. A director cannot know everything about every job involved in his production. In fact, the worst director I ever edited for *did* think he knew everything.

A good analogy is the orchestral conductor. A conductor cannot play every instrument in the orchestra; even when he attempts to sing the result is frequently cacophonous. Yet a good conductor has a fine ear for intonation and thus has the respect of the instrumentalists. He may not be able to play every instrument, but he knows the particular musical timbres of which each instrument is capable, and he respects the skills required to produce those sounds. Essentially he understands how to weld a group of individual talents into a homogeneity of orchestral texture. The same is true of a good director. There are many talents to command, all of them needed to make a successful film, and each of them benefits from the respect and understanding of the director. Just as no conductor would reach the exalted position of 'maestro' without a thorough knowledge of instrumental technique, no director will ever blossom without a grounding in visual language.

This book is an attempt to initiate that grounding and, I hope, make it seem fun. Film making *should* be fun!

Mike Crisp
July 1992

## NOTE

Throughout this book, the various persons involved are referred to as 'he'. This is simply for convenience and is intended only to avoid continually reiterating the awkward phrase 'he or she'.

# CHAPTER 1

# Introduction to lenses

The use of lenses of different focal lengths can have a powerful effect on the emotional impact of a scene. As far as medical science can assess, one set of human eyes is very similar to any other. If I stand on a hilltop and look across the valley, and I then stand aside and someone else takes my place, he will see exactly the same view as I did. The limits of his visual frame will be the same as mine. The perspective of the view remains the same from person to person. Humans have eyes of the same focal length. There is, therefore, a danger that a director will be unaware that the world can look different when seen through different optical equipment.

A lens with a wider field of view than the eye is often referred to as a 'wide-angle lens', and a lens with a narrower field of view as a 'narrow-angle'. The various names for the lens types tend to get muddled in professional use. 'Wide-angle lens' is in common parlance, but 'tele-photo' or 'long-focus' is much more likely to be used as the opposite of 'wide-angle'. 'Narrow-angle' is a term used much more often in a television studio than on a film set.

Take a look at the pictures in Figure 1.1. The views of Cromer Pier were all taken with the camera in the same position; only the lens was changed from telephoto to wide-angle. The lines drawn onto the widest angle clearly show the narrow field of view of the telephoto lens. It is clear that narrowing the angle is the same thing as magnifying the image.

The second set of pictures (Figure 1.2) was again taken with a variety of lenses, but this time the camera was moved from 5 ft (1.6 m) away from the subject to approximately 80 ft (25 m) away. The idea was to keep the actor, Miles England, the same size in each picture. The important difference between the various lenses becomes clear when you look at the background rather than the subject. The wide-angle lens gives an image with a lot of background detail, and contains a wide view of the castle. As the camera moves further from the subject, more and more magnification is required to keep the subject the same size in shot. You will also notice that progressively less of the background is seen, while the background goes progressively out of focus and appears to be closer to the actor. This effect of focal perspective provides a powerful weapon in the director's armoury.

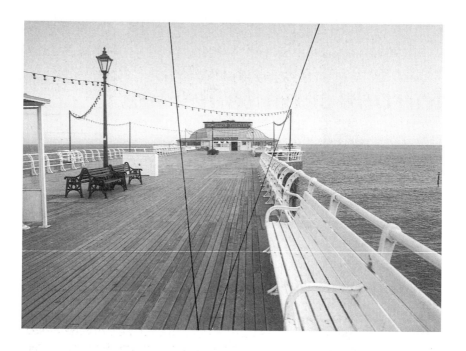

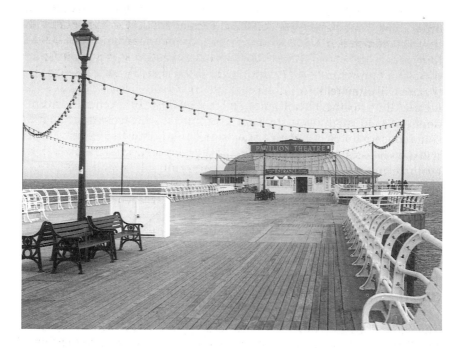

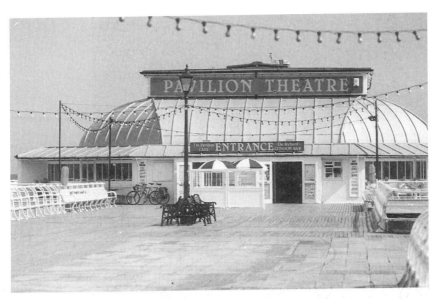

**Figure 1.1**

The wide-angle lens provides a large depth of field, i.e. both the subject and the background are in sharp focus. The telephoto shots, however, have a very limited depth of field. Miles is in sharp focus, but if he were to move a little further forward or back he would be 'soft'.

Opinions on the amount of technical knowledge a director requires in order to be competent at the job vary, dependent on the background of the protagonist. A director who was once a cameraman or (more likely) a film editor, will always affirm the advantage of a thorough knowledge of the techniques of cinematography, whereas a director grounded in the theatre will often relate more closely with the actors and want to leave the technicalities to the technicians. The example of lens perspective and depth of field might perhaps stimulate the non-technical director into some concern for photographic basics – not only because such knowledge will greatly assist his visual interpretation, but also as it will allow him to evaluate his technical demands. Quite simply, he will know whether he is asking for something technically difficult and time consuming, or for a straightforward effect that can be simply and quickly achieved. Whatever the pros and cons of a technical background may be, it is undeniable that a director with little knowledge of cinematography may be hopeless at estimating the schedule of a complicated sequence.

## PERSPECTIVE

The effect the different lenses have on perspective is of most concern to the director. The cameraman William Dudman once compared the choice of lens for a scene to the choice that a composer might make when he sets

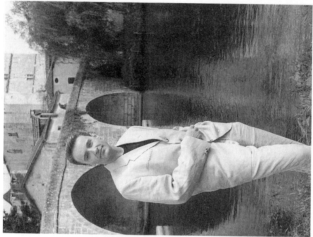

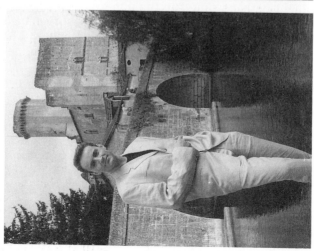

Figure 1.2

the key for a piece of music. The more deeply you consider the effect of perspective, the less fanciful the analogy seems. As we progress from shorter focal lengths to long-focus lenses, the particular perspective qualities of this group of lenses becomes increasingly evident. A long-focus lens has a very small depth of field, so that only the subject is in focus, but as the lens also foreshortens perspective the objects that surround the actor will appear to crowd in on him. The effect is ideal for creating a sense of claustrophobia or menace, but a soft background can also suggest poetry and romance. The close-up of the hero, and especially the heroine, will certainly benefit from the use of a long focus lens.

The operational difficulties of shooting with a long-focus lens are not really the director's concern, but he should certainly be aware that with such lenses focus is critical. The cameraman will require several rehearsals with his focus puller if there is any movement in a shot involving a long-focus lens. That is not to say 'never do it', as the device is frequently used; but be aware that the cameraman may not succeed at the first take.

One of the most common complaints when first-time directors see their rushes is that everything looks too wide. The reason is usually that the director has not allowed the camera crew sufficient rehearsal. In order to play safe the cameraman has used a wider-angle lens than was really suitable, to provide greater depth of field and fewer focus problems. The differing effects of wide-angle and long-focus lenses on movement is certainly something every director should know.

## LENSES AND MOVEMENT

Action towards the camera will appear faster if filmed with a wide-angle lens, but action across the axis of the lens will appear unimpressive. Action towards a long-focus lens will seem slower and even dream-like – the longer the lens, the more dream-like it will seem. Conversely, action across the axis of the lens will seem very fast if shot on a long-focus lens. The effect will be of a sharply-focused subject travelling against a background blurred by speed. Thus the effects of wide-angle or long-focus lenses are exactly opposite to one another.

## CHOICE OF LENS

The increasing move away from studio shooting to location filming over recent years has considerably limited the artistic use of the best lens for a particular shot. If the play is set in a small terraced house, and it is decided to film in a small terraced house, the choice of lens is immediately limited. If you require a two-shot, and the confines of the location have placed the cameraman against a brick wall, he cannot move further back, so he will

be forced to use a wide angle lens. The irony is that a wide-angle lens will exaggerate the size of the room and the whole agony of cramming a crew into a small room in a small house will become pointless. In practice the feeling of claustrophobia is best achieved with a long-focus lens, taking two-shots with the camera at some distance from the action. For this you need a lot of room, ideally a set built on sound stage. The generally similar appearance of present-day television film dramas has much to do with the obsession for location interiors.

## ZOOM LENSES

All film and video cameras arrive on the set equipped with a zoom lens, i.e. a lens with variable focal length. By moving a lever on the side of the lens barrel, the operator shifts the various elements within, altering the focal length of the lens between wide-angle and telephoto. Video cameras often have motorized zooms; the cameraman simply pushing a button rather than moving a lever. Most modern zoom lenses have a ratio of 10:1, that is to say, the largest focal length available is ten times the shortest available. A 16 mm camera may thus have a zoom lens whose shortest focal length is 10 mm and whose longest focal length is 100 mm, i.e. a 10:1 zoom range. Should you require a lens of shorter focal length than 10 mm, or longer than 100 mm, the zoom cannot cope. The cameraman simply takes the lens off the camera and fits wider lenses, (on 16 mm typically 9 mm, 8 mm, 5.9 mm or 3.5 mm, or for longer lenses, typically 150 mm, 200 mm, 300 mm or 600 mm). These supplementary lenses cannot zoom – they are of fixed focal length, so once fitted any change in image size can be achieved only by moving the camera closer to, or further from, the subject.

When location video was first rushed onto the market, the cameras had only zoom lenses. Nowadays, fortunately, video cameras are manufactured with a provision for fitting supplementary lenses, should they be required.

The term for any lens of fixed focal length (i.e. a lens that cannot zoom) is a 'prime lens'. If you are seeking the ultimate in picture quality, then a good prime lens is superior to a good zoom lens. This is because it is very difficult to design a zoom lens that is free from distortion at its extremes of zoom. It is as well to remember that, should you wish to fill the screen with a small object, you may well require a supplementary lens (often called a 'dioptre'). As a rough guide, it is usually possible to fill the screen with a watch face using a wide-angle lens and no additional lens; but should you wish to fill the screen with the maker's name on the watch, you *will* need a dioptre.

A word of warning about 20:1 zoom lenses. Cameramen generally loathe them, as they are cumbersome to fit, and it is almost impossible to hold the image steady at the extreme telephoto end of the zoom. It is certainly impossible to hold the image steady in a high wind. The other

good reason to avoid this lens is that a 20:1 zoom stretches the limits of lens design to the point where you can no longer guarantee the image quality, especially at maximum focal length, so the experienced eye can immediately detect the 20:1 shot as soon as it hits the screen, well before the spectacular (more often tedious) zoom out.

There has long been a somewhat puritanical prejudice that the use of the zoom lens is sloppy technique. Directors are heard to say 'I never use the zoom' with the self-righteous air of a vegetarian at a steak supper. It is certainly true that the over-use of the zoom can be a curse. We've all seen travelogues in which a close-up of the girl in the bikini zooms out to reveal the beautiful beach, which cuts to a close-up of a yacht, which zooms out to reveal the marina, which cuts to a close-up of the town crest, which zooms out to reveal the town hall, which cuts, etc., etc. This sort of 'tromboning' is obviously an abuse of the zoom principle. In nearly every case, the time taken from the start of the zoom to the wide shot is screen time wasted: a cut from close to wide would be preferable. It is worth remembering that the zoom lens was invented specifically to allow small changes in the size of a shot without moving the camera. It is also worth remembering that the human eye doesn't zoom: it cuts. Zooms can easily appear self-conscious, as the effect of zooming does not reflect human experience. If a visitor to an art gallery is attracted to a particular painting, then he walks towards it: the cinematic equivalent of a track in, not a zoom in. Nevertheless, in spite of purist arguments, there is no doubt that the zoom lens is a vital tool in efficient shooting. It offers a wide range of focal lengths without forever changing the lens; and, within the limits, those focal lengths are infinitely variable, so exactly the right focal length can be selected for any given shot.

## WHEN TO ZOOM

The business of zooming in vision, though still best used with discretion, becomes perfectly acceptable if motivated by some movement on screen, or disguised in a camera movement. Take the example of a wide shot of an office block, which zooms into a window. This will appear much less self-conscious if the zoom starts as a large eye-catching vehicle passes the lens. The zoom will have an apparent (albeit spurious) motivation. Zooming in or out while panning is a favourite device of camera operators, as the effect of the zoom is disguised by the pan, and may well go completely unnoticed (this is more true of using a pan to disguise a zoom out than it is to use a pan to disguise a zoom in).

Some drama directors and camera operators would never consider zooming in or out to cover the action of the scene, but nevertheless in the hands of an experienced operator this technique can be successful: again the zoom is best disguised as the camera pans (or tracks) with the action.

The zoom can be used for dramatic (indeed melodramatic) effect, by zooming in or out very rapidly – usually in the sort of situation when suddenly we realize just who the murderer is (crash zoom in to BCU murderer), or for comic effect (zoom out to reveal that pilot you assumed was flying a First World War aircraft is in fact riding a bicycle). Perhaps the best in-vision use of the zoom lens is the gradual tighten as the subject of an interview begins to reveal information of a personal or previously secret nature, or something that is charged with emotion. The audience naturally feels more interested as the 'beans are spilled', so the zoom from a medium close up to a big close up seems natural. (In such a situation, in practice, the director of screen drama would usually prefer to track in.)

One point to remember is that the camera operator will frequently use the zoom to check focus (particularly when shooting for television on 16 mm). At the start of a shot, the operator will zoom in, focus up and then zoom back out to the required size. This is simply because focus is more critical at the telephoto end of the zoom and, therefore, the procedure acts as a quick and accurate way of checking focus.

Finally beware of the effect that some zoom lenses produce when you are pulling focus. Many otherwise excellent zoom lenses show a small change in image size when the focus is shifted, almost as if the zoom were being operated. This is irritating, and should a scene contain a number of focus pulls the effect can become intolerable. 10:1 zooms are more prone to this effect than zooms of a smaller range. When in doubt a diligent cameraman will fit a prime lens if there is a strong focus pull required for a particular shot. It is certainly worth requesting that a prime lens is used if you want your focus pulls to be unobtrusive.

## FILTERS

From the earliest days photographers have experimented with the effects of coloured filters placed in front of the lens. In black and white photography the effects were dramatic. A yellow filter darkened the blue sky, but had no effect on the white clouds; as a result, the clouds appeared much more spectacular on the finished print. A red filter would change the blue sky to black (a red filter does not transmit any blue light and, therefore, blots out the sky). Of course, if the blue light cannot pass the filter, the film receives less light and the photographer must compensate by increasing the exposure. Each filter, therefore, was allocated a filter factor. If a filter had a factor of, say, 4, the photographer had to expose by two additional stops to achieve the correct exposure.

### 'Day for night' filming

It was soon realized that in black and white the use of a red filter and a correction of *less* than the required two stops gave the effect of night (black

sky and sunlight softened to moonlight). For the film-maker this effect was a real boon. It was possible to film during the day and yet filter the shot so that it looked like night. The process became known as 'day for night'.

Filters are still used for creative effect, but since the introduction of colour their use has to be much more precise. If you are shooting colour film, a yellow filter won't darken the sky and enhance the clouds; it will simply make everything look yellow! The red filter makes everything look red: the process of simple 'day for night' is thus no longer easily available. So why do film makers still attempt it? At first the reason was probably habit. Directors had got so used to the convenience of 'day for night' that they were reluctant to change. Nowadays, reasons of convenience and cost saving still persuade directors to attempt 'day for night' in colour.

Shooting at night requires a lot of light (normally a Brute or a 12K HMI 'skied' on a hoist to create moonlight). This will involve at least three electricians and a driver for the hoist, so, of course, it is expensive. Night filming is also time-consuming. Props get mislaid; scripts get lost; artists apparently go missing (they may be in fact standing right behind you); residents get annoyed by the film crew keeping them awake. All this makes night filming an experience to avoid if possible. However, 'day for night' filming in colour is a compromise, and is a compromise that will work if the following guidelines are followed:

1  Always film in sunlight (this applies to black-and-white or colour 'day for night').
2  Never show the sky (colour only).

It is the second restriction which applies to colour 'day for night' that is most restricting. You either have to film using a high angle looking down on your subject, or film in a courtyard or high-walled garden that naturally excludes the sky.

*Filters for colour*

It would be wrong to give the impression that the use of filters declined with the introduction of colour photography, but it is generally true that it is much harder to obtain a discreet effect from filters when you are working with colour. The graduated filter provides a good example. This is a filter which is clear at the bottom, but which gets gradually darker towards the top. It is used to create a dramatic dark sky or a bright day. The shot is lined up so that the horizon matches the point on the filter where the darkening starts. All will be well unless any object cuts across the horizon. A tree, for example, could appear on screen with its trunk unfiltered but its branches filtered. If this happens, the illusion will be destroyed.

Fog or diffusion filters are often used to soften the image and lend a degree of halation to the highlights. They come in various strengths, ×1,

×2 or ×3. The ×1 filter will scarcely be noticed, but will add a hint of romance to the shot – it might help a leading lady look more beautiful by flattering her skin texture. The effect of a ×2 filter will definitely be noticeable, and place the image in a slightly dream-like haze. A ×3 filter will definitely cloud the image, and when combined with smoke, for example, will supply a convincing fog effect. The ×1 or ×2 filters are sometimes used in period drama to give the effect of candlelight or gaslight (which seemed to be less harsh than electric light).

A neutral-density filter reduces the amount of light that passes through the lens to film without affecting its colour. It comes in various strengths. It is used when the cameraman is working in bright conditions, but wishes to use a large aperture to reduce the depth of field. (The depth of field on 35 mm is less than on 16 mm because the focal length of the lenses on 35 mm are greater.) Some cunning cameramen accordingly use a neutral density filter on 16 mm to reduce the depth of field and create the illusion of a 35 mm camera image.

## DIRECTORIAL DECISIONS

The three important choices that a director takes at the start of every shot are the position of the camera, the height of the camera, and the focal length of the lens. We have already discussed focal lengths. Now let's see how the other two variables combine with this knowledge to help us to decide how to shoot various shots that are common in film and television.

Even a simple establishing shot of a public building will change its emphasis depending on these three key decisions. The camera set at eye level, looking straight at the building from the opposite side of the road, using a standard lens (the nearest equivalent to the field of view of the human eye), will produce the least interesting result. A low camera angle, using a wide-angle lens, with the camera in the same position, will produce a more interesting shot, but the building itself will seem smaller than it actually is. The same lens and angle, but with the camera much closer to the building, will produce a dramatically strong shot, making the building appear quite overpowering, with greatly steepened perspective. It may be necessary to use an extreme wide-angle if the camera is close to the building and we wish to contain the whole structure. This will produce a powerful, almost surreal effect with some distortion. In this situation some cameramen prefer to use the 'Aspheron'. This is a supplementary lens that fits on to the front of the zoom, making the zoom's widest angle wider still. The Aspheron distorts much less than the nearly-equivalent 5.9 wide-angle lens. Whether you use the 5.9 or the Aspheron, it is important to hold a static shot of the building, as any panning will result in the most disturbing distortion of the building's vertical lines – great for a nightmare sequence or pop video, but out of place in a documentary.

Now let's suppose that we wish to film an actor/presenter/contributor entering the building – where is the best place for the camera now? If the camera is in its original position across the road and opposite the building, then the person entering the building can only enter frame from behind camera, and walk towards the building and away from the camera. Or he can enter the side of frame and walk along the front of the building until he comes to the door. In either case the shot will be weak. The reasons are:

1 Action away from camera reduces interest
2 Entrances/exits flat on to the lens from the side of frame are nearly always weak (the exception being silhouettes against a horizon or a sunset).

The strongest shot of our entrance will be if the camera is reasonably close to the building and looking towards the approaching person. As he gets near, the camera pans to reveal a strong shot of the building. (This pan might well also conceal a zoom out.) A shot like this will obey the rule that action is best towards camera – or, expressed another way, the camera is best placed at the point of the shot where the action finishes, *not* where it starts. There is no better example of this than in Billy Wilder's brilliant comedy, 'Some Like It Hot'. Tony Curtis and Jack Lemmon are running from the Chicago Mob, and they run into a shop to make an urgent phone call. In the last shot of the sequence, the camera is already in the shop and observes the two desperate musicians running past the window outside. They stop and see the sign 'You May Phone From Here'. They enter the shot and come right up to camera, forming a tight two-shot. If ever there was a shot where the camera was placed where the action finished, this is it!

Let's return to our other options on the establisher of the building. A high angle on a wide-to-standard focal length will enable us to see the building in its surroundings. If the purpose of the shot is to show that the building was the hub of civic/artistic life, then a high angle would work well. A high angle suggests that we are observers of the scene, and not part of it. This is why a high angle should be used sparingly in any domestic situation. The high angle combined with a long-focus lens will obviously exclude the surroundings, but would enhance the shape of the architecture.

So the director's choice of camera position, camera height and focal length of lens on this simple establishing shot are determined by all these considerations:

1 Should the building look as impressive as possible? (Camera low, close to the building and wide-angle lens.)
2 Is the shot to feature an individual entering the building? (Camera fairly close to the building, allowing a pan with the actor to reveal a good shot of the building at the end. Camera slightly below eye level and possibly widening on the zoom as the pan occurs.)

3 Should we see the building in its geographical or architectural context?
   (High angle with standard or long-focus lens.)

It is always dangerous to reduce film-making to a series of rules and
formulae, and it would be unwise to be dogmatic about the examples
above. However, there is no doubt that if the commentary line were to
read 'The impressive town hall was built in 1820 and dwarfs all the other
buildings in George Street', then the most suitable shot would be No. 1,
the low wide-angle, whereas, if the commentary were 'in the last few
years, the town hall has become a Mecca for the Arts', the high-angle shot
would be more appropriate. True, you may well not know the exact line of
commentary at the time of shooting, but you should certainly know the
purpose of the shot in your programme, and have a good idea of how it
fits into the general argument. This knowledge is all that is needed to
make the sensible choice of shot.

If we continue this line of thought to the interior of the building, as we
follow the entrance of our contributor, then again the rules apply. A
voice-over saying 'I've worked at the town hall for fifteen years now, it's
like a second home', would not be helped by a high shot looking down on
a tiny individual. On the other hand, if the voice-over stated 'I've worked
at the town hall for fifteen years, but I'm still impressed by its grandeur',
then the high angle would be the ideal choice. Again you can only make
this choice if you already know the content of the voice-over. It is always a
good idea to interview the subject of a documentary first, and shoot the
illustrative material second. Artistic effect and logistics are very closely
linked in any single-camera production.

It is sometimes thought that the making of a documentary necessarily
inhibits any strong creative input from the director at the time of
shooting. After all, the purpose of the documentary is to capture as much
reality as possible. Too many directors simply let the cameraman loose
and hope that they can cobble it together at the editing stage. Some film
makers actually believe that a point-and-shoot philosophy will capture
more reality than a considered approach. This is patently daft. The
filming or videoing of any activity imposes a style on the memory of the
event. The camera can look only one way at once, and moreover it
reduces a three-dimensional world to the two dimensions of the screen.
The film-maker can make up for this disadvantage by a careful selection of
images. The whole event cannot be captured on film or tape, but a
distillation of the event can. Camera position and choice of lens are part of
this distillation.

Let us consider another example which can again demonstrate the
importance of choice of lens. If the subject of our documentary was to be
the density of city traffic as gridlock approaches, then we will need a
number of shots where the sheer volume of traffic appears overwhelm-
ing. The most telling shots will be achieved by using a long-focus lens
pointing directly at a line of slow-moving traffic. The long-focus lens
compresses the image, giving the impression of a seemingly infinite

Flow of
traffic
down hill

Hill

Traffic lights (kept out of shot)

Main road

Camera fitted with
long-focus lens

**Figure 1.3** Traffic diagram.

queue of vehicles. This effect works even if the traffic is moving fairly freely. The fact that the traffic is flowing towards the lens also allows us to see more cars at any one time, and adds to the sense of remorselessness. The location is important – such shots work best at a T-junction controlled by a traffic light across the road directly opposite the junction. If the road is downhill to the junction it is even better, as more vehicles will be in shot at any time. (The traffic lights which reduce the flow can easily be excluded.)

The limited depth of field of the long-focus lens, and the fact that action towards the long-focus lens appears slower than it really is, both help in the impression we are trying to convey.

Some directors appear to think they need no knowledge of photography, and that an example such as that above would be provided by a good cameraman anyway. ('After all, they're the experts'.) To make an analogy with interior decorating, no-one would let a decorator, however expert, loose in their home with no discussion of colour scheme, or how each room was going to be used. That is the essential point. A cameraman, however brilliant, can be of service only to a director who can tell him the purpose of each shot. If the shot of the traffic is to work as

intended, the cameraman needs to know the effect required. (Then he will decide on a long-focus lens.) However, you need to know that the effect is possible, so you can take the crew to a suitable location where the shot can be quickly and safely achieved.

**Figure 1.4 Depth of field**. Picture 1 was taken with a small aperture. Picture 2 was taken with a large aperture. The same, 50 mm lens, (the standard for 35 mm films) was used for both photographs.

We have discussed three important variables. The fourth great variable is the weather, and is out of our control. At a given aperture, all wide-angle lenses have a greater depth of field than all long-focus lenses, but all lenses (wide-angle and long-focus) have a greater depth of field in bright light than in poor light, because the smaller the aperture, the greater the depth of field. On a bright day, with a wide-angle lens, there is no problem involved in holding focus. An object a yard (1 m) from the lens and an object on the horizon will both be sharp. On a bright day with a long focus lens, the depth of field may be up to 5 ft (1.5 m), so if the camera is focused on an actor some 16 ft (5 m) away, an object a yard (1 m) or so behind the actor will be in focus – after that the focus will tail off. If the actor moves forward up to a yard (1 m) or so, he will still be in focus (although a diligent cameraman would still pull focus). On a dull day the cameraman has to increase the aperture to let more light through the lens and on to the film, so the depth of field is reduced. The wide- angle lens will still have a considerable depth of field, but now the closest object in focus may be more like two yards (2 m) away from the camera if we still wish to hold a sharp horizon. The long-focus lens in duller weather will now have a very restricted depth of field. The actor 16 ft (5 m) away will only have to move a few inches back or forwards to be out of focus.

In all the previous examples I have used the terms 'wide-angle' and 'long-focus' as they apply to individual prime lenses, but the theory holds good for the 'wide' or 'telephoto' end of a zoom lens.

## SUMMARY

There are three important decisions to make about every shot:

1 Position of the camera
2 Height of the camera
3 Focal length of lens

Zoom lenses have a range from medium wide-angle to telephoto (long-focus).

If you need a wide-angle or telephoto magnification greater than the range of the zoom, then it is necessary to fit supplementary lenses or to take the zoom lens off the camera and fit prime lenses.

- Wide-angle lenses have a great depth of field.

- Telephoto lenses have very little depth of field.

- Depth of field increases the more light there is.

- Action towards a wide-angle lens looks faster than it is.

- Action towards a long-focus lens looks slower than it is.

- Action across the frame looks slower than it really is with a wide angle lens.

- Action across the frame with a telephoto lens looks *much* faster than it really is.

If you want objects, buildings or people to look impressive, then shoot with the camera low, and use a wide-angle lens – but beware of distortion, especially on facial close-ups!

If you want objects to look close to each other, people to look romantic, or to give a sense of claustrophobia, use a long-focus lens, but be aware of the depth-of-field limitation.

# CHAPTER 2

# Lighting and equipment

All picture recording, film or tape, is dependent on light. Generally speaking, the more light that is available, the better the picture quality will be. In order to overcome the difficulties of working in low-light conditions, the various film manufacturers produce a number of different film stocks. These divide into standard speed and fast stocks. A particular film's sensitivity to light is called its speed, and the faster the film, the more sensitive it is to light. The sensitivity of a given film is indicated by its ISO* exposure index. This may be arithmetic (formerly called ASA) or logarithmic (formerly called DIN). The former is more commonly used in Britain and the USA, the latter throughout Europe. Standard Eastman-color, for example, is ISO 125. Its faster form is ISO 400. Video cameras, are roughly equivalent to ISO 100 in daylight. Their sensitivity can be increased, in the same way that a microphone's sensitivity can be increased, by increasing the gain. But just as a microphone with increased gain will record more hiss, a video camera will record more picture 'noise'. Fast film stocks also give a more grainy picture than the standard stock, but it must be stressed that research and development in photographic emulsions over recent years has led to a dramatic improvement in picture quality. In this respect Kodak's T-grain and triple film emulsions are brilliant. It is also true that every new video camera that comes on the market has improved sensitivity to light, and gives better quality pictures in low light than its predecessor. However, it is worth bearing in mind that to update your video image you have to buy a new camera, whereas to update a film camera all you have to do is to load it with the latest film stock.

As every new development in film and video has resulted in both media being able to work in less and less light, so the belief has grown up in various production areas that nowadays you do not need lights to make a film. This is a dangerous belief, as it supposes that the only use a cameraman has for light is to gain an acceptable exposure. In fact, exposure is only one of the many reasons for using lights when shooting.

* ISO stands for International Standards Organization.

The creative use of lights is vital in bringing a sense of three dimensions to the two dimensional screen image, and, most important of all, continuity of light is essential in any single camera drama. Three minutes of screenplay may take a day or more to film – the sun moves every minute and the weather changes. It is only a skilled use of lighting that can give the illusion that the edited scene took place in 'real time'.

## LIGHTS

The more lights a cameraman has available, the less is the production a hostage to the fortune of the weather. If you are filming inside a church and you want the sun to be shining through the great East window, that is no problem if you have a three-man lighting crew, a small alternator and a large HMI lamp outside the church supplying the 'sun'. Your sun will shine through the window whatever the weather, and whatever the time of day. The other side of this 'equation of control', of course, is cost and mobility. To have total control over the lighting mood of the church interior, a production would require at least three lighting electricians and an a.c. generator. That is not to say that you can't achieve stunning photography in a church using a simple one-man lighting kit run off the local supply. You can, but if the sun isn't shining your lights won't be able to make it look as if it is, and if it *is* shining your schedule may well be controlled by its movement. Your shots of the East window will have to be taken in the morning because the sun won't be shining through it in the afternoon.

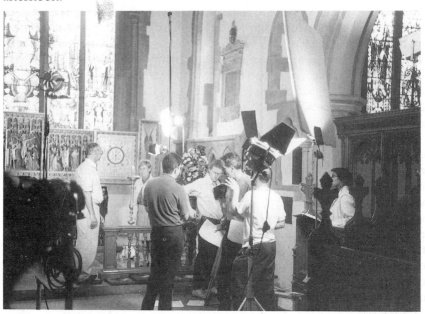

**Figure 2.1** Working with a one-man lighting kit.

There is a basic kit that provides very flexible and transportable light for documentary and small drama shoots. This consists of three 800 watt multi-beams, and two 2 kWs. The small lamp is usually painted red, the larger one yellow, colloquially known respectively as 'redheads' and 'blondes'. The knob at the back of the lamp moves the quartz halogen bulb nearer to or farther from the reflector, and allows some control of the spread of the beam. 'Barn doors' at the front also provide control. There is no lens in front of the lamp on either the multi-beam or the 2 kW, so they have a soft light source with a broad spread. Hard-focused dramatic shadows are impossible to achieve.

For a lamp to provide a hard-focused light source, it must be made with a Fresnel lens in front of its bulb. The smallest focusing lamp of this type is the Mizar. Mizars can be supplied with a 300 or 500 W lamp, and often form part of the small one-man kit. The control of the beam enables one particular object on a desk to be more brightly lit than its surroundings. The Mizar's beam can be focused to illuminate the object and only the object, whereas a multi-beam would flood the whole desk top with light. Mizars are frequently used to supply the pool of light around an on-screen candle or oil lamp; again it is their ability to focus that permits this effect.

In the days when the number of lights on a shoot was regulated by the number of electricians employed on the production, a combination of multi-beams, 2 kWs and Mizars made up the one-man lighting kit. The most common kit was three multi-beams and two 2 kWs, but three Mizars and two multi-beams was not unknown – it depended on what effect the cameraman hoped to achieve. Nowadays, the limits of lights per man are much less clearly defined. A cameraman may well bring a basic kit and light interview situations himself. This is all very well, but the director and especially the producer should bear in mind that a cameraman has enough to do without burdening himself with an additional job. Also, little is gained if one electrician brings two men's quota of lights and then takes twice as long to light every set-up. There are important safety and efficiency considerations in ensuring that every shoot has enough manpower to carry out the job.

Directors need to be aware of the lighting limitations of a small kit, especially when working in large interiors. Let's continue with our example of a church interior. At a stretch, the one-man kit will allow you to take a shot down the length of the church. If it is a bright day, the effect will look a lot more natural, but even so the cameraman will be using a wide aperture, so depth of field will be restricted. The small kit will not preclude all shooting, but it may well limit a particular effect. The area that the lights cover will also be limited. Any shot involving a pan from one wide area of the church to another will not be possible as it will in effect take in two lighting areas. Assume that the camera is in the middle of the church looking at the north door. An actor is to enter, approach the camera and then turn and walk towards the altar. With one-man lights you would have to shoot this action in two set-ups.

Set-up 1 – Camera facing actor. Actor enters, walks towards camera and
      exits frame RIGHT.

Set-up 2 – Camera facing altar. Actor enters frame LEFT and walks away
      from camera.

The obvious way to cover the action would be to pan with the actor, but
two 2 kWs and three multi-beams would simply not give you enough
cover. You need the additional lights available with a two- or even three-
man set. These extra lights would also provide the cameraman with an
overall higher level of light, and increase the depth of field.

## DAYLIGHT AND ARTIFICIAL LIGHT

Daylight and artificial light are of different colour temperatures. The
human brain sorts all this out for us, and it is only if we think about it that
we notice that the bulb in a reading lamp looks a lot more orange than the
daylight outside our window, or that the light from a neon tube looks
yellowy-green. Film and video have no brain to compensate for variations
in colour temperature. Professional film overcomes the problem by being
especially sensitive to blue (as there is very little blue in tungsten light).
When working in daylight this over-sensitivity to blue is compensated for
by using an orange filter (the Wratten 85). Video solves the problem with
the 'white balance' circuitry. Showing the camera an object which is
white, and then pushing the white balance button, allows the electronics
to switch in additional blue if tungsten light is used. Most film is colour-
corrected for artificial light simply because it is at its most sensitive
without the colour-correction filter, and as you have to pay for electricity
whereas daylight is free, it is best for film to be at its most efficient in a
studio situation, a situation which excludes all daylight.

    Location filming, however, always involves a mixture of daylight and
artificial light. Obviously the church location would involve this mixture:
daylight through the window, tungsten light from the multi-beams and
2 kWs (assuming we're using the small kit). The problem is that if the
camera now exposes the film for daylight (or white-balances the video for
daylight) then the daylight will appear correct, but the artificial light will
look orange. If the film is exposed as for tungsten (or the video balanced
for tungsten), then the daylight will look exceptionally blue. The solution
is to expose as for daylight and blue-up the lights. Blue gel is clipped over
the lights, and this brings them up to the colour temperature of daylight.
The film cameraman fits the Wratten 85 and exposes for daylight (video
white-balances for daylight). This is the common practice; indeed it is the
only option available to the small shoot, but it is not an ideal situation: the
blue gel reduces the light output of the lamps and, more significantly, the
Wratten 85 slows the film speed down from ISO 125 to (approximately)
ISO 80, or from ISO 400 to ISO 320. On larger-scale productions the
cameraman may well ask for the windows themselves to be covered with

Wratten 85 gels, so he can work without the filter or blued-up lights, and expose the film to its maximum sensitivity.

The last ten years have seen a revolution in the technology of light sources. This began with the introduction of HMI lights. These are gas-filled units (the gas is a metal halide). They work on 120 V a.c., and thus are much safer than the old d.c. lights. They are even safe in light drizzle because of their low voltage and watertight connections. Their most important advantage is that they give a light output that closely matches the colour temperature of daylight – they are a cold-light source. Don't be deceived, 'cold' doesn't refer to the amount of heat that a lamp generates; it refers to its colour temperature. A cold light source is bluish, like daylight, a warm light source is orange-red, like tungsten. In fact, as HMIs are very efficient lamps they also generate less heat per watt of light than their tungsten equivalent, so 'cold' is a doubly-appropriate adjective. HMIs come in a variety of sizes from the 270 W hand-held, in stages up to the large 12 kW, which is nearly equivalent to the old carbon-arc d.c. Brute.

## DEVELOPMENTS IN LIGHTING

Developments in lighting equipment are now coming thick and fast. The CID lamps have followed on from HMIs. These are fixed-beam lights with a square wave form. In 'director-speak' this means that they give a lot of punch. They are smaller than HMIs, but in some ways are less versatile – they can't 'spot' or 'flood' by the simple turning of a knob, but require a change of Fresnel lens, and this takes time if the lamp is hot. Latest on the scene is the MSR. This has a 'post-upright' lamp and comes equipped with interchangeable Fresnels to provide a variable spread. They are almost half the size of the equivalent HMI, though at the time of writing they are available only in 1.2 kW and 2.5 kW sizes.

The choice of the correct lights for the job is very much in the province of the cameraman, but it is very useful for a director to have a passing knowledge of what is available. The CID battery light is particularly useful for the documentary maker, as its powerful spread gives a natural effect on scenes shot at the end of a dull winter's day. The old battery lights had only enough power to 'beef up' the foreground presenter, and the effect on screen always looked false. The CID allows a much more natural fill-in to the background. Remember that battery lights should be used on stands whenever possible. Hand-holding a light looks dreadful unless you are trying to create a 'newsreel look'.

HMIs, CIDs and MSRs are discharge lamps. They require an additional surge of voltage to get started and a few minutes to reach full power. The additional surge is provided by a unit called a choke. This is a box which stands by each lamp. Directors should be aware that a hot discharge lamp will not immediately relight – the choke only works when the lamp itself is cool. This can lead to delays if the lights are continually being moved. A

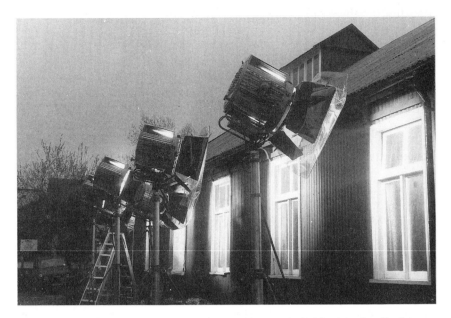

**Figure 2.2** A bank of exterior HMIs supply the 'sunlight' for interior filming on a dull, November day.

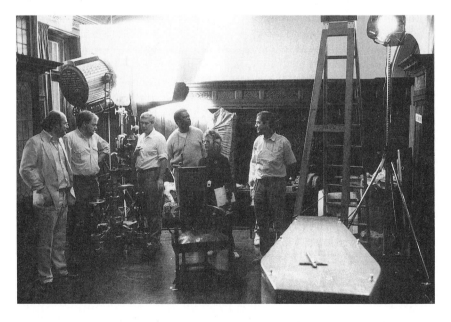

**Figure 2.3** HMIs light a drama location shoot. The key light is being bounced off a sheet of polystyrene.

wise director always plans his shoots to minimize the number of lighting set-ups and maximize the use of those set-ups. Shoot everything in one direction before going on to the next set-up. When you decide you've done all the shots involved in one lighting set-up, it is a good idea to talk through the remaining shots with your cameraman. Find out what is the most efficient order in which to light and shoot the remaining shots. A director, however experienced, can only guess this, and often what the director imagines will be a huge re-light may be quite simply achieved (and vice versa). A simple enquiry will discover the truth, as the cameraman will be able to advise on the lighting complexity of the remaining shots.

## LIGHTING AND LOGISTICS

One important difference between electronic multi-camera shooting and single-camera shooting is that single-camera shoots allow the director to achieve a total reverse angle and reveal the 'fourth wall'. However, this will involve a complete re-light. The sensible director will plan the total reverse angles at the end of the scene so as to reduce the lighting change as much as possible. Sometimes if two scenes take place in the same set then it is sensible to leave the reverses of *both* scenes until last. Other logistics such as cast availability may preclude such an economic use of lighting changes, but often the fact that the director has realized the possibility is all that is needed to save a great deal of time and money.

The other possible saving worth consideration is to limit the amount of background revealed in the reverses. In a church scene, a total reverse that revealed the opposite view right down the aisle would obviously involve a complete re-light. However, if the reverse is a medium close-up of one of the actors, then it might well be possible to back this shot with a pillar or some other piece of architecture, and thus considerably reduce the lighting effort required. If pressed for time, this compromise would be visually much more satisfactory than the alternative of not showing the reverse angle at all.

A great deal of time can be wasted if the director waits for the actors to be made up, dressed and ready before running the scene for the lighting cameraman. No lighting can take place until after this run, so such a procedure is doubly wasteful. The crew hang about waiting for the actors to be ready, and then the actors hang about waiting for the scene to be lit. At the start of each new scene, run the piece for the crew, regardless of the state of make-up and costume of the artists. Then send the actors to complete their costume and make-up while the scene is lit. If this procedure is adopted, then there is a good chance that the lighting will be completed at about the same time as the artists are released from costume and make-up, so that the shooting proceeds with the minimum waste of time.

## CAMERA RECONNOITRES (RECCES)

Any shoot, documentary or drama, will greatly benefit from a camera reconnoitre, or 'recce'. On a small shoot there will be fewer decisions to be made as the choice of lights and equipment will be limited by the amount of manpower available on the shoot. Even so, the recce will allow the cameraman to make the best decision on what lights would be best: Pups (with Fresnel lenses) instead of 2 kWs (without), Mizars instead of multibeams etc. On a large drama shoot the lighting recce is an absolute necessity. Large-scale location interiors may necessitate the construction of a large piece of scaffolding at some distance from the windows of the room(s) which will be used for filming. This, covered with suitable black drapes, will flag off the sun from the windows of the building. The sunlight can now be supplied by a large HMI, typically a 10 or 12 kW. Light focused into the room from a large lamp some distance outside will provide the realistic long shadows of sunlight, and most importantly, will only cast one set of shadows. Nothing looks more false than attempts to use two smaller lights to replace the sun, with their resultant multiple shadows.

The full-scale drama lighting recce will always have the chief electrician (or gaffer) in attendance. He will advise the lighting cameraman how many men will be required for the number of lights requested, and also what size of generator or alternator will be required to supply electric power for the largest anticipated lighting load: d.c. generators are very seldom used for location work these days. The old carbon arc, aptly named 'Brute', has nearly vanished into film history. The one effect that can still be satisfactorily achieved only from d.c. is lightning (produced from a scissor arc). This is a device which pulls two carbon rods apart causing the d.c. current to arc between them. The early designs had the rods mounted on a pair of giant insulated scissors. The vast array of location lights now runs off 110 volts a.c. This makes them much safer electrically; indeed it is possible to continue to film in drizzle or light rain in a fashion that would have been potentially lethal with direct current.

# CHAPTER 3

# Sound

Sound recording is often thought of as somewhat of a black art, but it really shouldn't be. The two most important factors in good sound recording are, first, that the microphone should be as close to the sound source as possible, and, second, that the various ingredients of the final soundtrack should be recorded separately from each other. Unfortunately, although this may be fine in theory, in practice all too often it is not so simple to achieve.

## CONTINUITY OF SOUND

Even the layman has some conception of the importance of visual continuity in the making of a film, yet it is much easier to deceive the eye than it is to fool the ear. If the editor makes an action cut from wide shot to medium close-up as an actress sits down on a park bench, there is every likelihood that a piece of bad continuity will go unnoticed. The continuity of movement will be sufficient to distract us from the fact that her purse is in the other hand or that her brooch is higher up the lapel. However, if the wide shot had a distant rumble of traffic or machinery on the soundtrack, and this vanished into silence on the cut to the medium close-up, the ear would immediately detect the fact. That, of course, is the chief purpose of the final sound mix (or dub). It is to mix a much-edited piece of sound in such a fashion that it sounds like an unedited recording. It is important to realize that the eye works in space, but that the ear sends its messages to the brain in time. That is why the eye can be educated into accepting a fast-cut series of images, the aural equivalent of which would be highly offensive. It is also the reason the ingredients of a good soundtrack need to be separate from each other. The final mix of our sequence of the actress in the park will work if the recordist has supplied a 'wild' track of the distant traffic which can be added to the medium close-up and then blended in with traffic which was present on the wide shot.

Another obvious example, one to avoid like the plague, is background music in pubs or supermarkets recorded at the time of shooting. Nothing

gives the lie to apparent spontaneity of time and place more than a piece of background music changing at every picture cut. If you are shooting in such circumstances, you *must* have the background music turned off before you shoot the interview (or the dialogue). If you add a continuous piece of music to the edited sequence at the dub, you will be adding to the illusion that the sequence took place in real time.

Background music and loud noises on location are pretty obvious, and most people would instinctively avoid them, but some apparently innocent sounds can play havoc with the editing. The tick-tock of a grandfather clock is the classic example. If this is recorded with the dialogue there is every chance that the edited sequence will contain a clock that sounds tick tock, tick tock, tock, tick, tick, tock, and so on. Again, record the clock as a wild track; then stop the clock, film the scene, and add the wild track to the edited dialogue track at the dubbing stage.

## DISTRACTING SOUNDS

It is possible that the novice director may make the mistake of thinking that an irritating background noise 'isn't too bad', and that rather than waiting for quiet it is preferable to push ahead with the shoot. This is a mistake. The human brain does filter out a lot of distracting background in real life, but unfortunately it doesn't when its owner is listening to a recording. The director of television drama *must* wait for quiet, especially if the film is a period piece.

I have had the pleasure of shooting a period drama in a film studio a couple of times, and on those occasions the freedom to deal creatively with the final sound mix was wonderful. Dialogue tracks recorded on the set in a film studio are absolutely free from unwanted background, and the director is free to add ticking clocks, passing carriages, distant howling werewolves, to his heart's content. If sound is recorded on location, even the interiors can require filtering; and the addition of wild-track atmospheres to smooth over the edits and the background noise soon builds up. Additional effects are then in danger of adding to the mess rather than enhancing the sound picture.

## POST-SYNCHRONIZATION

The feature film industry for many years has dealt with the problem simply but drastically: they use the sound recorded at the time of shooting as a guide track, and re-record everything, effects and dialogue, in a mammoth post-synchronization process. There is good economic sense in this if the film is destined to become a huge international success, as only a small percentage of the audience will see the film in its original language. For a film to be re-voiced in another language, the music and effects must be re-created free from spoken sound, and if that is necessary

then the producers may just as well re-voice the film in its original language as well. One can readily see the seeds of this process in post-war British films that were 90 per cent studio-based. Genuine exterior scenes were kept to a minimum, especially if they contained dialogue, and if they did contain dialogue, then that was post-recorded. The Ealing comedy, 'The Lady-Killers' is a good film to study in this respect.

Films shot for television seldom have the budget for total post-synchronization, and as a result some of the best actuality recording is achieved by recordists and boom swingers working in television drama.

## BOOMS AND WIND GAGS

The documentary crew will typically consist of a cameraman, an assistant cameraman and a sound recordist – on video it will often be just two men, the cameraman and the recordist. When the recordist works alone, he most usually records using a pistol-gripped, highly directional microphone (the gun mic). This is so-called because when equipped with its wind gag, the long microphone looks rather like a gun. A few years ago it was discovered that a fleecy nylon material fitted over the original hard plastic wind gag dramatically reduced the wind noise that the microphone picked up. These wind gags became known as 'Dougals' as they made the microphone look like Dougal the Dog in the Magic Roundabout puppet series. The highly-directional microphone fitted with its Dougal can record sound of remarkable quality at a considerable distance from the subject. The lone recordist simply points the microphone at the subject. Two useful facts for the director to keep in mind are that the microphone is very insensitive to sound that is behind it, but highly sensitive to all sounds that come from the front, so when filming in noisy locations (factories etc) it is hopeless to expect clear dialogue if the speech and the source of the background noise are coming from the same direction. On a beach, for example, the dialogue will be much better recorded if the camera (and, therefore, the microphone) has its back to the waves. In these sorts of circumstance it is usually perfectly possible to start the sequence with a shot including the sea (but containing no speech) and then cut to the reverse angle (looking away from the shore) for the shots which include the required speech.

Only the simplest drama scenes can be achieved with one-man recording. For any dramatic piece it is essential to employ an assistant recordist. He may well use the same microphone as the documentary recordist, but it will now be attached to a pole (called a fish pole) or, for more elaborate work, a boom. Nowadays the boom is seldom used on location, and is more usually associated with sound recording in a multi-camera studio where the length of the takes (often whole scenes at a time) would prove too tiring for a sound assistant with a fish pole.

On a drama, the sound department needs quite as much rehearsal as the camera crew. Some shots may be simple for camera but involve a lot of

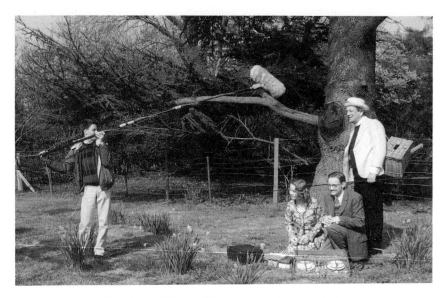

**Figure 3.1** The fish pole and 'Dougal' in use on a drama exterior.

'poling' as the assistant recordist follows the actors around the set. It is seldom difficult to keep the microphone itself out of shot, but the shadow of the boom is another matter. It is certainly a good idea for the director to encourage the sound recordist to rehearse shots with the cameraman right from the start. If not, a lighting set-up that has taken an age to complete may have to be altered when it is realized that the boom is casting shadows on the back of the set. If the assistant recordist rehearses the shot as the lighting is taking place, then the shadow problems will be spotted at an early stage and no time will be wasted.

## RADIO MICROPHONES

The easiest shots for the sound crew are tight close-ups, and the most difficult shots are wide shots, in particular wide shots that have a lot of movement within them. The more the fish pole has to move around to follow the action, the more likely it is to cast an in-vision shadow, and the wider the shot the higher the microphone has to be above the top of frame. A deep shot with two actors close to camera, and one or two actors several metres away will always present problems. The actors near to camera are no problem, but how do we record the actors in the background? – a microphone (usually abbreviated to 'mic') on a fish pole would probably have to be too high to be of much use. The obvious solution would be to fit the actors in the background with personal radio microphones, but these microphones present problems of their own. In a drama, they will have to be hidden under the artist's costume, and the

sound becomes muffled. The mic will also pick up clothes rustle as the actors move. These miniature microphones are omnidirectional and pick up more unwanted background noise than the highly-directional mic on the fish pole. The biggest problem, however, in the shot described, is one of perspective. The personal mics are actually worn by the actors, and so the sound from them appears very close. This inverts the natural perspective of the shot, as these are the very actors who are farthest from the camera. Even the most judicious sound balance cannot disguise the aural anomaly.

The sensible director would cover the actors in the background in their own closer two-shot, or individual close-ups, and *not* plan to use their sound from the wide shot very much (if at all) in the final edit. The very small personal mics used as radio mics have improved enormously in recent years, but they still do not equal the quality that can be achieved by the larger directional mics. It is important to remember that the personal mics are omnidirectional, and despite their proximity to the artist are much more likely to pick up unwanted background sound and wind noise.

## HELPING THE RECORDIST

The most helpful thing that a director can do to aid the sound recordist is to select locations which are as free from distracting background sound as possible. The reason that Dorset is a popular county for period drama shoots is simply because it is less over-flown by aircraft than any other part of England. Aircraft noise is the bane of all filming, especially in the London region. A location in the flight path into one of the airports is next to useless for any filming, as aircraft noise is impossible to exclude, and varies constantly in volume. It will, therefore, change abruptly in intensity at every sound edit. The only solution is to wait for quiet, and this is always frustrating and time-consuming. Some noises can be silenced by paying (or, frankly, bribing) the person who is causing it. Lawn mowers, pneumatic drills, chain saws etc. can usually be silenced for £25 or so, and it is well worth the money. However, if you are filming over a long period at one location, then there is the danger that many noise-makers will be keen to get in on the act, demanding payments for silence. The cameraman Freddie Young recently told me that in the 1930s people whose properties adjoined the MGM lot at Culver City were making a small fortune by mowing their lawns at inconvenient times. Eventually Louis Mayer issued an instruction that no more payments would be made for 'quiet' and that filming was to continue whatever the background racket. This pronouncement in itself probably did much to reinforce the feature industry's predilection for post-synchronization.

As long as the dialogue is clear, a certain amount of general background atmosphere is acceptable, provided its source is obvious to the viewer. A good example would be a pub interior. The background chat would be

expected, and not too much of a problem for the documentary maker. But beware! an interview in a pub with bar-room noise in the background is fine as long as the sequence confines itself visually to the pub interior. If the plan is to use some of the interview as voice-over for rural landscapes, then the pub background noise will be totally inappropriate. In a drama it is worth noting that the extras in the background would be asked to keep their actual volume of sound to a minimum, and that a wild track of their chat (recorded separately at full natural volume) would be added at the dub. Again it cannot be stressed too much that the secret of a good dub is that the various sound ingredients are recorded separately from each other. The classic example is the conversation between a young man in the open top sports car and the attractive girl who is walking along the country road. The shooting script may read something like this:

WIDE SHOT. THE COUNTRY ROAD OUTSIDE RISLEY.  EMMA IS WALKING
TOWARDS THE VILLAGE. A SPORTS CAR ROUNDS THE BEND AND PULLS
UP JUST PAST HER.  THE DRIVER, TIM STOGDEN, CALLS BACK TO
EMMA.

TIM : (CU)  Look, I'm sorry to bother you, but I'm a bit lost.
Is this the Risley road?

EMMA : (CU DEVELOPING TO TWO—SHOT AS SHE APPROACHES THE CAR)
Yes, you're nearly there.  Risley is about a mile up the road.

TIM :  (CU)  That's a relief, I thought I was lost.

EMMA :  (CU)  Did you?

TIM : (CU)  Like a lift?

EMMA : (TWO SHOT OVER TIM'S SHOULDER)  No thanks,  I'm out for
a walk.

TIM : (CU)  O.K. then, see you around.

CUT TO WIDE SHOT AS HE DRIVES OFF.

Now the point is that, in reality, the sports car's engine would keep running under all the dialogue, but that would result in some very

obvious sound edits on the various picture cuts. In the event, the correct procedure would be to have the engine running only in the first and last shot of the sequence. The car is moving in these shots, so the engine has to be running. In all the static shots, however, the engine can be switched off. A wild track of the tick-over must be recorded and this will be added at the dub. This continuous tick-over wild track will have two enormous advantages:

1  Its level will be completely controllable and will not affect the level of the voice track
2  The fact that it is continuous will disguise any other sound problems that may occur when the dialogue tracks are edited

This trick of separating the sound elements of a scene is very common in TV drama shooting; but there is one other important factor for the director to consider. If the tick-over is as loud as is normal, the actors would have to raise their voices above it. For the scene to play realistically the director may have to remind the actors that they will need to speak the dialogue as if they were pitching it above the engine noise.

## DIALOGUE OVERLAPS

Perhaps the most difficult artifice with which actors and directors have to come to terms is the need to separate the dialogue when filming close-ups. In a two-shot there is no problem. Actors can talk over each other, interrupt each other, just as they would in life. However, for close-ups to be edited with the characters interrupting each other, the sound that will interrupt Actor A on Actor A's close-up must be the sound of Actor B from Actor B's close-up. This can happen only if Actor B did *not* interrupt Actor A when you were filming Actor A's close up and vice versa. The problem usually arises when shooting a highly-charged argument where the actors would naturally interrupt each other. Simply don't let it happen. It needs only the merest breath between the speakers. Then Actor B can interrupt Actor A's close-up, and we can remain on Actor A for a few words before cutting to Actor B, in both sound and picture. In other words, Actor B's close-up sound has led the cut, and the fact that it was recorded clear has allowed us to do this.

## BUZZ TRACKS

Attention to details that allow the recordist to do the job to the best of his ability may be irritating at the time of the shoot, but they really do pay dividends during the post-production period. Time given over to good wild tracks will result in a much smoother and realistic final mix. Some wild tracks such as the sea or distant traffic noise are unlikely to be forgotten; however, the 'buzz track' often is. 'Buzz track' is slang for the

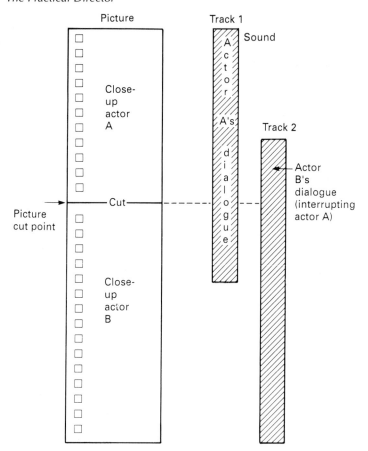

**Figure 3.2** Sound overlaps.

ambient noise of an empty building. A church interior may seem silent, but that 'silence' needs to be recorded, as it will be unique to the interior of that particular building, and cannot be satisfactorily conjured up from effects discs. The 'buzz' will be the same as the silent gaps between the dialogue on the sync takes and thus can be used to fill in any additional pauses that the editor may choose to make. Any unwanted clunks or bangs can be replaced by the buzz track, as long as they are clear of dialogue. A diligent recordist may well return from lunch fifteen minutes early to record sixty seconds of buzz while the building is quiet, or just simply ask for sixty seconds of hush at the end of the day – so allow time for this most useful recording.

When working on film the director has the choice of shooting sync (i.e. with the recorder running), or mute (camera only). On video the sound and picture are recorded on the same tape, so there is little point shooting anything mute. When wild tracks are recorded on video the camera is usually switched to 'bars'.

Unless there is some good logistical reason, it is best to shoot everything sync. Footsteps, door catches, and the like, are easy enough to record on location, but are very time-consuming if they have to be fitted in the cutting room. There is one important difference between film and video at the present state of development. On film, the off-screen lines (those spoken by the actors out of vision) do not have to be recorded on 'mic' as long as they are also covered on mic when the actors are in vision. What happens is that the film editor replaces the off-mic lines with the properly-recorded version poached from the on-screen takes. This is easy enough to do on film. It is possible to do this on video, but it is much more time-consuming. It could add as much as 30% to costly on-line editing time. Therefore, on video the recordist will do his best to record all dialogue on mic, whether the actors are in vision or not. This is a bit troublesome on location, but it really does save an enormous amount of extra work at the video edit. Incidentally the rules about overlapping dialogue still apply.

## SOUND IN POST-PRODUCTION

Armed with well-recorded dialogue effects and wild tracks the director is in a good position to make creative use of sound at the post-production stage. It is often not sufficiently realized how well sound can focus attention on the image. If a wide crowd shot simply accompanied by crowd noise is on the screen, the audience may not notice that in the crowd is a mother with a baby in her arms; add a crying baby to the sound track and all eyes go to the mother. We recently salvaged a rather inadequately-photographed comic scene by the same device. A bride-groom was to get out of a car and catch his tailcoat in the door, ripping it as he did so. The shot was in fact too wide to see this dire event, and (unforgivably) there was no close-up. A violent ripping sound added at the dub saved the day (and got a big laugh at the press viewing).

The very first 'Two Ronnies' in which I was involved had a similar problem. Ronnie Corbett as the squire's son chased the milkmaid into a barn. As they went in the door, a whole lot of chickens flew out of the top window. Again, the shot was held wide, (quite properly this time, for comic effect). However, it was not at all obvious that it was chickens that were coming out of the window: they looked more like brown paper bags! Sound effects saved the day. Loud clucking noises added to the soundtrack gave the chickens their proper identity.

Action scenes are heavily dependent on sound: 'prop' swords seldom make a very dangerous sound. Broadswords in particular are often made from aluminium and make a most unconvincing clack when they hit each other, and swords never 'swish'! The answer is to record the noise of two good old Wilkinson First World War swords which ring like a bell, and supply the swishes with a cane. Striking a cabbage is still the best and cheapest way to create body blows and punches. The list is virtually

endless; the few listed here are mentioned simply to prime the director's thought processes.

Period pieces can often be expanded by the subtle use of 'period effects'. A street scene set at any time between 1870 and 1966 may well benefit from a distant passing steam train, as well as the general period street atmosphere. A chiming clock can add punctuation to a scene, making the 'awkward moment' yet more awkward. Hospital sets are helped by the occasional arrival of an ambulance or tannoy calls for 'Doctor So-and-so to go to Casualty immediately', etc. Alfred Hitchcock, director of the first British talking picture 'Blackmail' in 1928, was a great manipulator of sound for shock or punctuation. A girl goes to scream, but instead we hear a train whistle which just anticipates the picture-cut to a steam train rushing towards the camera. Perhaps one of the many casualties that journalist programme-makers have brought to the television documentary is the reduction of sound to mere commentary, effects, and talking heads.

## STEREO SOUND

The latest development in television sound is stereo recording and mixing. In my ignorance I used to believe that stereo sound on the TV screen was pointless: surely the TV picture was too small for stereo to be of any real creative use? It took a simple demonstration from the BBC's former stereo expert, Bill Chesneau, to convince me I was wrong. What stereo sound brings to the image is an amazing power to focus the viewer's attention on the screen. The whole experience of watching the screen becomes much more real and involving. The reason for this is simple, given a little thought. Although stereo sound is achieved by a mix of the separate left/right signals, the effect is not so much one of left and right, but more of an aural three dimensionality (forward and back). Huge left/right differences are better kept for the wide screen of the cinema. On television the rule is that if the source of the sound is in vision then the sound is placed in the centre of the picture. Thus, a long shot of a train travelling across the screen may start with the sound on the left side of the sound image *before* it enters screen left, and may fade into the right-hand side of the sound image when it has made an exit screen right, but while the train is on the screen it will sound in the centre of the sound image, even though it is moving left to right in long shot. This procedure is a concession to the small TV screen, but it works well.

The stereo effect is achieved only at the final sound mix. Stereo, like every other element in the sound track, should be capable of total manipulation. Only after the picture is edited is the director in a position to decide the proper perspective of the sound stage. We have seen how the car engine's tick-over was combined with the dialogue only in the final sound mix of the screen play above; the same is true of stereo positioning. If the programme is for television use, again the chances are

that there will be little or no post-synchronization, and the sound recorded with the picture will be used in the final mix. Usually what happens is that for stereo the microphone wind gag contains two mics: the directional mic as used for mono, and another, wider perspective, mic to record the ambient background. The outputs from these mics are fed to two separate tracks on the recorder, which are in turn transferred to two separate tracks on the magnetic film track (i.e. centre and edge). At the final mix, the dubbing mixer can pan the sound from the directional mic into its perceived position in the background atmosphere. A highly convincing – though often entirely false – stereo effect is thus achieved. The most realistic stereo is obtained using this two-mic method, but it is possible to achieve apparent stereo by positioning the mono signal into background wild tracks that may or may not have been recorded on the actual location. In other words, with sufficient diligent track laying, it is possible to achieve a stereo mix from a film whose dialogue was recorded in mono. This is not so surprising when one remembers that most stereo music recordings involve recording each track of each contributing instrument on a separate track of the multi-track recorder with as little sound from the other instruments as possible, then mixing all of them together in an effective (but artificial) sound picture.

When recording stereo with two mics, the perspective mic is less directional than the principal mic, and consequently the advantages of the directional mic in excluding unwanted distractions are sometimes lost. If you want real stereo, then it is even more important to find a quiet location. If this is impossible, then the recordist will require time to provide you with a very full set of buzz tracks and 'atmosphere' wild tracks, so you can re-create the stereo later.

This is about the only additional time factor that stereo causes during the shooting. In post-production, things are different. Editing may take a little longer as the director and editor together work out the best stereo strategy for the film or tape. Dubbing will certainly take longer (perhaps 35 per cent longer) than a mono mix, as there are many more decisions to take. Not all mixers used to television are as yet completely familiar with the possibilities of stereo. The eventual dubbing time will no doubt be reduced as stereo becomes standard, but as there *are* more decisions to make it is likely that the final sound mix will always take longer than it did in mono.

## THE FINAL MIX

The final sound mix for a film may be compared with a sponge, which can only absorb a certain amount before it becomes useless. Sometimes at the sound mix of a long action sequence the dubbing mixer may ask the director, 'What do you want really loud, the music, the effects, or the dialogue?', and the director will understandably, but unhelpfully, reply, 'All of them'. The point is that even in the cinema, and especially on

television, there is a maximum recorded level that the system can sustain before going into distortion, so that if music is to be combined with effects and dialogue then it can only be a third as loud as if it were to be combined with just effects *or* dialogue. This may be technically a rather crude way of looking at things, but it can provide a useful guide to directional decision-making at the dub or even at the track-laying stage. A good example of this can be found in the brilliant battle sequence in Orson Welles's film, 'The Chimes At Midnight'. At the start of the battle the armies charge toward each other, and the sound track is full with clanking armour and horses' hooves. Then there is a cut to a high angle, and only then does the music crash in. The effects track dips to 'make room' for the music, but this does not matter, as the sound effects have already made their presence felt.

The music can now assert itself, for full excitement. This delay in the start of the music allows both sound effects and music to have an individual impact which would have been seriously diluted if they had started simultaneously on the soundtrack. The sequence then continues in a powerful montage of picture and sound to convey the brutality of a medieval battle. Much of the brutality is conveyed in the sound. Many of the images are shocking, simply because the sound that accompanies them is shocking.

The mix should aim to provide as clear a soundtrack as possible, so don't be tempted to 'overlard the cake'. If you are using voice-over in a documentary, and that voice-over already has a high background level, the addition of music will probably be more of an irritant than a stimulant.

## PRE-MIXES

Only the most simple programmes can achieve their final sound mix at one pass. It is usually necessary to do several pre-mixes first and then combine these into one final sound mix. If a documentary is intended for foreign sale, then it will certainly be important to provide an M & E (music and effects) mix. This is a mixed track that contains everything except the commentary. A foreign language commentary and translations of the sync sound when necessary can then be added to the M & E track by a foreign purchaser.

With drama it is common to make a dialogue pre-mix first, then a music and effects pre-mix, and then to combine the two. The purpose of the dialogue pre-mix is to even out the background sound and dialogue recording levels of the much-edited original sound, and make it sound as much as possible like a continuous, unedited recording. The effects and music are then mixed onto another single track.

The novice director should understand the process of pre-mixes and what it implies. If a telephone bell, for example, is pre-mixed in with office atmosphere, then the bell cannot be made louder on the final mix without bringing up the level of the office atmosphere as well – the two sounds,

once separate, have been combined at the pre-mix stage. For this reason, it is often a good plan to:

1 Pre-mix the dialogue
2 Pre-mix the background sound effects but leave off all important spot effects – door slams, telephones, gun shots, etc.
3 Combine pre-mix (1) and (2) and add music and key spot effects into a final sound mix.

This system provides the maximum flexibility and prevents the music becoming 'buried' in the mix. It does have the disadvantage, however, that in order to obtain a complete M & E track for foreign language versions you would need to repeat the process, leaving out the dialogue pre-mix.

Dubbing theatres vary in the quality and complexity of their equipment, but it is always worth checking to see that the one you intend to use has a 'sampler'. This is a digital computerized memory which allows the dubbing mixer to 'snatch' a piece of background atmosphere from a pause in the dialogue, and hold it in the memory for use later on. Thumps and bangs in the atmosphere can be disguised by using the quiet atmosphere held in the sampler (as long as these thumps are clear of dialogue). In other words, the sampler can instantly supply what would have once been achieved by atmosphere loops. The digital technology also allows for commentary to be shifted back or forward a few seconds without physically moving the tracks. The sampler's most spectacular trick, however, is its ability to alter the pitch of music or of a voice without changing the speed. This can be extremely useful. A lightweight performance can receive a touch more gravity, or a piece of music that has been speeded up to fit the picture can be brought back to its original pitch. In cases of dire necessity, rushes that have been filmed at the wrong speed (24 fps instead of 25 for example) can be corrected in pitch and still hold synchronization.

All in all, the post-production of sound is a very important element in programme making, and it is worth booking the best-equipped theatre you can afford. It is often the case that the equipment available in a more expensive theatre saves so much time that to work in a cheaper, less fully-equipped theatre is false economy.

# Production management

Good parking, toilets and a telephone: these are the three absolute basics of production management. The major drama production will have a budget allocated to make sure that all three are available, bringing in mobile toilets if necessary, but for the small documentary maker they should still never be overlooked. The greatest advantage of a well-managed production is that the minimum of time is taken up with the logistics, and that the members of the crew are at their most creative and co-operative simply because they have not suffered a whole variety of hassles before they have even unloaded the gear from the car. It is, therefore, common sense to realize that though this may be the first day of your shoot on your pet subject, it is just another programme to the crew. It will be perfectly possible to kindle some enthusiasm for your project; indeed it is easily forgotten that 99 per cent of all technicians went into film-making because they were film enthusiasts. However, on Day One they may well be suffering as a result of their previous production. They might have wrapped in Newcastle at 10 pm last night, and are making your rendezvous at 9.30 am in Croydon; the last thing they want is to find they can't park anywhere near your location.

The small documentary shoot is usually one of three types: the town or inner-city shoot, the rural village shoot, or the rural remote. Of the three, the second is the least problematic. Parking will be simple, and it should be easy enough to fix up toilets and phones at the local pub or farmhouse for the payment of a small fee. Do make such an arrangement. It really isn't good enough to knock on a door without any preliminary warning when someone is desperate for a pee. Apart from anything else, it's very embarrassing. The fact that the production has thought to make the arrangement will itself get your relationship with the crew off to a good start. The 'rural remote' location will also present no parking problems. The recce for this type of location should fix toilets, phone and shelter at the nearest practicable dwelling or pub. Portable phones are very common amongst crews these days, but remember that in many areas they simply don't work.

Toilets and phone will be easy enough on the town/inner city shoot, but

here the big problem is parking. If you can give enough notice it is sometimes possible to pay the local traffic authority in advance, and have a number of parking meters suspended for the day for your particular use. Unfortunately, this is becoming increasingly difficult. Some London districts simply refuse to co-operate, and those that do usually want weeks of notice and, worse, insist on knowing the numbers of all the cars – information which is seldom fully available until the day of the shoot. In any case, the suspended-meter solution is useful only if you plan to be in one place all day.

There are two other methods of tackling the parking problem. First, search the area for private parking, which you may be able to hire for the day. Even the locations which at first sight seem completely hopeless can often provide hidden parking areas behind the shops. These spaces belong to the shopkeepers or local residents, and these folk can usually be persuaded to part with their precious space for a day – for a fee! Local pubs and office blocks may possibly come to a similar arrangement. The second approach is to hire a minibus and driver for the day, and deliver the crew to location in that. The driver stays with the vehicle all day, and should if possible be contactable by walkie talkie, phone or bleep, so that he can be summoned whenever necessary. This is particularly important and explains why parking close to the location is vital. If you fix parking some distance from where you are actually shooting, it may well be possible to off-load the gear and re-park the vehicles; but what happens when someone discovers a necessary item of equipment has been left in one of the vehicles? Inevitably you waste a lot of time getting it, and Sod's Law dictates that there is always something left in the most distant vehicle! All this should make it abundantly clear that if you have an option on two locations, one of them with easy parking and one without, go for the one with the easy parking. Indeed, the director Joseph Losey once said that given a choice of two locations, one artistically perfect but a logistic nightmare, and one artistically only 80 per cent OK, but a logistic dream, he would always choose the latter. His reasoning was one that any experienced film maker would appreciate: any location forces artistic compromise on the director, and the greater the production management difficulties are, the greater the number of artistic compromises that will be necessary.

## THE RENDEZVOUS

Let us continue with the problems that beset the small documentary crew. Never mind the parking problems, the first thing is for the crew to get themselves to the right location. In towns and cities this is usually easy enough, and a clearly marked street map should be sent with the schedule. Sometimes it is not very easy to obtain street maps of the smaller towns, and it is worth remembering that most estate agents will have such a map which they will allow you to photocopy. Rural locations

should be easy enough, if you include a map and a specific address or landmark at which to rendezvous (say, outside the 'Dog and Duck'). Remote locations are another matter. It is stupid to write detailed instructions running into several pages and ending with something like 'left at the second fork and sharp right up rough track after the third gnarled oak tree'. Even worse (and infuriating for the crew) is to include 'If you get lost, ask'. If the location is all that difficult to find, the best thing to do is to meet the crew at an obvious place and take them on in a convoy. The instructions can now read: 'Exit 14 off the M4, rendezvous 9.00 am at the cafe on the left-hand side three-quarters of a mile down the road to Hungerford'. Such a plan will ensure that everybody meets up easily and, better still, the day's work can be discussed pleasantly over coffee, eggs and bacon. The day will get off to a good start. Try not to burden the cameraman with your apprehension at the breakfast meeting. He will not be pleased to hear that 'We've really got an awful lot to do, and we're going to have to move really fast to get it all in'. This may well be true, but stating it so bluntly gets the day off to a bad start, and also makes you look a fool for planning to do too much in the first place. A more sensible approach would be to say, 'I hope to fit in a number of locations – the first one is just up the road at the vicarage. It's an interview with the Reverend Jarvis, just a simple talking head'. This sounds a lot less daunting. You have mentioned the fact that there are a number of locations, but the cameraman knows that the first of these is easy, and he immediately has some idea of how much gear to off-load when he reaches the first location. If the day *does* contain a number of locations, and Location A is thirty minutes' drive from Location B, that does not mean that if you wrap at Location A at 10.30 am you will be shooting at Location B at 11.00 am. With luck you may be turning again at 11.30, but it is more likely to be 11.45. Remember, equipment takes time to load and unload, and a unit travels at the speed of its slowest vehicle (this is particularly important on a large shoot when the location shift involves a generator and cumbersome prop wagons). Travel time must be generously scheduled, but it *is* a waste of shooting time. Often it is possible to avoid wasteful journeys by some commonsense production management.

## SCHEDULING FOR EFFICIENCY

Imagine that you are involved in a film about dwindling congregations, and the possible closure of two picturesque country churches. You need to film:

1  An interview with the vicar of St Mary's
2  An interview with the Bishop
3  An interview with the Vicar of St Cuthbert's
4  A wedding scheduled for 2.00 pm.

If St Mary's is ten miles from the Bishop's Palace, and that in turn is fifteen

miles from St Cuthbert's, the crew is going to have difficulty in getting to the church in time to have the lights in position before the wedding guests begin to arrive for the service. One thought would be to film the interview with the vicar of St Cuthbert's after the wedding, but the crew – and you – are still very likely to have no time for lunch. The solution is one of production management. Do we really need to film the Bishop at his Palace? Would it not indeed be better to film him at one of the threatened churches? If he agrees to this, then the day becomes much more achievable and productive. We would film the vicar of St Mary's, drive to St Cuthberts and light the church, have lunch, film the wedding, have a cup of tea, then film the remaining two interviews. The cost of a car to fetch the Bishop would be money well spent.

Documentaries are often shot without the benefit of a camera recce, with the result that there are a number of things that the director should look out for if he is the only person to visit the location prior to the filming day. The first one is the direction of the sun: where is it at what time of day? Hatfield House is a prize example of the importance of this information. One of the most impressive shots of the house can only be taken in the afternoon, because in the morning it is in the shade and looks dull and grim. Try to recce your location at approximately the time of day at which you intend to film, then, should the position of the sun be a problem, you will be more likely to appreciate this. It is certainly worth recceing on the same day of the week as you intend to film. The sleepy market town may have no parking problems on a Tuesday when you recce, but if when you arrive to film on a Thursday it is market day, the shoot will be a nightmare. Remember market days, remember half-day closing – it may be an advantage to you that most of the high street shops are closed in the afternoon, or it may be a disaster – but you mustn't be taken by surprise.

Interiors will require light, so you should check to see if the location has a reasonable number of 13A sockets. Some old halls and churches don't have very many, and the wiring may be in such a state that your electrician will want to tap straight into the fuse board. In this case, it is very sensible to make sure the janitor, churchwarden, etc., is with you all day during the shoot. There is always some door that needs unlocking, or some switch that can't be found, and none of this is a problem if the man with the local knowledge is at hand.

Noise is another factor to which you should be sensitive at the recce. This is another reason for trying to recce on the relevant day of the week. Some noises – play groups, delivery lorries, even church bell practice – occur on one particular day each week, so checking the location on that same day will alert you to the horrors. When time allows, don't rush in and fix a location a soon as you've found it. Wait around for twenty minutes or so. In that way you are more likely to notice any noise problem (the local flying club, for example). You should be aware of the acoustics of any interior. Perhaps the boardroom has an echo, and a more suitable room could be found; though remember that even for an interview a big room is much preferable to cramped conditions.

Find somewhere for lunch; have lunch there yourself, if possible, before fixing it up for the day of the shoot. That way you can make sure the food is good and doesn't take an age to serve – this is very important. For speed of service, pub lunches are usually a better bet than restaurants. It is worthwhile making an arrangement for lunch, as finding somewhere on the shoot day can be a time-wasting and frustrating experience. Some pubs will reserve you tables, and often give you a menu so that you can phone through the crew's order at about 11.30 am. This ensures your food will be ready shortly after you arrive at the pub – again saving you production time.

## WALKIE-TALKIES

A pair of walkie-talkies is an invaluable aid to efficient production management. The cueing of action at a distance is simplified, and is much preferable to frantic waving of handkerchiefs. The trouble with handkerchief signals is that they assume that once you've signalled 'action' everything is going to run smoothly, that you won't need another take, or that you don't need to modify the action in any way. But you always do; and without walkie-talkies you spend an exhausting time running between camera and contributor. Any filming that involves vehicles definitely requires radio communication. The car may well be out of sight of the camera at the start of shot, and when you shoot a second take you will probably want the car to be moving slower, or faster, or nearer the middle of the road. All this information is quickly relayed over the radio link: without it, all concerned are in for a time-wasting saga of communication difficulties. Walkie-talkies also have their uses at train and bus stations. If you leave one with the station announcer, he may agree to delay announcements over the PA system when they know you are shooting a take. Of course, this obliges you to let them know as soon as you've cut. Sometimes when it would be too expensive to halt some background din for the whole day – pneumatic drills, chain saws and the like – it is possible to pay a smaller bribe and have an assistant on the end of a walkie-talkie stopping the noise for short periods when you are actually turning over. Always make sure that one walkie-talkie is with the camera and another is with the distant action you wish to control. It is not unknown for the director to wait half an hour while the actor climbs up the mountain path, only to discover that both walkie-talkies are with the camera!

## SHELTER

If your shoot is to be a day of exteriors, and you are working at a 'rural remote' location, then shelter may be an important requirement. You can't expect people to sit in a car for two hours waiting for the rain to stop:

it's much better to wait in a pub or, failing that, someone's house. And *do* wait! Bob Hope once remarked 'If you don't like the weather in England, wait five minutes'. This is a good thing to bear in mind before you cancel the day's filming. I was once shooting on the North Norfolk Steam Railway. The budget was tight and I couldn't afford to pay for the train to be in steam for more than one day. The weather that morning was dreadful: trees were blowing down. The train valiantly steamed into the station through hail and spray, and looked like something out of Doctor Zhivago. Unfortunately I wanted an idyllic Edwardian summer. We all retired to a nearby pub and waited three hours. The crew was in reasonable spirits thanks to a coal fire and sandwiches supplied by our excellent host. However, by 1.30 pm I was under some pressure to call it all off. I remembered Bob Hope's quip, and insisted on waiting until 2.00 pm before I made a decision. At two minutes to two the sun came out, and we had a glorious afternoon – people at the press show commented on how lucky we were with the weather! The important point I learned that day was that if my production manager, Matthew Burge, hadn't fixed up comfortable shelter, there was no way I could have kept the crew happy for three hours in a gale. I would've been under great pressure to pack up, and that would have been a wrong decision.

I mentioned earlier that the noise made by flying clubs is a pain in the neck for the film-maker, but even they have their uses. The local airport, whatever its size, always has the most accurate local weather forecasts available, so it is useful to have their telephone number with you. If you call them they might even agree not to overfly your filming area. It's worth a try; and you will get co-operation if the planes involved are just joy-riding light aircraft.

## PRODUCTION MANAGEMENT SUMMARY

The points so far apply particularly to the small documentary shoot. They can be summarized as follows:

- Parking

- Toilets

- Phones

- Direction of sun

- Provision of power points

- Lunch/shelter

- Sound problems

- Minimize travel within the shooting day

- Acquire as much local knowledge as possible (half-day closing days, market days, tide tables, telephone numbers of airports)

- Book a walkie-talkie if there is any chance of its being useful

- Be prepared to pay for the attendance of the janitor, house foreman, churchwarden, groundsman etc.

- Have enough money with you to pay additional facility fees (or bribes for quiet)

- Obtain police permission if you intend to film in a public place (for non-dramatic shoots this is usually a formality, but *must* be done)

## DRAMA PRODUCTION MANAGEMENT

The production management of a large drama shoot is a specialist job in its own right: directors who have never been production managers can do a lot to maximize the efficiency of the shoot if they are prepared to pay some attention to the organizational problems that are part and parcel of any major production. Directors who once were production managers do well to remember their past frustrations. Parking for a major production is a problem if you are shooting in the street, and so unless the script absolutely demands that big scenes are shot in inner-city streets, you would do well to consider reducing the scenes that actually take place in Soho, Cardiff Central Station, Trafalgar Square, Bradford City centre, etc., to a minimum. The absolute minimum of vehicles for drama shooting will be:

1  A camera car
2  A sound car
3  A grips car
4  A lighting car
5  An alternator (4 and 5 can sometimes be one vehicle if there is only a small demand for additional light)
6  A prop wagon (sometimes two)
7  A catering wagon (sometimes two)
8  A make-up caravan
9  A costume caravan.

After these, any number of private caravans for the cast can be added, as budget and space allow. Obviously a circus of this size becomes a nightmare of organization if it is to be taken into a city centre. Period drama (the recent Michael Caine 'Jack The Ripper' for example) will often

be forced to shoot on a Sunday or over a Bank Holiday weekend in order to obtain police permission. Be absolutely clear: the police cannot prevent you filming, as long as you are not doing anything in the nature of a staged crime. That is why in the documentary section I asserted that permission is a formality when you are shooting actuality in the street. However, the police can move you on for causing an obstruction, and on any drama you certainly will be doing so. Permission and co-operation are essentials. Some districts of London and some towns are more helpful than others. If the location is not fixed by the script, it is much better to be shooting somewhere where you are welcome than somewhere where you are not. The production manager can ask for a policeman to be with you for the day; the production will have to pay for his time, and he won't let you play havoc with the traffic or turn a blind eye if you break the law. However, he will be able to deal with that breed of aggressive nutters that descend on any city film shoot, and makes the production manager's task even less enjoyable than usual.

The parking of vehicles for a big shoot is a time-consuming process. The generator must be near enough to the location to reduce the cable runs, but far enough away for the low rumble of its engine not to be recorded on the soundtrack. Over the years generators have become much quieter but the big ones can still present a problem. This will be worse if they are parked in a courtyard where the sound can reverberate. The cabling into a location building is an important consideration. Cables can't go in through the front door if the action centres around that same front door. The weight of the generator and the height and weight of the prop wagon is something else to consider. If you recce in a car it is all too easy to fail to notice that your route has taken you over a weight-restricted bridge, or under a low railway bridge or a long-established avenue of trees with low overhanging branches. If you are working at one principal location, but camera, sound, grips and a few actors need to go off site for a few shots, the production manager must make sure that the necessary vehicles aren't blocked in by other vehicles.

The caterer and the make-up department will need power and water. It is best if they can obtain mains power or a supply from the generator, as otherwise they may be forced to fire up a noisy portable generator, with dire results on your sound recording.

The production manager has an enormous organizational task on his hands, and the whole purpose of his job is to free the director from logistical worries. However, the director should nevertheless take some of the problems into consideration. The most important contribution that a director can make to efficiency is to let everybody know what he plans to do, and then stick to the plan. If the director suddenly decides on an angle that was not in the original shot list, the chances are that some or all of the vehicles will have to be moved to exclude them from shot. Vehicles do have to be moved now and again, but the fewer the vehicles involved, and the fewer times it has to happen, the better. The working relationship between the director and the production manager should be one of

closely co-operating colleagues. If it is confrontational, the budget will escalate with the tension, and the efficiency of the shoot will decline.

## PRODUCTION SCHEDULING

There are many occasions when the director can make a real contribution to the efficient scheduling of a shoot. Consider the following problem, which is based on an actual production.

The production is on location for one day at a country house for a period drama. There are scenes to be filmed in a bedroom, on the staircase and in the living room. Each interior will be used for two scenes which will appear in different parts of the film. Only one actor appears in all the scenes, but he has a costume change. He will be in his nightshirt in the first bedroom scene, the first staircase scene and the first living room scene, and in his day wear in the second bedroom scene, the second staircase scene, and the second living room scene. His day wear is quite complicated, and it takes twenty-five minutes to dress him and check his make-up between changes. So the co-ordination of lighting and make-up costume changes presents a problem. The worst decision would be for the director to insist on filming in sequence, i.e. Scene One in the bedroom, moving to Scene Two on the staircase, moving to Scene Three in the living room, then changing clothes, returning to the bedroom and repeating the whole process. This order of shooting would be enormously time-wasting, as the crew would have to light each location twice. At first the solution might seem to be to change the actor three times and shoot:

BEDROOM, SCENE ONE - NIGHTSHIRT

(CHANGE ACTOR)

BEDROOM, SCENE FOUR - DAY WEAR

(CHANGE ACTOR)

STAIRS, SCENE TWO - NIGHTSHIRT

LUNCH

(CHANGE ACTOR)

STAIRS, SCENE FIVE - DAY WEAR

(CHANGE ACTOR)

LIVING ROOM, SCENE THREE - NIGHTSHIRT

(CHANGE ACTOR)

LIVING ROOM, SCENE SIX - DAY WEAR.

This schedule saves the lighting moves, but is very time-consuming (and tiring) for the actor.

Now, the change from day wear to nightshirt is going to be much quicker than the change from nightshirt to day wear, as the nightshirt is

easy to put on and the make-up much less critical (it doesn't matter if the actor looks tousled – indeed it would be preferable if he did). A sensible schedule would, therefore, be:

```
SCENE FOUR, BEDROOM - DAY WEAR (THE ACTOR CAN GET
READY WHILE THE SET IS LIT)

SCENE ONE, BEDROOM - NIGHTSHIRT (AN EASY CHANGE)

SCENE TWO, THE STAIRS - NIGHTSHIRT (NO CHANGE FOR
THE ACTOR)

LUNCH

CHANGE ACTOR

SCENE FIVE, THE STAIRS - DAY WEAR

SCENE SIX, THE LIVING ROOM - DAY WEAR (NO CHANGE)

SCENE THREE, THE LIVING ROOM - NIGHTSHIRT (BUT AN EASY
CHANGE AT THE END OF THE DAY).
```

Decisions often have to be made as to whether it is best to move lighting set-ups, or change actors' costumes and make-up. There can be no hard and fast rules, but usually it is best to change the actor and to make the change from the complicated costume and make-up to the simple costume and make-up. It is much quicker to remove a heavy make-up (i.e. a werewolf) than to apply it.

If the example above involved such a heavy make-up change (and monster make-up can take anything from one to three hours), then the production would have to re-think; the best schedule would be:

```
SCENE ONE, BEDROOM - WEREWOLF MAKE-UP

SCENE TWO, STAIRS - WEREWOLF MAKE-UP

SCENE THREE, LIVING ROOM - WEREWOLF MAKE-UP

CLEAN OFF MAKE-UP
```

SCENE SIX, LIVING ROOM - ACTOR AS NORMAL CHARACTER

RETURN TO BEDROOM, SCENE FOUR - ACTOR AS NORMAL CHARACTER

SCENE FIVE, STAIRS - ACTOR AS NORMAL CHARACTER.

Ideally, it would be better to schedule the shoot over two days. But if the schedule had to be achieved in one day, this would be a reasonable solution, especially if the bedroom was fairly small. It would then be possible to leave lights set in the bedroom, and move on to the other scenes using other lights. It is unlikely that the production would have enough lights to leave the stairway lit and still be able to set up yet more lamps for the living room. So the director should consider whether the shots on the staircase are really necessary. Could the shots with the actor as the normal character be dispensed with? The day would then be a lot easier. Maybe we only need to see his feet descend the stairs, in which case he needn't remove the werewolf make-up.

Perhaps these schemes seem fanciful, but it is such devices that keep the TV movie on schedule and on budget, and only a director and production manager working closely together can reach ingenious solutions to scheduling problems.

If the director hasn't worked with the production manager before, it is very dangerous for the two not to consult together about how much time is allocated for the shooting of each scene. An innocent paragraph of the script may require a *tour de force* of action shots, which the director knows will take several hours (maybe even a couple of days) to complete. On the other hand, the director may be confident that a long dialogue scene can be disposed of in a couple of tracking shots, and so three hours will complete the whole thing. The production manager needs to know this information.

The wise director will not start out on the first day of a long shoot with some incredibly difficult sequence. Every department, however experienced, needs to settle in. Props, in particular, will benefit if the first day is light from their point of view. The props for Day One can be packed separately and will, therefore, be immediately available. Meanwhile, as the shooting proceeds on Day One, all the other props can be unpacked and prepared for the relevant day's use. Any unusual or novel technical equipment is also best scheduled a few days into the shoot. This gives the crew a chance to check it and make sure all of it is present and correct. A cameraman should appear confident on the set, and if he hasn't had a chance to practise with whatever technical wonder the director has insisted upon, tempers can become unnecessarily frayed.

Film-making is an unpredictable process. Weather, noise, unexpected turns of events do happen. (One crew for a police series turned up to find the whole area had been demolished since the recce.) However, if the production is well organized overall, i.e., people are kept informed,

comfortable and well-fed, then there will be plenty of co-operation when the going gets tough. The director can expect little co-operation if it is plain that the production would have trouble organizing a two-car funeral.

Example of filming schedule for a simple documentary shoot

**_TUESDAY 23RD OCTOBER_**

**PRODUCTION CREW TO TRAVEL TO LONG MELFORD**

**R/V :**           1530 for recce at Kent Well Hall:
                Cameraman; Sound Recordist; Gaffer

**LOCATION :**      Kent Well Hall, Long Melford, Suffolk

**CONTACT :**       Dawn Friend      Tel: 0787-XXXXXXXXX

**BBC CONTACT :**   Kate Berry       Tel: 081-XXXXXXX

**DIRECTIONS :**    See Maps C & D

                <u>By Road</u>:  Drive through Sudbury and on to Long
                Melford.  As you leave Long Melford you will see
                Melford Hall on your right hand side (**N.B.** this is
                not Kent Well Hall).  After church on left hand
                side you will see the entrance to Kent Well Hall
                opposite 'The Hare' public house.

                <u>By Rail</u>:  During day - train from Liverpool Street
                Station to Marks Tey.  Then a connecting service to
                Sudbury.  Trains from Liverpool Street 32 mins
                past the hour.

**PARKING :**       Outside the Hall - no problem

*Page One*

## *WEDNESDAY 24TH OCTOBER*

| | |
|---|---|
| **UNIT CALL :** | 0930 |
| **ARTISTS CALL FOR MAKE-UP :** | 0900 |
| **AUTOCUE :** | 1300 (to be ready for 1400) |
| **R/V :** | At location |
| **LOCATION :** | Kent Well Hall, Long Melford, Suffolk |
| **CONTACT :** | Dawn Friend    Tel: 0787-XXXXXXX |
| **BBC CONTACT :** | Kate Berry    Tel: 081-XXXXXXX |
| **DIRECTIONS :** | See Maps C & D and directions on Page One |
| **PARKING :** | Outside the Hall - no problem. |
| **LUNCH :** | 1300 - 1400 approx. Suggest 'The Hare' pub near location |
| **TO SHOOT :** | a.m.  Exts. at Kent Well Hall p.m.  Int. Great Hall |
| **SPECIAL REQUIREMENTS :** | Autocue p.m. Second dummy camera Walkie-talkies |
| **WRAP:** | 1800 |

**\* ACTRESS TO TRAVEL UP TO LONG MELFORD \***

*Page Two*

<u>**THURSDAY 25TH OCTOBER**</u>

**UNIT CALL :**            0930

**AUTOCUE :**            0930

**ARTISTS CALL**
**FOR MAKE-UP :**       0900

**R/V :**                  At location

**LOCATION :**           Kent Well Hall, Long Melford, Suffolk

**CONTACT :**            Dawn Friend      Tel: 0787-XXXXXXX

**BBC CONTACT :**        Kate Berry       Tel: 081-XXXXXXX

**DIRECTIONS :**         See Maps C & D and directions on Page One

**PARKING :**            Please keep the drive outside the Hall free in
                         the morning as we will be filming exteriors/

**LUNCH :**              1300-1400 approx
                         Suggest 'The Hare' pub near location

**TO SHOOT :**           a.m.  Ext. Kent Well Hall
                         p.m.  Int. Sitting Room

**ADDITIONAL**
**EQUIPMENT :**          Autocue
                         2nd dummy camera
                         Walkie-talkies

**SPECIAL**
**REQUIREMENTS :**       Log fire if possible

**WRAP :**               1800

*Page Three*

# CHAPTER 5

# The actor's psyche

Film directors tend to fall into two categories: ex-technicians who are brilliantly efficient with the technical logistics of the shoot, but who can be unhelpful, even unwittingly rude to the actors; or ex-actors who identify with their cast, and can be deeply irritating to their crew. The ideal is to achieve the perfect balance and to draw perfection from both the cast in front of the camera and the crew behind it – indeed, to forge the two separate elements into one creative team. The essential point for the technical director to appreciate is the vulnerability every actor feels in front of the camera. It is often said that editors make the best directors (and as an ex-editor myself I should like to think so). However, directors who come from the cutting rooms have one potential weakness. They are so well-versed in manipulating performances on film or tape that they expect actors in the flesh to be equally malleable. This approach can lend to serious tensions on the set. The trouble is that good acting, even great acting, is a self-effacing art, and so it all looks easy. Every director of actors for the screen should try delivering lines whilst being filmed in medium close-up making a pot of tea. This simple experiment would provide a revelation to those who might not otherwise begin to appreciate the film actor's difficult craft.

Actors and actresses need to be confident that they understand the character of the person they are playing. They frequently require the director to discuss the biography of the character. If director and actor agree on the history of the character's life prior to that part of it expounded in the script, then there is a much greater chance that the actor's interpretation of the character will be what the director expected it to be. Actors cannot be convincing if they themselves are unconvinced. If the choreography of a scene is motivated solely by the director's need for pictorial imagery, then the scene will surely fail. If the character and the relationship between the characters is understood by the director and the cast, the choreography will quickly become self-evident. Character A hates Character B, therefore they will never willingly stand close to each other. If they are to play a scene in a large room they will almost certainly keep a good deal of space between them, and are very unlikely to share a

sofa. However, if it is a party scene, and the large room is crowded, they may be forced to sit on the only seats available and perhaps this could be the sofa. Such devices allow the director to gain dramatic tension from the circumstances that surround the characters.

If the script concerned two actors who hated each other forced to share a dressing room, there would be much more chance of comedy if the dressing room were small. It would be no trouble to invent appropriate business where they got in each other's way simply because the smallness of the room forced them together. The same business, set in a large dressing room, would not work. If in reality the space allowed our two protagonists to avoid each other, that is what they would instinctively do, and it would be foolish to direct the scene otherwise.

In the small dressing room the humour would have to be built around their mutual irritation as they got in each other's way: knocking over the coffee, jolting the arm as lipstick is applied, etc. In the larger room they would sit at the extremities of the room, so neither of those events would be likely to occur. However, actor A could knock over his own coffee unawares, while actor B, who has noticed, says nothing, and sits gloating in his corner of the room while the coffee stains actor A's dress shirt.

The essential point about these two situations is that in both cases the actors' behaviour remains in character, and that the alteration of the comic business reflects the differences in the characters' situation. But what if there is a need for the two of them to be close together in the large dressing room? Well, then the director must invent a believable reason for them to invade one another's space. Perhaps only one dressing table has mirror bulbs that work, so that they fight to use the same mirror. Perhaps, more likely, there is only one wash basin or hair drier; or perhaps the bulbs around actor A's mirror fail so that he has to attempt to share with actor B,then after a lot of angst, the lights on actor B's mirror fail and the lights on actor A's come on again. Business of this complexity is admittedly in the realm more of the writer than of the director, but a director does need to keep his imagination alert to the comic possibilities of the scene – and once again these possibilities are 'character driven'.

So what should a director look for as he reads a scene or a whole script for the first time? Again it is character interaction. The plot, after all, has been supplied by the writer, and changes to it are seldom part of the director's job. How the characters behave and how their behaviour allows the plot to develop in a credible and dramatic fashion, *that* is the job of the director.

The first task is to note the relationship between the characters – who loves whom, secretly or overtly, who dislikes/hates whom, who is dominant over whom, etc. Who is dominant over whom is often the most crucial consideration, first because this should be reflected in the visual conception of the scene, and second because the situation of dominance often shifts back and forth as the scene develops. This, in turn, should be reflected on the screen.

One important thing to look out for as you read a script is any

inconsistency of behaviour in the characters. These sometimes slip past in a first cursory reading, while inconsistencies of plot do not. Sometimes such inconsistencies are useful and subtle clues as to the nature of the character, sometimes they are simply a result of sloppy writing. It is the director's task to decide which, and either tackle the writer or work out a biographical reason for the character's behaviour.

These are the areas that will be of real concern to a diligent actor. The director will need to have an answer when the actor points out that his character would never do 'such and such'; and that answer has to be based on a convincing theory as to the hidden complexities of the character.

I have been present at interviews where actors have stated that when working on film they require the director to move them around like a marionette. This would seem to fly in the face of everything stated above. However, remember that such statements usually refer to hitting precise marks on a film set, and moving from one set of marks to another. This is especially necessary if the composition of the shot is critical (e.g. if you were using a long-focus lens). In this sense the actor *is* a puppet, and his moves are both dictated and limited by the director. That is emphatically not to say that the moves were not comfortable or believable to the actor in the first instance.

This sounds very well if the director is working with a script for a television film or the screenplay of a feature. But how about the bread-and-butter end of the market, a corporate video for example?

## SAMPLE SCRIPT

In practice, the same rules apply. Consider the following dialogue, which is typical of the competent but uninspiring dialogue with which the jobbing director is often confronted:

```
SCENE FIVE

LUNCH TIME.   EVERYONE HAS GATHERED TO DISCUSS LIZ'S IDEA.

   LIZ :   So are we all agreed to stagger our holidays this year?

   JOHN :   I'm not so sure, I'd like to discuss it.

   PETE :   Well, of course we want to discuss it, that's why Liz

   called the meeting.

   LIZ :   How about you, Tracey?
```

**TRACEY :**  *I suppose it's a good idea.*

**PETE :**  *Right, so it's settled then - (HE MAKES AS IF TO GO.)*

**LIZ :**  *Where are you off to?*

**PETE :**  *Just to get paper and pencil, O.K.?*

**LIZ :**  *You're right, someone should be taking notes.*

**PETE :**  *(WRITING) So - "holiday rostering", what's the date?*

**TRACEY :**  *The 25th - oh, my Mum's birthday's the day after tomorrow.*

**LIZ :**  *Tracey, can we stick to the point?*

**TRACEY :**  *Just reminding myself.*

**PETE :**  *Well don't.*

**TRACEY :**  *My God, you're very important all of a sudden.*

**JOHN :**  *Are we having a meeting, or another office bitching session?*

**TRACEY :**  *We're having a meeting of course. I mean, we're all here, aren't we?*

**PETE :**  *Some of us are more here than others.*

**LIZ :**  *Oh for God's sake!*

Is there very much that can be done to enliven a scene like this? Can there be a wrong or right approach to something so straightforward? The answer to both questions is 'yes'.

The scene is set in an office at lunch time. Obviously it is a fairly static

scene. There is one move when Pete goes to get pencil and paper. What should they all be doing? Not just sitting at their desks looking at each other, that's for sure. Liz has instigated the meeting so she could believably sit in the middle of the office to indicate that she has taken control. It's lunch time, so John maybe has his feet on the desk and is drinking a cup of coffee. The dialogue suggests that he is not very impressed with the proceedings, so he could be browsing through a magazine – what magazine? Does the script indicate that John has any particular interest? Certainly the excerpt doesn't, but other parts of the script may. If there is no clue in the script as to John's outside interests, then there is still a chance for the director to indicate something of John's character by the choice of the magazine he is reading.

In the full script the office hierarchy is as follows. Liz and John hold equal status in their respective areas. Pete and Tracey are office juniors. This information is important in the blocking of the scene. Blocking (i.e., the positions of the actors within the scene) is also very important to the final edited look of the scene. A static scene like this will look very fragmented if played in a series of intercut close-ups.

The diagram above indicates positions that would work well for the scene. Liz commands the scene as she has moved her chair between the two desks. John sits at his with his feet up. Tracey perches on her desk (eating a yoghurt?) and Pete lolls against the wall behind Liz until he moves to get his paper and pencil. Now it is his new position that is the key to the simple completion of the scene. If Pete crosses over to Tracey,

picks up his paper and sits on the desk beside her, the latter part of the scene is enormously simplified. This is because Pete and Tracey always speak after each other, and a two-shot of them will hold on screen for these exchanges. Had Pete not ended up beside Tracey, then every line would have involved a close-up. This would have looked 'over-cut'. So even the most mundane of scripts can benefit from the application of sound technique.

## REHEARSALS

The ideal procedure to adopt for any dramatic dialogue scene is as follows: ask the actors to read the scene through (either on set or in the rehearsal room). Do not interrupt this read-through if an actor has, in your opinion, a completely incorrect idea of the character; don't chip in with direction at the read-through stage. It may be that you are right, and that the actor may need to be weaned away from his interpretation of the role to one that more closely resembles your own. It is just possible, however, that by the end of the read-through you may begin to think that the actor's idea had something in it and that it was less facile than your own knee-jerk response to the script. You don't need to confess as much to the cast unless you know them particularly well, and even then you can tell yourself that you had the good sense to cast highly intelligent actors in the first place!

Whatever may be going through the director's mind at the read-through, it is important for him to understand that this is a testing time for the cast, and that their nervousness is eased by an uninterrupted read. Some actors will not give much of a performance at all at a read-through, others will. Don't be surprised if your cast contains a mixture of artists who adopt both methods. It is often the case that the actor who gives little in the read-through will build through rehearsal to a fine performance on screen. It is also sometimes true that an actor who performs brilliantly at the read-through has already reached a plateau and has nothing more to bring to the part.

If the director has worked out something of the biographies of the characters, it will be helpful if these are discussed before or immediately after the read-through. In this way the characterization that the director wishes the actor to discover is achieved more subtly than by the more confrontational, 'No, I don't think he's an Irish rugby player, I think he's a Northerner and he's very camp'.

The more a scene can be rehearsed before shooting commences, the better. Nowadays, few films for television or the cinema allow themselves a long rehearsal period before the first day of shooting. Sometimes a few days are tacked onto the front of the schedule; more often, everything starts on day one of the shoot. Now, this is not so serious a problem in a well-tried series where the characters have developed and everybody (writers, cast and director) knows a great deal about the relationships

between the characters. It is, of course, much more of a problem if the story is a one-off film, and the actors and the director require time to discover what makes the characters tick – the subtext or internal chemistry of the script. The director's job is to arrive on the set with a clearly-worked-out vision of the piece as a whole; but should this vision conflict with that of one or more of the leading players, then an enormous amount of expensive crew time will be wasted – a rehearsal period, and time for debate, would have avoided this. It can be argued most strongly that adequate rehearsal time is not a luxury, but a guarantee of rounded performances and efficient shooting. Eric Lubitsch rehearsed his films for several weeks before they took the floor, so did Billy Wilder. There is no better recommendation.

## BLOCKING

Even under severe pressures of time and budget, don't start to shoot a scene without blocking it at all. This does sometimes happen, and leads to disastrous results. We have seen in the corporate script (above) that the most basic material can be strengthened by good blocking. The best position for props can only be decided if the scene has been choreographed from start to finish before shooting commences. Is it right for the pen, decanter, cigarette box to be near the actor, or would it be better if he had to cross the set to get them? If he does cross the set, should he resume his first position or would it be better to return to another? This is very much the fundamental detail of rehearsal, but unless that foundation has been laid before shooting, then halfway through the scene it will be discovered that although it would be much better if the pen, decanter, cigarette box had been close to hand or far away, the items have already been established in the wrong place and nothing can be done except perhaps to re-shoot from the top of the scene.

Continuity benefits enormously from adequate rehearsal. If a scene is sufficiently rehearsed, the actor will find exactly the best moment to take off his glasses, pour the drink etc., and will repeat that in every size of shot. If unrehearsed, he may go for it, but then may well find a better place to execute the business in later takes. If a scene has been completely blocked it quickly becomes clear what shots are required, and, most important whether a set-up is useful again later. Shooting off the cuff can be terribly wasteful if, towards the end of the scene, we discover that all the lights need to be returned to a position they were in previously. On a recent low-budget drama I cajoled two days' rehearsal out of the production company; it wasn't enough, but was better than nothing. The play was largely set in an office. The two days of rehearsal allowed us to read through and discuss characters, and allowed the cast to get to know each other. It also revealed the best position of furniture in the office and the more useful shots. We were able in the time available to rehearse three scenes fully and to block another three for moves only. So when the crew

arrived on day three, we were in a strong position. We were able to run the first two scenes that we were scheduled to film, and the cameraman could see exactly what the lighting requirements were, and could suggest optimum positions for tracking. As a result we were well ahead of schedule by the end of day two. After three days' filming we had run out of scenes that had been rehearsed, so on day four I called the cast for 9.00 am and the crew for 10.15 am. We were now sufficiently used to the set for it to be possible to block a good deal in that hour and a quarter. When the crew arrived we showed them what we'd done, and sent the artists to make-up while the crew re-lit the set. By 11.00 am we were back on course with both cast and crew confident in what they needed to achieve. Remember: it is never a good idea to hold everything until the cast are fully dressed and made up. Run the scene, then use the time taken while the artists complete to light the set.

## FURNITURE POSITIONS

The position of the furniture is vital to the successful blocking of a scene, and is often very different for the screen than for the stage. If an object is downstage the camera can more easily exclude it by working deeper into the set. If it is upstage (the traditional place of least importance in the theatre), then it cannot be excluded. If a telephone, a desk, a filing cabinet, is to be the centre of a good deal of the action, then this is much more accessible if it is close to camera rather than at the back of the set. Working with a single camera it is possible to show all four walls, so it could be argued that there is no upstage and downstage in the theatrical 'proscenium arch' sense. However, every scene has its principal angle. It is from this viewpoint that key props (telephone etc.) should be close to camera.

As an example, let us return to the dressing-room set. If that set is a basic three-sider with floating flattage that can be set in when necessary to provide the fourth wall, then it would be fine for the costume hamper to be set against the back wall if it were merely a piece of dressing. If much of the action centred around the packing of the hamper, then a position at the back of the set would result in the action being difficult to light and shoot. These problems are solved if the hamper is moved to the front of the set, and perhaps placed on top of another hamper to bring it off the floor a foot or so. Re-setting the hamper in a better position for the camera will make little or no difference to the actors; they will be happy to work with it in either position. The director's job is to set the scene so that the moves are comfortable and credible for the actors, but equally comfortable and achievable for the camera. It is counter-productive to rehearse a scene so that it works well for the actors, and only then to work out how to shoot it. The director needs to consider the camera positions right from the outset. It is no trouble to say to an actor at rehearsal 'I think it would be better if you crossed to the chair rather than the dressing table, because

that will be better for the camera'. The actor will happily accept this, and the rehearsal will proceed on course. If, however, it is not until the shoot that you discover that the move to the dressing table is messy for the camera, the actor has every right to complain. He has rehearsed a move, maybe even invented business involving the dressing table, and now you tell him he has to do something else.

The more the director can tell the actors about the various shots in the scene the better. It is good for an actor to know where the camera will be for any particular speech, and it is particularly important for him to know what you plan to shoot in close-up. At the actual shoot, it is well worth while informing the actors of the size of each shot. Experienced film actors often have a good idea of the shot simply by observing the camera position and distance away from them. However, the zoom lens can be very deceptive. If the cameraman is working well back from the artist on the long-focus end of the zoom, then the actor needs to be told that the lens is zoomed in and that the shot is a close-up. An actor's performance is different in a close-up: he needs to do less. The body is necessarily less mobile (otherwise the actor's head will keep bobbing in and out of shot), and facial expression is reduced to a minimum. Actors sometimes need to be reminded of this, but most experienced performers for the camera automatically reduce the size of their portrayal if they know they are in close-up: plainly, they *need* to know. This is the reason that filming with two cameras at once, one taking the two-shot and one taking the star's close-up, is invariably unsuccessful. Not only does it waste an enormous amount of film, (each N.G. take is filmed twice), but it results in harmfully compromised performances. It is usually the television mini-saga – high on hype and low on schedule – that uses this unpromising technique. Perhaps it is because the acting in these pieces is usually so feeble that shooting with two cameras at once is reckoned to make little difference!

## ATMOSPHERE ON THE SET

The more the director engenders an atmosphere of co-operation, the better for everyone, cast and crew alike. It is amazing how many directors fail to introduce the actors to the technicians. If the cast are about to reveal the intimate details of their screen personae, they are unlikely to give their best if surrounded by technicians who are to all intents strangers.

Another cause of needless tension on the set can occur when the director and the cameraman or recordist go into a huddle and discuss some problem or other in dark whispers. It may well be purely a technical problem that is of no concern to artists, but you *must* let them know. If an actor overhears the recordist say, 'Frankly it sounds bloody awful', his first thought will be that this is a criticism of his vocal powers – he will not immediately realize that the remark referred to the air conditioning. If the actors are aware of a technical difficulty they may well be able to offer a solution themselves. This is particularly true of 'shadowing'. In a two-

shot where one actor may shadow the light from the other, a simple awareness of the problem and a rehearsal to find safe positions will be a lot quicker than a re-light.

Actors require to know the precise length of a shot. They want to be quite clear about the first line of dialogue you expect to hear on 'action', and, just as important, when you intend to cut. They need a trajectory – and a point at which to aim – and if you don't say 'and we'll cut at such and such', they will become anxious. No actor enjoys playing a scene on and on until someone fluffs, and only then does the director say 'cut'. Also, whenever possible, avoid shooting in such a way that you plan to use the dialogue immediately after 'action'. In other words, if you are shooting a close-up of Actor A that follows the long speech from Actress B, ask Actress B to give the last three lines or so of her speech to ease Actor A into his close-up.

It is not the director's job to keep everybody happy, but a good director is always sensitive to atmosphere on a set. If an actor appears moody or very quiet, then there are two possible causes. One is that he is finding the role difficult and requiring a great deal of concentration, in which case all is well. The director can help by assuring the artist that his performance is fine. Remember that not all actors are extrovert, indeed the best ones are usually somewhat introvert. The other cause for an artist going quiet is more serious. It may be that they are unhappy with their performance or your direction of the scene, or that some technician consciously or unconsciously has made some half-smart remark that has dented the actor's confidence. In this case the director has to decide whether to ignore it all, or whether to arbitrate. Of course he can do neither if he doesn't enquire what's the matter. Again tact is required. 'What the hell's wrong with you?', may be the thought in the director's mind, but this is far better expressed as 'I thought that was excellent, Peter, but are *you* happy with it?'

You should be able to differentiate between the positive tensions on the set, and the tensions that are destructive. At rehearsals especially, but also during the shoot, the actor is making himself into another person – developing ways of being, moving and talking that are probably very different from his own. To be able to do this at all requires the actors to demolish those barriers against self-revelation which we all hide behind in our everyday lives. Actors can break down those barriers, but they may find it an uncomfortable process. Prickly moments are often the result. The director must, therefore, be prepared to use these moments when they are positive and defuse them if they start to become indulgent and harmful.

A good theatre director will know all this. The role of director as catalyst is well established in the theatre, so most of what I have said is intended as a guide for the documentary director who is not used to working with actors. One thing that the director near to the medium may find, to his dismay, is the inadequacy of the rehearsal time available. There is little time for development in the rehearsing of a film, and the director is

required to have a much clearer idea of the final result on screen than a theatre director would have at the first rehearsal of a stage presentation. The ideal situation is for the film director to have strong visual interpretation in mind from the outset, combined with a fairly open mind as to the characterization that the actors may bring to their various performances.

# CHAPTER 6

# Visual interpretation

If a strong visual imagination was all that a director required to make a successful film, then most good cameramen would become good directors. The fact that few cameramen do become good directors suggests that there is another factor.

When an audience watches a play in the theatre, its attention is drawn by lighting, movement, stage positioning and the charisma of the actors. The audience is persuaded to concentrate on those parts of the overall picture which the director considers important. However, the audience's attention can wander, and some members of the audience may be seeing the scene in a mental 'wide shot' when the director hoped that they would be watching in close-up (and vice versa).

In the cinema and on television, this isn't so. The director can show the audience exactly what he considers it should see and, even more important, can show it to them at precisely the most effective point dramatically. Chapter 9 deals with some of the basics of shooting material that will 'cut together', but some aspects of the subject are so interrelated that it is proper to deal with them here. If the director of film/single camera has no overall visual concept of a scene at the time of shooting, two things are almost certain: many more shots will be taken than are necessary; and the scene is unlikely to cut together smoothly.

The first point is self-evident; but people are sometimes surprised by the second. It is widely believed that if you film enough material then it's bound to be possible to cut it together somehow (the 'Don't worry, I've got a shot of the shields on the wall' school of film directing). The important intuition the director needs is to be able to show the audience a shot at the right moment, to be able to cut to a shot when it is dramatically potent to do so. This involves planning and deciding on the result you require before you shoot a frame. If the sequence has not been thought through, then over-covering will not solve the problem. The editor may be able to find some way of cutting the scene together, but that may involve going to close-up for no better reason than that there was nothing else to cut to, or may force him to stay wide for longer than was comfortable.

*DIALOGUE FROM 'THE IMPORTANCE OF BEING ERNEST'*

**LADY BRACKNELL :**   *Now to minor matters.  Are your parents living?*

**JACK :**   *I have lost both my parents.*

**LADY BRACKNELL :**   *Both?  To lose one parent maybe regarded as a misfortune - to lose **both** seems like carelessness.  Who was your father?  He was evidently a man of some wealth.  Was he born in what the Radical papers call the purple of commerce, or did he rise from the ranks of the aristocracy?*

**JACK :**   *I am afraid I really don't know.  The fact is, Lady Bracknell, I said I had lost my parents.  It would be nearer the truth to say that my parents seem to have lost me - I don't actually know who I am by birth.  I was - well, I was found.*

**LADY BRACKNELL :**   *Found!*

**JACK :**   *The late Mr Thomas Cardew, an old gentleman of a very charitable and kindly disposition, found me, and gave me the name of Worthing, because he happened to have a first-class ticket for Worthing in his pocket at the time.  Worthing is a place in Sussex.  It is a seaside resort.*

This excerpt from the famous handbag scene in 'The Importance Of Being Ernest' provides a clear example for minimal but effective single-camera shooting of a piece. Assume that Lady Bracknell is seated, and that Jack (Mr Worthing) is standing. He is rather frightened of Lady Bracknell, so he would be standing some distance away from her.

The absolutely basic cover for the sequence would be a two-shot from behind Lady Bracknell showing most of her chair and a nearly full-length Jack, and a medium close-up of Jack and a matching close-up of Lady Bracknell. There is little to be gained from the reverse two-shot (over Jack's shoulder). It will be wrong dramatically, as Lady Bracknell will look weak when the scene demands her to be dominant. In most two-handed exchanges it is seldom necessary to shoot the two-shot in both directions. One two-shot and two singles are quite sufficient. The two-shot should

always favour the character with the lion's share of the dialogue. (If you apply this rule of thumb, you will be spared from having to cut to close-ups for irritating interjections like 'But what if . . .', 'Oh, really . . .' etc., from the character with the smaller part.

If we have the basic cover of the three shots (two-shot favouring Jack (18/3), MCU Jack (19/1), MCU Lady Bracknell (20/1)), the best use of those shots for rhythm and dramatic sense would probably be:

| | |
|---|---|
| *20/1 MCU LADY BRACKNELL* | **LADY BRACKNELL :** *Now to minor matters. Are your parents living?* |
| *19/1 MCU JACK* | **JACK :** *I have lost both my parents.* |
| *20/1 MCU LADY BRACKNELL* | **LADY BRACKNELL :** *Both? To lose one parent may be regarded as a misfortune – to lose **both** seems like carelessness. Who was your father?* |
| *19/1 MCU JACK'S REACTION UNDER LADY B's DIALOGUE* | *He was evidently a man of some wealth.* |
| *20/1 RESUME LADY BRACKNELL'S MCU* | *Was he born in what the Radical papers call the purple of commerce, or did he rise from the ranks of the aristocracy?* |
| *19/1 MCU JACK* | **JACK :** *I am afraid I really don't know.* |
| *18/3 2/S FAVOURING JACK* | *The fact is, Lady Bracknell, I said I had lost my parents. It would be nearer the truth to say that my parents seem to have lost me – I don't actually know who I am by birth.* |
| *19/1 MCU JACK* | *I was – well, I was found.* |
| *20/1 MCU LADY BRACKNELL* | **LADY BRACKNELL :** *Found!* |

```
19/1 MCU JACK            JACK :  The late Mr Thomas Cardew, an old

                         gentleman of a very charitable and kindly

                         disposition, found me, and gave me the

                         name of Worthing, because he happened to

                         have a first-class ticket for Worthing in

                         his pocket at the time.  Worthing is a

                         place, in Sussex.  It is a seaside

                         resort.
```

In case there is any doubt, the script is marked-up as it should be edited. At the shoot, each slate, 18, 19 and 20, would run continuously through the dialogue from start to finish. You will also notice that it took three takes before a satisfactory version of Slate 18 was in the can, but after that the actors were able to get their close-ups in one. This is very common and it is better to establish the performance in several goes at the wide shot, when the actors feel a bit less threatened, and then shoot their close-ups when they are at their most confident and rehearsed.

An editing scheme such as the one suggested breaks up the scene sufficiently to avoid the 'ping-pong' effect of too many intercut close-ups, and certainly will provide little difficulty in cutting together. A close-up of Lady Bracknell is bound to cut to a close-up of Jack. The only real continuity to concern us is that between Slate 18 (the two-shot) and Slate 19 (the MCU of Jack). After three runs at Slate 18, Jack's continuity should be fairly well fixed.

So the sequence will work; but, frankly, it will look pretty bland. A simple directorial/editorial device could rescue it from limbo. Imagine that Jack, in his desperation to ingratiate himself, draws nearer to Lady Bracknell as he says: 'Worthing is a place, in Sussex. It is a seaside resort'. It would then be effective to intercut ever-increasing close-ups of Lady Bracknell looking in blank amazement as Jack makes his advance.

```
        (MID-SHOT JACK ADVANCING)

        JACK :  Worthing is a place, ...

        (MCU LADY BRACKNELL)

        (MCU JACK)

        JACK :  In Sussex.
        (TIGHTER C/U LADY BRACKNELL)
```

*(MATCHING TIGHTER SIZE JACK)*

*JACK :* *It is a seaside resort.*

*BCU LADY BRACKNELL.*

*LADY BRACKNELL :* *In what locality ...*

This is a *device*. It could only be used sparingly, certainly no more than once in the scene, probably only once in the whole play. It is included as an example of the importance of the director's planning his ideas beforehand because:

1 The idea would be very effective, but is very simple to shoot.
2 The increasing close-up size of Lady Bracknell must be planned in advance and photographed accordingly.

The intercuts could be added as an afterthought by the editor, but unless the director has provided the close-ups of increasing size, the only shot of Lady Bracknell available will be the original MCU. Intercutting this will look mannered rather than stylish.

# The two-dimensional image

That the screen image is only two-dimensional is a fact that any director should keep in mind when setting a two-handed scene. If, for example, Lady Bracknell were to be left of screen throughout the whole of the handbag scene and Jack always right, the scene would be very boring to look at. Now, as Lady Bracknell is seated at the top of the scene, and Jack is so over-anxiously respectful, he is unlikely to wander about, so that the director has to accept that a large part of the scene will be static, Lady Bracknell seated screen left, Jack standing screen right. However, when Lady Bracknell does stand, the director can grasp the opportunity. She should cross and reverse the position (left and right) of herself and Jack. There are many points at which this can occur and the best point for this 'rise and cross' action is for each director and each cast to discover for themselves. The action should not be long delayed. This device of changing actors left and right is something that the novice director very often fails to utilize. It is one of the simplest pieces of technique, and makes an enormous difference to the 'watchability' of any single-camera drama. There are hundreds of examples in every competently-crafted feature film. A very clear one occurs (again) in 'Some Like It Hot', in the scene where Tony Curtis and Jack Lemmon come into the shop to make an emergency phone call. (The same scene referred to earlier.) Tony Curtis is screen left and Jack Lemmon screen right. As they come forward to the wall phone the camera pans with them and they cross each other, so that on the phone Tony Curtis is screen right and Jack Lemmon interjects from screen left.

Perhaps the following example is even clearer. Actor A and Actress B have met for a romantic supper. They are sitting on the sofa and later in the scene will move forward and sit at the supper table. If Actor A was to the right of Actress B as they sat on the sofa, it would be visually tedious if they remained in the same spatial relationship when they moved to the table. This point in the scene would provide an obvious and easy chance for the actor to show the actress to her seat (at the centre of the table), and then move to his seat to the left of her. This left-and-right swap is such a useful device that it is worth the student director watching videos of

features films or TV plays with the technique specifically in mind. Note the positions of the characters at the start of a dialogue scene and see how long it is before they change over left to right. Also note how the move is achieved in each case.

## SPEECH PATTERNS

The left/right changeover is a device to alleviate the dangers of visual tedium, but the director must also be aware of the dangers of aural tedium. If two actors are insecure with their characters' and each other's performances, they sometimes start to copy each other's speech patterns. A spurious rhythm develops, with both actors stressing the same number of syllables in each line. In student films this can usually be taken as an indication that the actors have had no direction whatsoever. However, it can happen at rehearsals, particularly if you are working with in-experienced actors and classic texts such as Ibsen, Shakespeare, Wilde. As soon as you detect the practice you must persuade the actors to abandon it before it becomes a habit. Usually a re-emphasis on the individual characteristics of the person the actor is portraying will be sufficient to eradicate the fault.

## TENSION

There is a danger that if a scene is particularly violent, emotional or comic, the actors' performances will get broader as the scene (or the takes) progress. The level of performance may be just right at take two, but if you need to go to take five before everything is technically perfect, beware lest the level of performance goes over the top. For example, in an argument that builds to a final violent explosion, the actors will need to calm down at the end of the take before you go again, otherwise they will still be in the emotional state that they had reached by the time you said 'cut'. In such a situation you need to lower the tension and settle down the actors between takes. Experienced artists may do this for themselves by making a joke, even in the most serious of pieces. Don't be put out by this: don't imagine that you or the piece is not being taken seriously. It is just a device to guard against performance overload. (The actor, George Baker, insists that Sir John Gielgud's solution to this situation is to go into a corner and sing 'Three Coins In The Fountain', leaving the crew and director to wonder what it is the great man is doing. The answer is that he's releasing the tension for himself.)

## CASTING

It may seem strange to leave the section on casting until last, but an

awareness of some of the earlier material in this chapter may make the following easier to assimilate. Small- and medium-size productions are still cast solely by the director. Larger productions employ a casting director to prepare a short list, but the ultimate decision still rests with the director. Who plays what part is unquestionably the most important decision the director makes. Get the casting right, and 95 per cent of your problems are solved. As an example, consider the number of situation comedies that depend on the actors to nurse them through a couple of duff scripts in the middle of the series. The director must have an overall view of the cast. Hamlet at 6 ft 3 in is not going to pair well with Horatio at 5 ft 4 in, and the reverse would look even more improbable. Assuming a small-budget piece with no stars as part of the package, how does the director go about casting? The only way is to plough through 'Spotlight', the actors' directory, and note the name of each artist who seems suitable for the parts you are casting. Then phone the agents to see if the people you wish to meet are available during your production period. If they are, ask them along for an audition. Some agents may request travelling expenses, especially if you are auditioning out of London or the actor lives miles away (it is up to you whether you agree to pay them). If so, you may take it as an indication that the agent will be pretty sharp should you wish to engage that particular artist – not that this should put you off!

Try and allow at least twenty minutes for each actor that you intend to interview, and ten minutes between the end of one appointment and the start of the next. You may well wish to spend more time with some than with others. Remember that the actors themselves will be tense and eager to get the job: put them at their ease, but remain a little distant, as you will be telling most of them that, unfortunately, they haven't got a part in your production.

Let the actor talk for about five minutes about what he has done recently. Maybe they've worked for a colleague of yours, so you can check with that colleague how they rated. Tell the actor about your film – don't assume that the agent has done this. If he has you can bet he got most of it wrong. Have a couple of short scenes from the film available for the actor to read (three or four pages of each is enough), and allow him time to read through these carefully. You can tell a lot from the care the actor takes at this point, and also if he asks any pertinent questions about the character. (You should have given him some pretty strong clues in your opening chat.) Next, read through the scene playing the other character(s) yourself – you can tell very quickly if the actor has 'got something', and if he has, give him some direction and ask him to play the scene again. You will quickly learn how easily the actor takes direction and adapts his performance to your suggestions. You may think it useful to ask him to improvise some dialogue. Give him a situation that occurs to the character in the film, and then ask him to recount the experience as he would to a friend over a pint (or whatever circumstances would be appropriate to the character). You should remember that some actors hate improvisation, just as some actors hate reading. If you get a brilliant reading followed by

a brilliant improvisation, then you have probably found the right actor. If the reading is good, the actor looks right and is intelligent in his approach, then you still have most likely found your man, even if the improvisation is a bit feeble. So don't be worried if an actor confesses that he is not the best improviser in the world.

The physical appearance of other members of the cast also plays an important part in your final decision. I once saw an extraordinary production of 'The Importance Of Being Earnest', in which the actor playing Algernon was about 5 ft 1 in, and the actor playing Jack was at least 6 ft 2 in. If the director hoped that this discrepancy would add to the fun, he was much mistaken. It just looked daft.

A Polaroid shot is a useful *aide memoire* for an audition session. Some people even go to the length of using a video camera. Polaroid shots taken at the audition may well give you a better sense of visual reality than the actor's own carefully chosen 'Spotlight' picture: these are often as misleading as estate agents' photographs.

Don't forget to enquire about any special skills an actor may have, especially if you require some such skill from the character he is to play. Never assume, for example, that everyone can drive, or even ride a bike, and remember that horse riding is a skill that every actor claims to possess until the time comes for you to film the chase sequence.

If you are interviewing a large number of artists over a number of days, it is a good idea to work out a score sheet, listing such key points as Reading, Improvisation, Physical Suitability, Physical Matching with Other Characters, Special Skills etc. Award each actor you see points out of ten for each category. This list, combined with the actor's CV and the Polaroid you took at the audition, will help you make up your mind – at least it will enable you to decide which artists to recall for a second audition. In the end, however, nothing can replace the instinct you have that 'this actor is the one'. That realization most often occurs as soon as he walks into the room.

# CHAPTER 8

# Visual language

The phrase 'a developed visual imagination' used to appear as an essential requirement in every advertisement for any job in BBC Television production. The irony of this was that very few people have a visual imagination, and those few that do have it are seldom encouraged to develop it. Traditional education confines imaginative communication to the written word. Pupils are exhorted to admire the brilliant descriptive prose of Charles Dickens or P. G. Wodehouse, but scant attempt is made to teach an appreciation of the narrative power of the images in film by D. W. Griffith or Buster Keaton. Only the most primitive languages were written in pictures: the Sumerians, c. 3500 BC, used a drawing of a horse and three lines to represent three horses, but it was quickly realized that picture writing is severely limited. 'Today the King will give three of his finest horses to the visiting Queen of Sheba' would be much too complex to be expressed in early Sumerian – which was presumably why by 3100 BC the ancient Egyptians had developed hieroglyphs. It was not until film enabled pictures to be presented in a cogent order, with rhythm, and in a display of cause and effect, that visual communication could begin to match words in the transmission of complex ideas. In the intervening five thousand years human beings became very much set in their communicative ways. Then, just as the world was beginning to understand the power of telling stories on film – largely transcending all language barriers – talkies were invented, back came the words, and (purists would argue) everything was lost. Personally I don't think much *was* lost, until journalists invaded television in the late 1950s; that was when the rot set in. The spoken word returned in triumph, and pictures became so debased as to make the Sumerian horse and three lines seem by comparison like a Shakespearean sonnet.

It is common to be able to understand a foreign language much better than one can speak it; and so it is with the language of film. Every audience on the edge of its seat during a horror film has been worked into a state of excitement by the director's skill: by the use of camera angles, sound effects, shock cuts and suggestive camera moves. Every member of that audience understands the language. It is only if, as a novice director,

one of them tries to tell a similar tale, that he comes to realize that it is a language that needs to be learned. The first thing to appreciate about visual language is that it requires a clear statement. An idea does not communicate itself to the audience simply because it was in the director's head at the time of the shoot.

Let's take an example. We want to show a man in bed being woken up by a noise. Now if that noise is a scream of brakes and a crash there is no problem. A shot of the man fast asleep suddenly sitting up is all we need. If we lay the sound of a scream of brakes and the crash at the point where he sits up, the audience will not be confused at all. Their experience of the world will tell them that the sound came from outside the house, and that it was so loud the collision must have taken place nearby. They would expect the man to go to the window and look out and, indeed, the director would probably direct the actor to do just that.

However, suppose that the man was to be awoken by deafening music from the flat above. The sequence will require a greater visual vocabulary. The shot of the man will still be valid, indeed essential, but simply adding loud music at the point when he sits up in bed will be confusing. What is the music? Where is it coming from? If the music was present from the start of the shot the audience might even confuse it for incidental music! Just as the man rushed to the window in the first example, he should now indicate the source of the noise by looking up and shaking his fist. But even this might be ambiguous. What the sequence needs, in order to clarify the situation, is a shot of the bedroom ceiling taken from the man's point of view, with the ceiling light swinging about in a frantic fashion. Visually now we have a clear statement that the music is coming from the elephantine neighbours above.

Suppose that our shot of the man sleeping is intercut with a tracking shot that approaches his half-open bedroom door. We can see him asleep beyond the door. We cut back to the original shot and the man wakes up. The statement now is that the man was woken up by the presence, possibly the sinister presence, of another person in the house. Continuing the idea further, imagine these shots for a haunted house sequence:

1 Man sleeping fitfully
2 Track into half-open bedroom door
3 Man sleeping even more restlessly
4 High shot looking down at the man – crane down
5 Man sits up into big close-up looking terrified
6 Shot of hideous ghost.

In terms of visual language, shots 2 and 4 are from the ghost's viewpoint. In shot 2 the ghost approaches the bedroom, in shot 4 it is hovering above the man. It would, technically, be perfectly possible to cut part of the high shot (4) into the sequence before shot 2. Like this:

1 Man sleeping fitfully
2 High shot of man (old shot 4)

3 Man again, resume shot 1
4 Camera tracks into bedroom door
5 Man wakes up in terror.

However, the high shot used in this way is much less effective. It is only another view of the man's rather than the ghost's point of view. The ghost arrives in the bedroom with the tracking shot, so only if the high shot comes after the tracking shot will the audience subconsciously feel that the high shot is the ghost's point of view of the man. If we apply the same grammar to the end of the sequence:

5 Man wakes up in terror
6 Shot of hideous ghost

we can quickly see that a 'single' of the ghost will be much more frightening that a two-shot over the man's shoulder looking towards the ghost. This is because with a cut from the close-up of the man's terrified face to a shot of the ghost the audience 'becomes' the man and sees exactly what he sees. Whereas if the back of the man is included in the ghost shot, the audience remain observers at some distance from the events on screen.

## VISUAL LOGIC

A sequence must have a visual logic; a strong change of angle needs a justification. Many new directors are fascinated by high shots, and distribute them at random throughout otherwise unremarkable dialogue scenes. The effect on the audience is bewilderment. A high shot strongly implies that a third party is overhearing the conversation, especially if the shot is taken from a landing looking down on a hallway, or from a minstrels' gallery. If the shot is taken with the camera at the top of a stepladder, the audience may well begin to wonder why the ceiling lighting unit is suddenly so significant. Shots need justification. If the film was set in a Renaissance Court or a Soviet hotel, then high angles would be effective, as they would imply that everything and everybody was observed and overheard; but if high angles have no *raison d'être*, they quickly become a distraction.

Martin Scorsese's remake of 'Cape Fear' had some wonderfully unsettling camera movements. As the tension within the house built up, so the camera became increasingly nervous and unsettled. This was a skilful device. Had the film been a light-hearted comedy, such moves would have been irritating in the extreme.

Camera position can trigger a range of possibilities in the mind of the audience. Consider this sequence (from a hundred and one thrillers)

1 Wide shot Girl leaves house at night and approaches garage
2 She enters the garage and approaches the car
3 She gets into the car and drives off.

If we know that a killer is at large in the district, then we are anticipating visual clues from the director. If when the girl arrives at the garage door we cut to a blank screen which, as the doors open, reveals that the camera is now deep inside the garage looking towards the girl, the implication is that the camera is the killer's point of view. If when the girl gets into the car the camera observes this from a viewpoint in the back seat, the overwhelming thought is that the killer is in the car already, unbeknown to the girl. These are strong suggestions with which the director may choose to tease the audience, and keep them on the edge of their seats. If as the girl enters the garage she turns her back to camera as she unlocks the car, and at that point the camera tracks in quickly to the back of her head, the visual statement that she is about to be attacked is so strong that only the most eccentric director would shoot it, if in fact the girl was going to get in the car and drive off calmly into the night.

## SUBJECTIVE CAMERA

The switch from objective to subjective camera is a common directional trick, but again it is effective only if good grammar is maintained. Suppose that a man is being chased through some woods and we plan to run cut to his subjective point of view. The cameraman would be asked to run along the same piece of track allowing the undergrowth to break past the lens as he did so. In the cut sequence, this shot will only have full value if it is preceded by a big close-up of the man running towards us. Then, we will understand that the subjective shot is the man's point of view. If the subjective tracking shot is cut in some random way with general shots of the pursuit it will simply look messy. In fact, the human brain does such a good job of ironing out the bumps and jerks in our vision as we run along, that subjective camera shots of the type described usually look very artificial anyway. They look it simply because they don't closely resemble human experience: the replication of human experience is a good rule to guide any director.

Low angles always make the subject matter seem more impressive, be it a building, a telephone or a person, but, as with high angles, extreme low angles should be used with discretion. Imagine a shot of two actors talking together. A low camera angle will make them seem imposing characters – but what happens when we want to cut to close-ups? In a conversation the close-ups provide one actor's view of the other; this certainly can't be from a low angle if they are of approximately the same height. The close-up cut will, therefore, involve a change of camera height as well as a change of shot size, and provide a rather surreal effect. In general, it is not easy to cut out of a high angle or an extremely low angle.

Imagery is an element all too rare in the majority of films for television. As the picture quality and technical facilities of the old black-and-white electronic studios improved, so an obsession with realism grew up. This

spilled over into television film. The result is that British cinema – the little there is of it – and British television drama have been largely 'realistic'. Audiences and directors are not particularly well-schooled in the use of imagery. Recently a student film-maker was shooting a story which involved a girl pestered by a man who is forever trying to date her over the telephone. In the end she agrees to meet him. There is a sequence where we see each of them getting ready, and we realize that one of them is a serial killer. The point of the film is that the audience believes that it is the man, and is surprised when it turns out that the murderer is, in fact, the girl. The imagery is important. The 'preparation' montage must contain shots that make it quite clear that a murderer is making ready. Obviously this needs to be visually powerful, and while it must suggest that it is the man who is preparing it must remain ambiguous. When the audience learn the truth, it is important that they realize that they have been led to a wrong conclusion only by the *interpretation* they gave to the images, not by the images themselves. In the end the film failed, because it was plain that it was the girl who was getting ready. It is, therefore, perhaps worth considering the images that were used, and why they failed.

1  Girl with towel around her. Hand runs bath
2  Hands stirring the bubbles in the bubble bath
3  Girl at make-up mirror
4  Gloved leather hand places a rope and handcuffs in leather bag
5  Drawer opens – knife and video camera taken from drawer
6  Same placed in bag
7  Hypodermic syringe
8  Girl finishing make-up
9  Man's hand lights candles of dining table – door bell sounds
10  Door opens to reveal girl

It is interesting that, on paper, this reads quite well. The murder images are powerful, and there is no clue as to the identity of the killer. The weakness is that there are no shots of the man preparing. The thought was that after a couple of shots of the girl getting ready, the audience would assume that the gloved hand was that of the man. But the audience doesn't make that mental connection; they've already seen the girl start her preparations, the film language strongly suggests that the gloved hand with the knife etc. is the girl continuing to prepare. The film grammar clearly tells the audience precisely what the director did not want them to know! The sequence required intercut shots of the man getting ready before any of the sinister material:

1  Shot of girl at bath
2  Shot of man shaving
3  Shot of girl washing hair
4  Shot of man greasing his hair
5  Shot of girl at make-up mirror
6  First shot of leather-gloved hand etc.

A sequence such as this, by rhythm and visual suggestion, would have created the desired false impression, and had the man been dressed in a black polo-neck sweater or a black leather jacket, the deception by implication would have been even more effective.

In another, more successful, student film the director was trying to portray the fear of water that a married woman suffered at her swimming lessons. This was because her self-confidence had been damaged when, as a child, she had been sexually abused by her father. A film dealing with such a complex thought process requires some clear potent images, and the one I remember as most effective was the sequence when the woman was changing for her swim. As she discarded her clothes, the director cut to the children's bedroom floor, strewn with toys as the *child's* clothes fell to the floor. This provided the audience with a very strong clue as to what the film was all about.

These two examples, successful and unsuccessful, should make it clear that imagery, information and implication are closely linked with editing, the subject of the next chapter.

# CHAPTER 9

# Editing

Every film or videotape that is shot with a single camera falsifies real time. The exploitation of this falsification lies at the very heart of creative direction. If the director ends up with material that won't cut together, it is simply because time as captured by the single camera has not been adequately directed. As the move towards directors doing their own off-line editing gathers pace, it follows that they need to know more about editing nowadays than ever before. There is also a serious danger that directors who have not been editors, but have made a number of films, tend to believe that 'anyone can do it', just as any man who observes any skilled professional at work may come to believe that 'it's all very simple'. Editing comes in a category somewhere between brain surgery at one extreme and tiling the bathroom at the other.

For many years, the intractable machinery that surrounded their craft encouraged videotape editors to believe that editing merely consists of cutting one shot smoothly to another: they came from an engineering background, and wondered what film editors and directors were on about when they talked of rhythm and pace. Nowadays every new month brings a device on to the market that increases the flexibility of video editing and makes it more comparable with film. Many film editors have become 'bilingual' and work with both film and tape. Unfortunately, just as the creative playing field is becoming level, economics have begun to dictate that pictures are not cut by an editor at all, but by the director, who may or may not have an editing background. In either case, the huge benefit of a second dispassionate pair of eyes to evaluate the material is lost. I have stated, rather grandly perhaps, that editing is more than simply cutting shots together, that it is about pace, rhythm and dramatic emphasis; but I believe this to be an unquestionable truth. I should also be foolish not to agree that the first requirement of any film is that shot A cuts to shot B.

So, let's start with some basics. Suppose you were shooting a simple home movie of the family in the garden. You start with a wide shot of the garden, with the house in the background, and we see some people coming out of the French doors. You stop the camera and a few seconds

later you start it again with the camera in the same position. A viewing of the unedited material would reveal a jump cut at this point. The missing seconds would be obvious, as there is a visual constant against which the eye can judge the passing of time. Now, had you moved the camera in close on the French windows, and changed the angle a little between shot one and shot two, even the unedited (or rather camera-edited) home movie would have been much smoother to the eye. The cheating of time would be disguised by the closer cut to a new angle. Fooling the eye into accepting a cheat of real time is the trick; shooting material which frees the editor from the constraints of real time is the skill.

Consider another simple example. A man is sitting in an armchair. He rises, crosses the living room and gets to the door. He turns and says 'I'm just going to the shops, OK?' This action could be covered in three shots:

1 Medium Close-Up, Man sitting in armchair. He rises.
2 Wide Shot – Man crosses the room to the door.
3 Medium Close-Up – Man at door: 'I'm just going to the shops, OK?'

If the last shot of the sequence started with the man at the door, and on 'action' he turned and said his dialogue – this would most likely cut reasonably well with the wide shot (assuming that the continuity of the man's turn by the door was roughly the same in each shot). However, the sequence would be stuck in real time because the editor would not be able to cut away from the wide shot until the man had reached the door. If the third shot had been directed to start with the man out of frame, and on 'action' he entered the shot, turned and said his dialogue, then we are freed from real time. The editor could cut out of the wide shot much earlier, or could take it to the bitter end. If the first shot had been directed (as it should have been) for the man to rise from the chair and leave frame, then the wide shot could be dispensed with. The sequence could run simply:

1 Medium Shot – Man rises from armchair and exits frame right
2 Medium Shot door – man enters frame left, turns and says 'I'm just going to the shops, OK?'

You may argue that the audience would need to see at least some of the man's walk across the room; you may be right, but the point is that *how much* they see of it is now entirely a matter of pacing. How much of the cross is required for the rhythm of the scene? The editor can decide.

## CONTROLLING TIME

Here is another simple yet important example. Imagine two shots. A long shot, looking down a hallway. Halfway down is the hall table with the telephone on it. At the end of the hall we can see the staircase. The phone starts to ring. Our heroine comes down the stairs and answers the phone. The director wishes to cut to a close-up of her dialogue. So what is the

second shot of the sequence? If it is a close-up of the actress with the phone to her ear, the sequence is stuck in real time, and the cut will be jarring. If the second shot starts with a close-up of the actress as she brings the receiver to her ear, the cut will be smoother, but we remain stuck in real time. For maximum editing freedom, the second shot should start with a close-up of the phone. On 'action' the actress's hand enters frame and picks up the receiver. As she does so, the camera tilts (or better still jibs) up to form her close-up. This shot will allow us to condense or extend the time it takes the actress to reach the phone from the long shot.

The 'hands out of frame' rule is a very useful device in both drama and documentary. Imagine a gardener at work. Nearby is a wheelbarrow. After a minute or two he stops weeding, goes to the wheelbarrow and wheels it away. If your second shot starts with a close-up of the wheelbarrow's handles, and the gardener's hands are already on it, then you cannot cut out of the first shot until the gardener's hands are actually on the barrow. If the second shot starts with a close-up of the handles and the gardener's hands enter frame and grab them, then you can cut to this shot whenever you like.

Dialogue scenes benefit from a variant of the same technique. A wise director will plan the blocking of a two-hander in such a way that a two-shot develops into a single of one of the actors, this then cuts to a single of the *other* actor who may well move to reform the two-shot and so on. Example:

```
TWO-SHOT JOHN AND PETER

PETER :  Are you sure you won't have a drink?

JOHN :  Oh alright, you've twisted my arm.

(PETER MOVES TO THE DRINKS TABLE; THE CAMERA PANS
WITH HIM, EXCLUDING JOHN.)

PETER :  Seen anything of Daphne recently?

(CUT TO JOHN, MCU)

JOHN :  No, not for ages.  Oh, not too much gin,
dear boy.  (HE CROSSES TO PETER TO REFORM THE TWO-SHOT)
```

Now, unless John has grown a beard or changed costume, the cut to his single is bound to work, because he was out of frame before we cut back to him. His continuity is, therefore, not crucial, and the timing of his line is in the hands of the editor.

The most important point to remember – it is more a rule – is that in any single camera operation it is stupid to plan to cut from a two-shot to another two-shot. The reason is obvious, given a little thought. To do so is to presume that the actors' continuity – not just their individual continuity, but their continuity one – with the other – is perfect, and, what is more, that it is perfect at the precise $^1/_{25}$ s where dialogue and movement dictate that you make the edit. (It never is.) And the more actors that are involved, (a three-shot cutting to a three-shot) the worse the problem becomes. This is a mistake often made by directors used to multi-camera electronic studio work. Here, group shots are quite common, but of course when the vision mixer presses the button, the cut occurs in real time so continuity is no problem.

Sometimes cameramen will argue that a close-up would look better if a little bit of the other actor is included. Don't be tempted. The reason cameramen are fond of this suggestion is that they don't have to try and cut the shots together. A two-shot will cut to a *clean* close-up, but if the close-up has a bit of the other actor in it, it isn't a single, it's another two-shot, and the gremlins of real time are back in charge. It must be admitted that in some circumstances, when the actors are so obviously close together in the two shot, a clean single *would* look strange. In these circumstances, you might consider whether a single is really necessary. The situation usually arises in intimate conversations, as when two people are forced to be close together in the back of a hansom cab. In cases such as this the two-shot is nearly always strong enough to sustain a short scene. But what if the scene isn't short? Then the director must in some way invade the territory of the screen writer. Take our hansom scene as an example. No sensible screen writer would set dialogue in a hansom that ran for much more than three pages of script. The reason is part of the problem already mentioned. Intercuts are difficult, yet you can't hope to sustain a two-shot on the screen for more than a few pages. Intercutting provides a solution. A good writer would present the script in such a fashion that the dialogue between the couple in the cab was intercut with scenes at the ball to which they were travelling. The same amount of dialogue (say ten pages) would then be split over three or four intercut scenes. The director could then vary the angle or size (or both) of the cab interiors. The information contained in these scenes would be exactly the same as the less digestible ten-page chunk, but the audience would find the film much more watchable.

If the writer has failed to provide opportunities to intercut, then the director must find some. Shots of the hansom travelling towards camera would be better than nothing. It is important that these exteriors of the cab are always travelling towards camera; passing shots are no good. Imagine the result.

*THREE PAGES, TWO SHOT DIALOGUE - CAB INTERIOR*

*EXTERIOR CAB PASSES*

*FOUR PAGES, TWO SHOT DIALOGUE - CAB INTERIOR*

*EXTERIOR CAB PASSES*

*FOUR PAGES OF DIALOGUE - CAB INTERIOR*

A sequence like this has no sense of progression; the cab keeps passing us by, yet we constantly catch up with it. There is no grammar to such a sequence. The following, on the other hand, makes visual sense, and gives the audience a feeling of progression.

*THREE PAGES DIALOGUE - CAB INTERIOR*

*SHOT OF CAB APPROACHING CAMERA; AS IT IS BIG IN FRAME, CUT TO*

*FOUR MORE PAGES OF INTERIOR DIALOGUE*

*EXTERIOR AGAIN - CAB APPROACHING - AS DIFFERENT AS POSSIBLE FROM THE PREVIOUS APPROACHING SHOT TO SUGGEST THE TRAVELLERS ARE MAKING PROGRESS - CUT TO*

*FOUR MORE PAGES OF DIALOGUE*

*A FINAL CUT TO AN EXTERIOR OF THE CAB PASSING AND DRIVING AWAY WOULD LEND A CADENCE TO THE SEQUENCE AND PROVIDE A SMOOTH CUT TO THE BALL, OR WHATEVER FOLLOWED*

## INTER CUTTING

The ability to intercut is an important editing technique, whatever the genre of film. Documentaries that are stating a pro-and-con argument do well to establish both arguments early in their construction. It is then

much more possible to abstract the best pieces of 'talking head' from the protagonists without too much recourse to cutaways. Colonel Horsewhip puts the right-wing view, and Millicent Marx the left. When the Colonel becomes boring, or wanders from the argument, it is possible to cut to Millicent, and when she has said enough we can cut back to the Colonel at a point where he has regained his train of thought. If the film has been directed so that they are looking out of frame in different directions (right and left would seem appropriate), then the cuts between the two of them will look very acceptable. This is especially true if their shot sizes are a good match, and if as the film progresses they get gradually larger. A simple device at the shooting stage invests the editing with a real feeling of progression. That is to agree on, say, three camera sizes with your cameraman before you start each interview. Mid-shot Colonel (favouring frame right), medium CU and BCU. If Millicent's interview is conducted to the same formula in every respect, except that she will be favouring frame left, then the two of them will cut together smoothly.

Action sequences always benefit from the ability to intercut. If a fight in the log cabin cannot be intercut with a fuse burning ever lower, or with the cavalry riding to the rescue, then the fight has to be a damned good one. There is much less of a problem with the cutting if the traditional intercuts are available to the editor, for if the fight begins to look unconvincing, we can cut away to the fuse before the fight looks fake, and cut back again at the point when the action picks up. The intercuts not only save the scene, the pacing they bring immensely improves it.

All these devices, the intercuts in the hansom cab, the intercuts between Colonel Horsewhip and Millicent Marx, and the action sequence, can be described as parallel action. The more opportunity for parallel action that a director can offer the editor, the better the result will be.

## SHOT SIZES & EDITING

The size of a shot will determine the length of time it needs to remain on the screen. In a sequence, say, of a windmill starting up, the shots could be:

1 Long shot of the windmill against a dawn sky
2 Medium shot of mill door – the miller comes out and looks for a sign of wind
3 Trees (the miller's POV) – they rustle slightly
4 The miller goes back inside the mill
5 More trees and stronger wind
6 The miller takes off the brake
7 The mill sails shudder slightly

All the shots above would be long shots or medium long shots, except the shot of the brake. They need to be long shots for us to be able to

understand the situation, and they need to be on screen for a fair amount of time to establish a tranquil mood. The shot of the brake provides a punctuation that will change that mood. It is a short action; it is on screen for a moment, and therefore needs to be a strong close-up. Although the windmill sails shuddering will be in mid-shot, they will look best shot from beneath, so this too will be a strong shot. From this point on, the shots will get bigger and bigger as the mechanism becomes faster and faster. Foreknowledge of the editing intent of the sequence is the director's best guide as to what shots are needed. It should be possible for a director to read a dialogue scene and be sure of what lines need to be played in close-up.

> YOUNG MAN :  What's the quickest way out of here?

> CRUSTY OLD CLUB MEMBER :  Well you can take the stairs.

> YOUNG MAN :  Oh.

> OLD CLUB MEMBER :  Or you can use the lift.

> YOUNG MAN :  I see.

> OLD CLUB MEMBER :  Or you can jump out of the window
> and break your bloody neck.

The dialogue obeys the comic 'rule of three' with the punch line coming after two lesser remarks. It is pretty obvious that the punch line must be played in close-up.

Sitcom directors know only too well that a laugh can be wrung out of a line, even if it isn't very funny, as long as the line is played in close-up. It stands to reason that a line which *is* funny is also going to work better in close-up. However, our dialogue example would look inept if it were simply delivered in a two-shot and a close-up like this.

> (TWO-SHOT FAVOURING OLD CLUB MEMBER)

> YOUNG MAN :  What's the quickest way out of here?

> OLD CLUB MEMBER :  Well, you can take the stairs.

> YOUNG MAN :  Oh.

> OLD CLUB MEMBER :  Or you can use the lift.

**YOUNG MAN :**  *I see.*

*(CU CLUB MEMBER)*

**OLD CLUB MEMBER :**  *Or you can jump out of the window and break your bloody neck.*

The rule-of-three rhythm of the exchange, and the final comic line would have a much greater impact if presented like this:

*TWO SHOT YOUNG MAN AND OLD CLUB MEMBER*

**YOUNG MAN :**  *What's the quickest way out of here?*

**OLD CLUB MEMBER :**  *Well, you can take the stairs.*

*(CUT TO MCU YOUNG MAN)*

**YOUNG MAN :**  *Oh.*

**OLD CLUB MEMBER :**  *(DIALOGUE UNDER YOUNG MAN'S CONTINUING CU)  Or you can use the lift.*

**YOUNG MAN :**  *I see.*

*(CUT TO CU OLD CLUB MEMBER)*

**OLD CLUB MEMBER :**  *Or you can jump out of the window and break your bloody neck.*

It is unlikely that any director would arrive in the cutting room without the shots described above, but if thought has been given to the final edited look of the sequence, the director may well decide to shoot the close-ups of the old man in two sizes, one an exact match of the young man's close-up, and one framed tighter for maximum impact. The decision of which to use can be made in the cutting room, my guess is it would be the tighter size.

## CROSSING THE LINE

'Crossing the line' is a phrase to chill the heart of the novice director. Even experienced directors may turn a little pale. They know that if they 'cross the line' and get it wrong, there is nothing that the editor can do to save them. To understand the problem is to come close to overcoming it. The line is a problem simply because when we shoot a film/video, we reduce our three-dimensional world to two dimensions. In a three-dimensional world, left and right are constantly changing. If I stand facing St Pancras Station, Kings Cross is to my right and Euston is to my left. If I turn my back on St Pancras Station, then Kings Cross is to my left and Euston to my right. The line occurs at that point in the three-dimensional world where left becomes right. What this means in practice is that if you have established in a two-shot that two actors are looking at each other, the line is between their noses. If the camera remains the same side of the line when you take the close-ups, all is well. When you come to cut the shots together, the close-ups of the actors will still appear to be looking at each other. This seems so obvious that you might well wonder why there ever is a problem. The answer, of course, is that films are not always shot in sequence, and that is how our three-dimensional world can play tricks. If we return to the vicinity of St Pancras Station, imagine a shot of a man walking left to right across the frame. If the camera is facing St Pancras Station, he will be walking towards King's Cross and exit frame right. In the next shot he must enter frame left if he is to appear to be walking in the same direction. If for some reason the most suitable position for the camera for the second shot is with its back to St Pancras, then the actor must still enter frame left, even though in three-dimensional reality he will be walking in the opposite direction (towards Euston). On screen, however, his journey will appear entirely natural.

Shots involving vehicles are always a problem. The camera is shooting our heroine waving to the crowd from an open carriage and pair. The 'Victoria' carriage passes camera left to right, and the young princess is seated on the camera side of it. So when we come to film her in close-up with the camera on the seat beside her, what happens? The camera crosses the line! The princess, who was facing out of screen right in the passing shot, is now facing out of screen left when the camera for her close-up is placed beside her. There are a number of solutions. One would be to place her in the middle of the seat in the establishing shot. In that case, there would be room for the camera to get into the carriage beside her on the correct side of the line. Should this be impossible, then the close-up should be frontal with the camera opposite the princess. A final, more complicated, solution would be to fit the carriage with a side mount for the close-up. With this mount available, the princess could be close to the camera side of the carriage in the wide shot, and the close shot from the camera mount would be on the right side of the line.

I've used the open carriage-and-pair as an example, as I hoped the image would be easy to visualize. Of course, all these problems recur

when you come to edit interior dialogue scenes in cars. In such cases, camera mounts are almost essential, and 'the line' should persuade you to take your close-ups from a bonnet mount. Frontal close-ups will cut in easily from a two-shot taken with the side mount. Dialogue sequences covered from both sides of the vehicle will look a mess, as every cut will cross the line.

Crossing the line is at its most dangerous in dinner-party scenes. A sequence of a number of people seated at a round table talking to each other seems certainly doomed to include several close-ups where the actors are looking in the wrong direction. Practically every television film drama with a dinner-party scene contains this fault. The reason is that in a dinner-party scene, (especially one at a round table) it is easy for the director to forget the line. In fact it is still there, and, worse, there is more than one line to consider! Imagine four actors seated around a round dinner table. Imagine also that the table is a clock face. Actor A sits at 12

**Figure 9.1**

o'clock, Actress B opposite him at 6 o'clock. Actor C sits at 9 o'clock, Actress D opposite Actor C at 3 o'clock. There is a line between the 12 and the 6, but there is also a line between the 9 and the 3.

If the camera takes all the shots for the sequence from a position contained by one quarter of the clock face (say between the 9 and the 6), then neither of the two lines is crossed, and nothing will look strange on screen. If, however, the camera moves into another quarter (between the 9 and the 12 for example), then one of the lines will have been crossed, in this case the one between 9 o'clock and 3 o'clock. This means that whilst shots of Actors A, D and B, taken from either position will cut together, shots of Actors D and C will not; because this cut will cross the line between 9 o'clock and 3 o'clock. You may well like to draw your own diagram and plot a scene accordingly, using all four quarters and crossing no lines. Let us be clear, the only line that must not be crossed is the one that applies to each individual cut. It must be admitted that even the best directors, when faced with the dinner party problem, cheat; they film the

close-ups twice, with the actors looking out of screen right in one version and screen left in the other. If the scene is short, this is often the most expedient answer.

## SCREEN TIME

The left/right rules which govern the presentation of screen geography have remained firmly in place since the beginning of movie-making, but rules about the presentation of screen time have changed dramatically. An actor answers the telephone: the call is from his fiancée in desperate need of his help. He leaves the house, gets into his car and drives off. At one time it would have been considered good grammar for us to see the actor replace the receiver and leave frame, then cut to the exterior of the house and see him come out and get into the car. Perhaps we would see him put the key in the ignition and press the starter (after all, this sort of film was made in the thirties and forties). Finally, we would cut to a shot where the car drives away (a low angle with a wide lens to give the final shot some oomph!). In a modern thriller all this could be reduced to three shots:

```
SHOT ONE - MCU PHONE RINGING.  HAND COMES INTO SHOT AND
PICKS UP THE RECEIVER.  JIB UP TO BCU HERO.

HERO :  Hello, Helena? - Yes, yes, I understand - don't
panic, darling - I'm on my way.

SHOT TWO - CAR DOOR SLAMMING

SHOT THREE - CAR AWAY FAST.
```

The intervening shots of the hero leaving the house, walking to the car, getting in, starting up, etc., are a waste of screen time, and audiences have een educated to do without them. But this raises a very important point. Can the director do without them? If the film has reached a point where it would benefit from a fast progression through time, then the shots described above would certainly compress time. If, however, the director wanted to frustrate the audience, and get them on the edge of their seats, then maybe we *should* see a detailed sequence of the hero going to the car – maybe he could have trouble unlocking the garage, maybe the car is difficult to start – all these devices expand time and build tension. The point is that the time taken from the moment when the phone starts to ring to the moment when the car drives off, is no longer represented as real, simply because of a slavish adherence to rules of film grammar. In either version, long or short, they only bow to the dramatic function of the sequence.

# COMPRESSIONS OF TIME

Compressions of time like the 'into the car and away' sequence very much depend on strong close shots. A close-up of the hero on the phone, followed by a wide shot of the house with the car in front of it and the actor already in the vehicle shutting the door, simply wouldn't work. If the audience can see the distance he must have travelled to reach the car, they are confused if they don't see him walk that distance. What is needed after the close-up of the actor on the phone is a strong, even stylized shot of the car filling the frame. If it was a Mercedes, for example, a close up of the badge photographed with a wide angle would provide a dynamic image, and have sufficient depth of field for us to be able to see the actor at the wheel slamming the door. Compressions of time and montages very much depend on close, powerful images. The pre-title sequence of John Schlesinger's film, 'Midnight Cowboy' is a good example. The shots as Joe Buck unpacks his new clothes are all big close-ups, and allow the director an enormous compression of real time. That particular sequence is a model for anybody who wants to study the possibilities of playing tricks with time, both visual and aural. At one of the cuts, the picture advances Joe Buck from nudity in the shower to half-dressed in front of a mirror – but the sound continues in real time as, on the cut, Joe proceeds from one line of a song to the next. The sequence also includes the voices of the unpleasant bosses that Joe has decided to let down. Sometimes these are played as voices over the images of Joe, sometimes in close-up of the characters themselves. The whole brief sequence is a model of economical story-telling, and points up the fact that in film/video the quantity of information imparted can be much greater than the sum of the separate visual and aural parts.

# MONTAGE SOUND

Sound is a very powerful tool in the practice of dramatic cutting, especially where the reduction of time is concerned. The acceptability of our sequence (CU of man on phone, car door slams, car away), would be greatly helped by the sharp noise of the door slam and the noise of the start-up and fast getaway. The one, two, three rhythm of the sequence would also be assisted by these sounds. Again, the 'Midnight Cowboy' sequence has several good examples. As Joe Buck zips up his trousers the noise on the track is exaggerated. If sounds are to help in fast editing of powerful close images, then those sounds must be short and percussive in themselves. In other words, a gun shot, a door slam, or a short blast on a factory whistle are ideal. Wedding bells, pneumatic drills and waterfalls are not. The latter group, when edited quickly, provide sound bursts, and these are much less acceptable to the ear. Short intercuts of wedding bells, drills etc., may look fine, but will sound awful. Such bursts of sound work much better as punctuation, when intercut with scenes of comparative

quiet. The heroine waits in the church, whilst her boyfriend races to meet her on his motorbike – that is a sequence where the contrasting sound tracks would very much add to the effect. If she waits for him at a noisy fairground, the intercuts will lose 95 per cent of their effect.

## VOX POPS

These tricks of sound editing are entirely available to the documentary director, and are probably most useful as a trigger for a change of scene. The most common picture and sound intercut used in documentary, however, is the 'vox pop' sequence. This is a sequence where brief statements from members of the public are presented to express public concern or opinion about the topic under discussion. Vox pops require direction if they are to work, just as do other more complicated sequences. The talking heads involved should be filmed in the same size, and the camera should be at the subjects' eye level. I once saw a vox pop sequence which intercut comments from people standing in a canteen queue with comments from people sitting down eating their food. The camera remained at the height of the people standing, even when it was filming the people seated, and the result was inelegant, to say the least. Remember that with vox pops you need short statements, as they will be intercut quite fast. Get close-ups that match for size, and get some subjects talking out of frame right, some left and some straight to camera. This will give a much more polished look to the final intercut sequence. Remembering what might happen if wedding bells were to be intercut with a pneumatic drill, it is sensible to record vox pops with as similar a sound background as possible. As quiet as possible is the ideal, but you often have to film these pieces in busy streets. In any case, be aware that a statement shot in a quiet field will not give a very satisfactory intercut with another shot in a noisy factory.

## ROUGH CUTS

Whether the material is edited by a videotape editor or a film editor, or off-lined by the director, it is common practice to assemble a rough cut and then to refine this to the director's final cut. Only then can the material be neg cut or conformed on-line. The first cut of a drama is likely to be nearer the final result than the first cut of a documentary, because the drama has been shot to a pre-determined script, and whatever changes may occur in the cutting room, the piece is bound to have an overall structure. Some changes may be made at the editing stage, intercutting between scenes in a way that the writer may not have conceived for example, but if the original script had 36 scenes, then the rough cut too will have 36.

In a documentary it is different. If the director has any sense, the

material will have been shot to follow a pre-planned script, but the control and value of the various contributors – be they experts, interviewees or vox pops – cannot be judged until the editing takes place. Sometimes, one contributor is surprisingly better (or worse) than was expected, and this can alter the overall shape of the final film. In such a case, the director may well find that less commentary is needed than was originally intended, (or more if the interviewees proved disappointing). It is brave – some would say foolhardy – to decide that a documentary will have no commentary as a matter of policy. It's fine if the film sustains itself without commentary, but there is no point in distorting the structure of a film, often including a lot of extra tedious talking heads, simply to satisfy a director's quirk. The audience doesn't care whether a film has commentary or not; they are certainly not impressed if it hasn't; but they are easily bored and confused if a film needs a commentary but hasn't got one. It is thus likely that a documentary will change dramatically from rough cut to fine cut in a way that a drama will not. Structure really *is* all, and that is why it is so important to have a clear idea of the purpose of the documentary before you shoot a frame. It is a terrible waste to end up with a rough cut of two-and-a-half hours for a film that is scheduled for a fifty-minute TV slot. The cheapest form of editing is to cut the script before you start shooting.

If the structure of a documentary is proving difficult, it may be a good idea to cut various sequences as separate entities, and watch them with an open mind. This allows a natural order and progression to emerge, which may be less easy to discover if the sequences are joined together in the order that seemed deceptively obvious at the outset. Again, documentary differs greatly from drama in this respect, as such alterations to the order of events are much less likely in the rough cut of a screenplay. Notice that I mentioned the 'separate sequences' of the documentary. It is a very useful technique to think in sequences when you shoot a documentary. If part of the film features a factory, don't just knock off a few random exteriors and interiors. Show the delivery van being loaded, and driving out of the gates. Show the factory workers operating the machinery, with all the close-ups of faces and machinery necessary to allow the editor a full creative range.

One very useful method of approach (particularly on film) is not to bother with too many sound overlaps at the rough cut stage. The more cuts that are straight (picture and sound together), the easier it is to unpick and re-cut a sequence. If a sequence is going together well, the editor may be confident enough to overlay sound and achieve a virtual fine cut with the first assembly: but if a scene is proving difficult, it is best to keep the re-editing options as open as possible; straight cuts ensure this is so. Overlays of whole sentences, or just a couple of syllables, can be made easily enough once you are happy with the shape of the problem scene.

A similar trick is available to documentary makers. It is a mistake to put in all the cutaways in the first assembly of the interview sections. Simply

jump-cut them together. Once this is done, you can assess your cutaway requirements and, if necessary, shoot some relevant stills – maps etc. – to cover at least some of the jump cuts. The others can be covered with reaction shots or illustrative material that you shot for the purpose. It is much better not to include all the detail at the first cut, because some of the interviews will certainly end up on the cutting-room floor, so time spent making them slick is time wasted. It is easier to judge the overall worth of the interviews if they are simply down to length, and the sooner you have the whole film running to time, the better. Once it is down to time, the process of going through and inserting material to iron out the jump cuts is a straightforward process. If your budget is tight, then don't plan to have all your graphics and bench work shot before the editing is under way. Once you know what is needed to illustrate (and cover over the jump cuts of) the edited interviews, then you are in the best position to shoot exactly the stills you require. It isn't a bad idea to have a day, or even two days shooting available to you at some time well into the editing process (on a documentary film this would be after three weeks). This is a guarantee that you will be able to obtain any material that becomes suddenly conspicuous by its absence in the first assembly.

No one has ever regretted taking a close-up of some important action. No one has ever looked dejectedly at a disapproving editor and said 'I wish I hadn't taken that close-up.' There are, however, countless occasions when omitting to take a close-up has caused pain and woe at the editing stage. If it is important that we see Billy Liar slip the passion pills into Barbara's drink, or that we read the cryptic clue in Bertie Wooster's crossword, then take it in close-up! It often happens that cameramen insist erroneously that the action is perfectly obvious in the mid-shot, and that the close-up would be a waste of time. Many directors take this advice and then wonder what on earth had possessed the cameraman to make such a stupid remark, for once in the cutting room the action in the mid-shot is by no means obvious and cries out for a close-up. Surely the cameraman was not being deliberately perverse? After much pondering, it dawned on me that why the cameraman can see the passion pill business quite clearly in the mid-shot is that after a couple of rehearsals he knows where to look, and knows exactly what it is he is supposed to see. So, of course, he sees everything clearly. The audience doesn't share this foreknowledge and has only one chance to glimpse the action. That is why you need the close-up. It is always frustrating not to have a close-up available when you are editing because you were talked out of it against your better judgement, and particularly so when such close-ups can usually be achieved in a matter of moments. If the scene is lit for the mid-shot, all that needs to happen is for the action to be repeated with the camera zoomed in. An alert director will always have an eye for useful close-ups; that can be quickly obtained by this method. Most important to remember is that it is bad enough to be missing shots you genuinely neglected to take, without the added frustration of not having shots you wanted to take but were persuaded not to. Always remember

that it is not the cameraman who has to edit the material together: it's you.

'Master shot' is a term to mistrust deeply. It suggests that the surefire way to film a scene is to shoot the whole scene from the beginning to end without a cut, and then go in and take the two-shots and the close-ups. The belief (completely fallacious) is that if you've missed any shots it doesn't matter because you can always cut to the master shot for the sections where you are lacking the close-ups. This theory exposes a deplorable paucity of cinematic understanding. If a shot is so wide that it can contain all the action, it will stand out like a sore thumb should you cut to it in the middle of the sequence. Cutting to the master from a close-up will provide a visual jolt, and if you cut to the master from a two-shot or a three-shot, then you are landed with the two-shot to two-shot continuity problem discussed earlier. All in all, having wasted a lot of time and actors' energy in achieving a master shot, you will end up using little or nothing of it. There can only be one shot on the screen at a time. A good director will know what that shot should be, and will shoot just that with a sensible, but minimal, amount of alternative cover. The master shot is tantamount to a declaration that the director has given no thought to the look of the cut sequence, to what the audience needs to see, and the angle from which they need to see it.

There may well be a wide angle that takes in the whole scene, and you may legitimately wish to cut to it at appropriate points, (e.g. as one actor walks right across the set), but still you do not need to film the whole scene from this ultra-wide angle. Run the shot for the action you require, plus a few lines more, then cut. Proceed to a new slate (the next shot that uses this wide angle), and film the action you require, again allowing dialogue/action to overlap at the start and finish of the shot. Repeat this process for as often as you require the wide shot. Then you can break the set up and move in closer. A cynic might argue that what I have described is just a master shot by another name – a master shot that has been broken down into bite-sized chunks. This is not so: the wide shot in the fragmented version is a considered angle required for specific parts of the scene, not wasteful belt-and-braces cover for an indecisive director.

It is always a great help to know exactly how you plan to edit a sequence if you are shooting a long speech, and there is a danger of the actor 'drying'. If the ghost of Hamlet's father fluffs a line near the end of a long speech which you are filming in close-up, then you do not need to start again from the top of the speech if you know that you plan to cut to a close-up reaction of Hamlet in the middle of his father's monologue. All you need to do is pick the speech up (on a new slate number) from just before the planned cutaway. Pick-ups can save enormous amounts of time and energy, and reduce the irritation and tension surrounding an actor's fluff, or an extraneous noise that has ruined an otherwise good take. The procedure of pick-up shots is much less irritating to the editor if they are clearly slated so there is no confusion and anxiety in the cutting room. It is particularly important on a video shoot. Cutting to a shot that comes to a grinding halt half way through is even more of an irritation at a

video edit, and clear slates save you from this. If the thought of using clapperboards to slate the shots on a video shoot comes as a surprise to you, bear with me! The clapperboard as an indicator of synchronization is redundant on video, and time code can provide a shot indent; but nothing beats a slate for simple reference when you come to marking up an editing script. After all, shots were slated even in the days of silent films. The ideal information for the editor working on video is:

SLATE NO 12   TAKE 3   TIME CODE 0094530:05
                   ACTION AT TIME 0094545:05
                      RUNS TILL 0094750:05

Time code is usually registered in hours, minutes, seconds and frames (25 frames per second). The time refers to the time of day: this is another good reason for using slates. There are no repeated numbers if you use slates, but if you use time code and shoot over several days at the same time of day, there will be a duplication of time code numbers. The great advantage of slates is that they are so much quicker to read.

## SAMPLE SCRIPT

In 1986 I wrote and directed a modestly-budgeted horror film, 'Bright Wolf' which starred George Baker. There follows the last few pages of the script as originally written; next the list of the shots that I intended to shoot; after that the script as presented to the film editor with the slate numbers marked in lines. These lines indicated the action and dialogue that each slate covers. They were marked in the script by my PA at the time of the shoot. Finally, there is the list of shots that we actually took. When you read the list of shots actually filmed, you will be able to get an idea of how the set-ups were used to maximize efficiency. For example, all the shots of Sir George, (slates 153–162), then all the shots of Emily, (slates 163–166), when Stopes enters on Slate 166, the camera is in the right place for his close-ups, so they were the shots we did next (slates 167/168 and so on).

The director should always endeavour to supply the editor with exactly what is wanted for the sequence, and to shoot that footage in an order that is as efficient as possible for the cast and the crew.

**Figure 9.2** George Baker as 'Sir George' in 'Bright Wolf'.

## **BRIGHT WOLF - EXCERPT**

### **SCENE 27.**

### **INT. HALL AGAIN.**

**EMILY :** Am I your prisoner, Uncle?

**SIR GEORGE :** We are all prisoners here - prisoners of Stopes and his ancestors.

**EMILY :** Of Stopes?

**SIR GEORGE :** Stopes is a witch. It was a Stopes who cursed Bordolph.

**EMILY :** But Christian depends on Stopes, he always says so.

**SIR GEORGE :** That is the exquisite irony of Bordolph's curse; that through the centuries the D'Aubigyns should depend on those murderous wretches for the one substance that can bring relief to our inherited agonies - blood, Emily, human blood - blood that gives me strength, blood that prevents my son and I from degenerating into baying beasts.

**SCENE 28**

CHRISTIAN SLEEPS FITFULLY ON HIS BED - THE
ROOM IS LIT UP BY THE OCCASIONAL FLASH OF
LIGHTNING.  AS THE CAMERA TRACKS IN,
CHRISTIAN CHANGES INTO A WEREWOLF
(INVISIBLE EDIT AS THE CAMERA TRACKS PAST
A POST OF THE FOUR POSTER BED).

**SCENE 29**

THE HALL.  EXT. NIGHT.  COVERDALE RIDES
INTO FRAME AND DISMOUNTS.  AS HE TETHERS
HIS HORSE, STOPES CREEPS UP BEHIND HIM ,
HE IS HOLDING A BUTCHERS KNIFE.  COVERDALE
TURNS ALMOST TOO LATE AS THE KNIFE
DESCENDS.

**SCENE 30**

THE HALL.  INT. AGAIN.

<u>SIR GEORGE</u> **:** That was the knowledge that
drove Christian's mother to madness. She
didn't want to bear my children, didn't
understand that the line must continue.

*At first we thought the boys were fit and strong, but then as they approached their twelfth year, we knew, we knew - it was Eleanor who killed Gideon, Emily.  Yes, and she would have poisoned Christian too if I hadn't had her committed to the Asylum.*

**CHRISTIAN :** *(AT THE TOP OF THE STAIRS) You liar!*

**SIR GEORGE :** *It's true, Christian, would that I was lying.*

**CHRISTIAN :** *But why?*

**SIR GEORGE :** *Your mother wanted the D'Aubigny line to die, and the D'Aubigny curse to die with it.  It was my duty. No-one must ever learn our secret.*

*(EMILY MAKES A MOVE FOR THE DOOR, SIR GEORGE AIMS AT EMILY)*

**SIR GEORGE :** *Hold Emily!*

**EMILY :** *(TURNING ON HIM) Your wife is dead Uncle, she was the escaped lunatic - she escaped and was murdered; murdered for her blood!*

*(SIR GEORGE STAGGERS BACK WITH A CRY AND BREAKS DOWN IN SOBS - CHRISTIAN DESCENDS TO EMILY)*

**CHRISTIAN :** *Get away, Emily - Go now.*

*(EMILY GOES TO THE DOOR WHICH BURSTS OPEN TO REVEAL A BLOOD STAINED STOPES)*

**SIR GEORGE :** *Satan - (HE FIRES HIS GUN AT STOPES AND WINGS HIM, STOPES THROWS HIS KNIFE INTO SIR GEORGE. CHRISTIAN CHASES STOPES UP THE STAIRS)*

**SIR GEORGE :** *(WITH HIS DYING GASP) Burn then, damn warlock.*

*HE THROWS AN OIL LAMP AT THE STAIRS WHICH BURSTS INTO FLAMES - SIR GEORGE FALLS DEAD - COVERDALE ENTERS HALF DEAD FROM STAB WOUND)*

**COVERDALE :**  Emily!  (HE AIMS A PISTOL
INTO THE FLAMES)

**EMILY :**  Stephen, no.

(COVERDALE SHOOTS AND KILLS CHRISTIAN WHO
FALLS THROUGH THE FLAMES TO EMILY'S FEET)

**STOPES :**  Chaos.  All is chaos.  I am Lord
of Chaos.

**THE END**

## *SHOT SCHEDULE*

| DATE | SCENE | PAGE | SHOT | DESCRIPTION | ARTISTS | LOCATION | SPECIAL REQS. |
|------|-------|------|------|-------------|---------|----------|---------------|
| Thursday 18 Dec. | 25 | 45 | 108 | Emily at top of stairs, starts to descend | Sara Coward (Emily) | Top of stairs | Candlelight Open Fire |
| | 25 | 45 | 109 | MCU Emily descends | Sara Coward (Emily) | Stairs | Candlelight Open Fire |
| | 25 | 45 | 110 | MCU Emily's feet descend | Sara Coward (Emily) | Stairs | Candlelight Open Fire |
| | 25 | 45 | 111 | Over Emily's shoulder as she approaches the door. Track with her to door - she turns into BCU on Sir George's voice over "You're not leaving us Emily" | Sara Coward (Emily) | Hall | Candlelight |
| | 25 | 45 | 112 | MCU Sir George - Portrait in b/g - "You'll never leave" | George Baker (Sir George) | Hall | Portrait b/g Flash of lightning Huge shadow Lamplight |
| | 27 | 47 | 115 | MCU Emily (Emily) | Sara Coward | Hall | |

| DATE | SCENE | PAGE | SHOT | DESCRIPTION | ARTISTS | LOCATION | SPECIAL REQS. |
|---|---|---|---|---|---|---|---|
| Thursday 18 Dec. | 27 | 47 | 116 | Sir George as per shot 112 with portrait in b/g. Dialogue: as per script | George Baker (Sir George) | Hall | Portrait b/g Lightning Huge shadow |
| | 30 | 50 | 121 | MCU Sir George as (112 and 116) "That was the knowledge ... to the Asylum." | George Baker (Sir George) | Hall | " |
| | 30 | 50 | 122 | Christian at top of stairs. "You liar." "But why?" | Miles England (Christian) | Hall/stairs | Half werewolf |
| | 30 | 50 | 123 | Camera from Christian's p.o.v. at top of stairs to Sir George "Your mother .... Hold Emily" | George Baker (Sir George) | Top of stairs | |
| | 30 | 50 | 124 | BCU Sir George "Hold Emily" | George Baker (Sir George) | Hall | " |
| | 30 | 51 | 125 | Emily turns into CU "Your wife .. for her blood" | Sara Coward (Emily) | Hall | " |

Note row 123 special reqs: Candlelight Open fire Lamplight

| DATE | SCENE | PAGE | SHOT | DESCRIPTION | ARTISTS | LOCATION | SPECIAL REQS. |
|---|---|---|---|---|---|---|---|
| Thursday 18 Dec. | 30 | 51 | 125A | BCU Sir George staggers back | George Baker (Sir George) | Hall | " |
| | 30 | 51 | 126 | WS Christian descends stairs to Emily Christian: "Get away Emily – Go Now" Emily goes to the door – cam. goes with her to reveal Stopes as the door opens. | Miles England (Christian) Sara Coward (Emily) Nigel Descombes (Stopes) | Hall | Bloodstained Stopes Continuity knife Wall Hall |
| | 30 | 51 | 127 | Sir George fires at Stopes. Sir George: "Satan" | George Baker (Sir George) | Hall | Pistol for Sir George |
| | 30 | 51 | 128 | MCU Stopes throws knife | Nigel Descombes (Stopes) | Hall | Prop knife for Stopes |
| | 30 | 51 | 129 | Sir George with knife in him | George Baker (Sir George) | Hall | Knife effect Open fire Candlelight Lamplight Smoke |
| | 30 | 51 | 130 | BCU Emily screams | Sara Coward (Emily) | Hall | |

| DATE | SCENE | PAGE | SHOT | DESCRIPTION | ARTISTS | LOCATION | SPECIAL REQS. |
| --- | --- | --- | --- | --- | --- | --- | --- |
| Thursday 18 Dec. | 30 | 51 | 131 | Christian chases Stopes up the stairs | Miles England (Christian) Nigel Descombes (Stopes) | Hall/stairs | |
| | 30 | 51 | 132 | Sir George throws the lamp: "Burn then, damned warlock" | George Baker (Sir George) | Hall/stairs | |
| | 30 | 51 | 133 | Lamp lands and fire starts | | Hall/stairs | Smoke |
| | 30 | 51 | 134 | Christian and Stopes struggle in the flames – Christian gets shot | Miles England (Christian) Nigel Descombes (Stopes) | Hall/stairs | Pistol hits smoke |
| | 30 | 51 | 135 | Coverdale enters and shoots at Christian | Tristram Davies (Stephen) | Hall/Stairs | Pistol hits smoke |
| | 30 | 51 | 136 | BCU Emily: "Stephen, no" | Sara Coward (Emily) | Hall/stairs | |
| | 30 | 51 | 137 | Christian (normal make-up) rolls dead at Emily's feet. | Miles England (Christian) | Hall | Smoke |

| DATE | SCENE | PAGE | SHOT | DESCRIPTION | ARTISTS | LOCATION | SPECIAL REQS. |
|---|---|---|---|---|---|---|---|
| Thursday 18 Dec. | 30 | 51 | 138 | MCU Stopes through the flames: "Chaos, all is chaos. I am Lord of chaos." | Nigel Descombes (Stopes) | Hall/stairs | Smoke |
| | 30 | 51 | 139 | The portrait, flames foreground. (Also, portrait reflects flames for start of fire." | | Hall | Flicker effect |
| | 30 | 51 | 140 | Shots of artists against white flattage for matt shots | George Baker Sara Coward Nigel Descombes Miles England Tristram Davies | | White flats |
| Friday 19 Dec. | 9 | 20 | 44 | Cocoa - pan to Emily | Sara Coward (Emily) | Emily's bedroom | Moonlight |
| | 9 | 20 | 45 | Wider shot Emily sits up and swings her feet out of bed. Tighten as she hears the music. | Sara Coward (Emily) | Emily's bedroom | Moonlight |
| | | | 46 | WS Emily crosses the bedroom and exits | Sara Coward (Emily) | Emily's bedroom | Moonlight |

| DATE | SCENE | PAGE | SHOT | DESCRIPTION | ARTISTS | LOCATION | SPECIAL REQS. |
|------|-------|------|------|-------------|---------|----------|---------------|
| Friday 19 Dec. | 10 | 21 | 47 | Emily along landing | Sara Coward (Emily) | Landing | Moonlight |
| | 10 | 21 | 48 | Track Emily along landing, MCU feet. MCU face. | Sara Coward (Emily) | Landing | " |
| | 10 | 21 | 49 | Emily down stairs MCU face | Sara Coward (Emily) | Stairs | |
| | 10 | 21 | 50 | Emily down stairs MCU feet | Sara Coward (Emily) | Stairs | |
| | 10 | 21 | 51 | Emily's hand on door knob, opens door and reveals Christian deep in shot playing the piano. | Sara Coward (Emily) | Drawing Rm.Door | Moonlight |
| | | | | | Miles England (Christian) | Drawing Room | " |
| | 10 | 21 | 52 | CU Emily watching | Sara Coward (Emily) | Drawing Room | " |
| | 10 | 21 | 53 | Emily's p.o.v. - track into Christian - he turns to reveal werewolf face. | Miles England (Christian) | Drawing Room | Werewolf face Open fire |

| DATE | SCENE | PAGE | SHOT | DESCRIPTION | ARTISTS | LOCATION | SPECIAL REQS. |
|---|---|---|---|---|---|---|---|
| Friday 19 Dec. | 21 | 41 | 104 | Christian in bed - action as per script | Miles England (Christian) | Christian's bedroom | Moonlight |
| | 28 | 48 | 117 | Christian on his bed, gets up and walks towards mirror (Christian as himself) | Miles England (Christian) | Christian's bedroom | Moonlight Mirror |
| | 28 | 48 | 118 | Reflection of Christian as himself to be matted into mirror | Miles England (Christian) | Christian's bedroom | |
| | 28 | 48 | 119 | Christian as half werewolf over his shoulder looking into mirror - cam. locked off. Place white card in mirror and continue to run for trick | Miles England (Christian) | Christian's bedroom | Half werewolf White card |
| | 30 | 51 | 137 | Christian (as himself) | Miles England (Christian) | Hall | Smoke FX |

SCENE 27

(154/2)

(164/1)

(INT. HALL AGAIN)

EMILY : Am I your prisoner uncle?

SIR GEORGE : We are all prisoners here –
Prisoners of Stopes and his ancestors.

EMILY : Of Stopes?

SIR GEORGE : Stopes is a witch.   It was
a Stopes who cursed Bordolph.

EMILY : But Christian depends on Stopes,
he always says so.

SIR GEORGE : That is the exquisite irony
of Bordolph's curse; that through the
centuries the D'Aubignys should depend on
those murderous wretches for the one
substance that can bring relief to our
inherited   agonies – blood Emily,
human blood – blood that gives me
strength – blood that prevents my son
and I from degenerating into baying
beasts.

(154/2)

(164/1)

SCENE 28

200/1

202/1

201/3

(CHRISTIAN SLEEPS FITFULLY ON HIS
BED ~~THE ROOM~~ IS LIT UP BY THE
OCCASIONAL FLASH OF LIGHTENING,
AS THE CAMERA TRACKS IN CHRISTIAN
CHANGES INTO THE WEREWOLF ~~(INVISIBLE~~
~~BUT) AS THE CAMERA TRACKS PAST A POST~~
~~OF THE FOUR POSTER BED)~~.

202/1

201/3

200/1

SCENE 29

(93|3)

(THE HALL EXT. NIGHT - COVERDALE
RIDES INTO FRAME AND DISMOUNTS -
AS HE TETHERS HIS HORSE STOPES
CREEPS UP BEHIND HIM, HE IS
HOLDING A BUTCHER'S KNIFE.
COVERDALE TURNS ALMOST TOO LATE
AS THE KNIFE DESCENDS).

(94|2)

(93|3)

(94|2)

ADDITIONAL SHOTS OF
TERRIFIED HORSE
95|1 + 95/2

(155/2) (THE INT. HALL AGAIN)

SIR GEORGE : That was the knowledge that
drove Christian's mother to madness.  She
didn't want to bear my children, didn't
understand that the line must continue.
At first we thought the boys were fit
and strong but then as they approached
their twelth year, we knew we knew      (164/1)
was Eleanor who killed Gideon Emily.
(174/2)
Yes, and she would have poisoned
Christian too if I hadn't had her
committed to the Asylum.
(160/3)

CHRISTIAN : (AT THE TOP OF THE STAIRS).
You Liar!

(155/2) SIR GEORGE : It's true Christian, would
that I was lying.

CHRISTIAN: But why?

SIR GEORGE: Your mother wanted the
D'Aubigny line to die and the D'Aubigny
curse to die with it.  It was my duty.
No-one must ever learn our secret.

(EMILY MAKES A MOVE FOR THE DOOR,
(156/3)    SIR GEORGE AIMS AT EMILY)
(165/3)  (174/2) (156/3)

SIR GEORGE : Hold Emily           (164/1)
(160/3)

(165/3
Cont.)

157/2   165/3 Cont

EMILY : (TURNING ON HIM) Your wife is
dead Uncle, she was the escaped lunatic –
she escaped and was murdered; murdered
for her blood!   165/3   157/2

(SIR GEORGE STAGGERS BACK WITH A
CRY AND BREAKS DOWN IN SOBS –
CHRISTIAN DESCENDS TO EMILY)

175/1   166/3   175/1

CHRISTIAN : Get away Emily – Go now.

(EMILY GOES TO THE DOOR WHICH
BURSTS OPEN TO REVEAL A BLOOD
STAINED STOPES).   166/3

181/1+2   158/1   158/1   159/2   159/2

167/1   SIR GEORGE : Satan – HE FIRES HIS GUN
AT STOPES AND WINGS HIM, STOPES THROWS
161/1   HIS KNIFE INTO SIR GEORGE, CHRISTIAN   161/1   N.B
177/3   CHASES STOPES UP THE STAIRS) 167/1   STOPES
REACTION
177/3   168/3

171/1

SIR GEORGE : (WITH HIS DYING GASP).
Burn then damned warlock.

N.B. Stopes   162/2   162/2
reaction
179/1   (HE THROWS AN OIL LAMP AT THE   178/1
178/1 STAIRS WHICH BURSTS INTO FLAMES,   184/2   172/1
184/2   SIR GEORGE FALLS DEAD, COVERDALE   169/2
ENTERS HALF DEAD FROM STAB WOUNDS).

COVERDALE : Emily!   (HE AIMS A PISTOL
INTO THE FLAMES).

172/2   169/2

EMILY : Stephen No.

173/1   173/1

181/1+2   182/1   (COVERDALE SHOOTS AND KILLS CHRISTIAN   182/1
WHO FALLS THROUGH THE FLAMES TO EMILY'S
198/1+199/1   FEET?   198/1
+
199/1
183/2

STOPES : Chaos.  All is chaos.  I am
Lord of Chaos.   183/2

THE END   170/1 Reaction shot –
*******   Emily.

(NB CHRISTIAN INTO FLAMES 185/1)

SHOT LIST

| SCENE NO | PAGE NO | SHOT NO | DESCRIPTION | DUR: | FR NO | SR NO | S/M |
|---|---|---|---|---|---|---|---|
| 14 | 29 | 149/2 | Action a/b - n.g. her eyeline | 22" | 28 | 14 | S |
| 14 | 29 | 149/3 | n.g. - cam o.o. film | 26" | 28 | 14 | S |
| 14 | 29 | 149/4 | n.g. - plane noise | 10" | 29 | 14 | S |
| 14 | 29 | 149/5 | Action a/b - OK until he rises on "But you know..." | 57" | 29 | 14 | S |
| 14 | 29 | 149/6 | Pick up from Christian's "But you know..." n.g. | 15" | 29 | 14 | S |
| 14 | 29 | 149/7 | Pick up from a/b "But you know..." OK | 25" | 29 | 14 | S |
|  | 29 | 150/1 | (After false start) MCU Christian Dialogue "Why Emily, you're trembling...tilt up with him as he rises on But you know ..... Emily .....I'm beginning to understand | 1.15 | 29 | 14 | S |
| 14 | 29 | 150/2 | a/b - better | 1.17 | 29 | 14 | S |
| 14 | 28 | 151/1 | Empty frame, piano keyboard L f/g - Christian in from R. sits down, sorts his music, starts to play | 18" | 29 | 14 | S |
| 14 | 28 | 151/2 | Action a/b - better | 19" | 29 | 14 | S |
| 25 | 45 | 152/1 | MLS Sir George with portrait of Bardolph b/g - points pistol. (Lightening FX) Dialogue "You're not leaving us Emily... You'll never leave D'Aubigny Hall." n.g.lightening FX | 9" | 29 | 15 | S |
| 25 | 45 | 152/2 | a/b - n.g. FX | 10" | 29 | 15 | S |

| SCENE NO | PAGE NO | SHOT NO | DESCRIPTION | DUR: | FR NO | SR NO | S/M |
|---|---|---|---|---|---|---|---|
| 25 | 45 | 152/3 | A/B (after 8" frog in throat) - n.g. | 19" | 29 | 15 | S |
| 25 | 45 | 152/4 | a/b - OK | 10" | 29 | 15 | S |
| 27 | 47 | 153/1 | MS Sir George relaxes gun - track in & zoom out on his "Blood Emily". Dialogue "Am I your prisoner Uncle?... degenerating into baying beasts". n.g. Sir George dries | 32" | 29 | 15 | S |
| 27 | 47 | 153/2 | a/b - n.g. track | 48" | 29 | 15 | S |
| 27 | 47 | 153/3 | a/b - OK but track a bit fast | 42" | 29 | 15 | S |
| 27 | 47 | 153/4 | a/b - OK but a bit croaky on "Stopes" | 48" | 29 | 15 | S |
| 27 | 47 | 154/1 | a/b but pick up from dialogue Emily "But Christian depends...Sir George ....baying beasts" n.g. Sir George dries | 29" | 30 | 15 | S |
| 30 | 50 | 155/1 | MS Sir George - n.g. camera only - sound recordist not present! | 37" | 30 | 15 | S |
| 30 | 50 | 155/2 | MS Sir George - turns up and looks up L. on end. Dialogue Sir George "That was the knowledge ... Christian: "You Liar" | 35" | 30 | 15 | S |
| 30 | 50 | 156/1 | MLS Sir George looking up stairs L. turns to cam. points gun "Hold Emily". n.g. action | 10" | 30 | 15 | S |
| 30 | 50 | 156/2 | a/b - n.g. action | 13" | 30 | 15 | S |
| 30 | 50 | 156/3 | a/b - OK | 9" | 30 | 15 | S |

| SCENE NO | PAGE NO | SHOT NO | DESCRIPTION | DUR: | FR NO | SR NO | S/M |
|---|---|---|---|---|---|---|---|
| 30 | 51 | 157/1 | MS Sir George staggers back R on table portrait of Bardolph b/g. Dialogue Emily "Your wife is dead Uncle...for her blood". n.g. action | 16" | 30 | 15 | S |
| 30 | 51 | 157/2 | a/b - OK | 18" | 30 | 15 | S |
| 30 | 51 | 158/1 | Sir George collapsed on table a/b tilt up with him as he stands and points gun to camera "Satan" | 9" | 30 | 15 | S |
| 30 | 51 | 159/1 | CU Sir George's hand & gun held up into shot - portrait of Bardolph b/g - gun fires - loud bang. n.g. for camera | 10" | 30 | 15 | S |
| 30 | 51 | 159/2 | a/b - OK | 12" | 30 | 15 | S |
| 30 | 50 | 160/1 | H/A Cam. from Christian's p.o.v. looking down on Sir George looking up to cam. turns on end and points gun. Dialogue Christian "Your liar... Hold Emily" n.g. for sound | 18" | 30 | 15 | S |
| 30 | 50 | 160/2 | a/b - n.g. for camera | 24" | 30 | 15 | S |
| 30 | 50 | 160/3 | a/b - OK | 20" | 30 | 15 | S |
| 30 | 51 | 161/1 EB | MS Sir George with knife in him falls R. OK - use this take | 12" | 30 | 15 | S |
| 30 | 51 | 161/2 EB | not so good action | 10" | 30 | 15 | S |
| 30 | 51 | 161/3 EB | again not so good | 10" | 30 | 15 | s |
| 30 | 51 | 162/1 | MS Sir George half dead with knife in him - grabs lamp from R and throws it up oov L. n.g. lamp collapses! | 15" | 30 | 15 | S |
| 30 | 51 | 162/2 | a/b - OK | 15" | 30 | 15 | S |

| SCENE NO | PAGE NO | SHOT NO | DESCRIPTION | DUR: | FR NO | SR NO | S/M |
|----|----|----|----|----|----|----|----|
| 27 | 47 | 163/1 | MS Emily - intense stare on end. Dialogue "Am I your Prisoner Uncle? ..Sir George... baying beasts." | 50" | 30 | 15 | S |
| 27 | 47 | 164/1 | MCU Emily - looks and gasps of horror on end. - repeats gasps of horror twice and holds hand up to her face in horror. Dialogue Sir George "Blood Emily ... baying beasts | 53" | 30 | 15 | S |
| 30 | 50 | 164/1 | (Boarded in error should be 165/1) MS Emily turns sneaks to door b/g on end. Dialogue Sir George "It was Eleanor who killed ... Hold Emily". | 29" | 30 | 15 | S |
| 30 | 51 | 165/1 | MLS Emily at door - turns in anger walks to cam. into MCU. Dialogue Sir George "Hold Emily - Emily : ".. murdered for her blood." n.g. for camera | 21" | 31 | 15 | S |
| 30 | 51 | 165/2 | a/b - not bad | 19" | 31 | 15 | S |
| 30 | 51 | 165/3 | a/b - BEST | 20" | 31 | 15 | S |
| 30 | 51 | 166/1 | L/A Cam. looking onto MLS Emily backs to door looking up turns to open door - door burst open to reveal blood stained Stopes with knife - lightening FX. Dialogue Christian "Get away Emily .. Go now." - Emily : Scream Sir George "Satan" n.g. lightening a bit late | 15" | 31 | 15 | S |
| 30 | 51 | 166/2 | a/b - n.g. FX | 13" | 31 | 15 | S |
| 30 | 51 | 166/2 | A/B - NOT BAD | 12" | 31 | 15 | S |
| 30 | 51 | 166/3 | (n.b. boarded in error should be 166/4) a/b - BEST | 12" | 31 | 15 | S |

| SCENE NO | PAGE NO | SHOT NO | DESCRIPTION | DUR: | FR NO | SR NO | S/M |
|---|---|---|---|---|---|---|---|
| 30 | 51 | 167/1 | MS Stopes reacts with scorn to bullet having missed him - throws knife up and oov L. | 10" | 31 | 16 | S |
| 30 | 51 | 168/1 | MS Stopes looking R reacting to Sir G's knife - sharp turn to cam for look upstairs and runs oov behind cam. R. n.g. action | 7" | 31 | 16 | S |
| 30 | 51 | 168/2 | a/b - n.g. action | 10" | 31 | 16 | S |
| 30 | 51 | 168/3 | a/b - OK | 10" | 31 | 16 | S |
| 30 | 51 | 169/1 | Looking onto door half closed - MS Stephen staggers through door half dead reacts to oov Emily - turns to cam. for look upstairs and takes aim with pistol. Dialogue Stephen "Emily" - Emily "Scream" Eamily: "Stephen no." not bad but possible overlap on sound. | 15" | 31 | 16 | S |
| 30 | 51 | 169/2 | a/b - very good | 18" | 31 | 16 | S |
| 30 | 51 | 170/1 | MLS Emily with Stephen dying on her L reacts to general horror - Stephen slips down dying | 15" | 31 | 16 | M |
|   |   |   | & again - OK | 20" | 31 | 16 | M |
| 30 | 51 | 171/1 | Emily on floor reacts to knife being thrown - oil lamp thrown - Sir G's death - action on stairs. Screams | 43" | 31 | 16 | Gui de |
| 30 | 51 | 172/1 | Emily on floor reacts to Stephen - action on stairs - Stephen aiming "Stephen no" struggles up. n.g. eyeline | 10" | 31 | 16 | S |
| 30 | 51 | 172/2 | a.b. OK | 10" | 31 | 16 | S |
| 30 | 51 | 173/1 | CU Stephen's gun - fires | 13" | 31 | 16 | S |

| SCENE NO | PAGE NO | SHOT NO | DESCRIPTION | DUR: | FR NO | SR NO | S/M |
|---|---|---|---|---|---|---|---|
| 30 | 50 | 174/1 | Cam. looking up stairs - Christian half werewolf moves forward to MS Dialogue Sir George: "Yes and she would have poisoned ... Hold Emily" n.g. action | 1.00 | 31 | 16 | S |
| 30 | 50 | 174/2 | a/b - OK | 41" | 31 | 16 | S |
| 30 | 51 | 175/1 | MS Christian gestures with arm "Get away Emily - go now" | 7" | 31 | 16 | S |
| 25 | 45 | 176/1 | WS side angle staircase - Emily in from R creeps down stairs & oov L. n.g. action | 15" | 31 | 16 | S |
| 25 | 45 | 176/2 | a/b - with look to cam. and behind her. OK | 27" | 31 | 16 | S |
| 30 | 51 | 177/1 | MLS Christian on stairs - Stopes runs up to him - Christian kicks him oov L. n.g. action too violent. | 10" | 31 | 16 | S |
| | 51 | 177/2 | a/b - n.g. action | 17" | 31 | 16 | S |
| 30 | 51 | 177/3 | a/b - BEST | 10" | 31 | 16 | S |
| 30 | 51 | 178/1 EB | Section of staircase - oil lamp falls through frame R-L - catches fire | 20" | 32 | 16 | S |
| 30 | 51 | 179/1 | CU Stopes on stairs reacts to oil lamp being thrown | | | | |
| 30 | 51 | 180/1 | W/A side of staircase - Christian - Stopes runs in from L - they fight midst flames | 20" | 32 | 16 | s |
| 30 | 51 | 181/1 | Close on action midst flames - Christian fighting with Stopes who falls, Christian turns on end as if to oov Emily's "Stephen no" - realises he is about to be shot. n.g. action | 12" | 32 | 16 | Gui de |

| SCENE NO | PAGE NO | SHOT NO | DESCRIPTION | DUR: | FR NO | SR NO | S/M |
|---|---|---|---|---|---|---|---|
| 30 | 51 | 181/2 | n.g. action | 10" | 32 | 16 | S |
| 30 | 51 | 181/2 | (Boarded in error should be 181/3) | 16" | 32 | 16 | S |
| 30 | 51 | 182/1 | MCU Christian falls down oov into flames | 9" | 32 | 16 | S |
| 30 | 51 | 183/1 | MS Stopes rises up into shot midst flames holds his hands up - flames obscure his face on end. "Chaos, All is chaos, I am the lord of chaos" action - not bad | 30" | 32 | 16 | S |
| 30 | 51 | 183/2 | a/b - very good | 30" | 32 | 16 | S |
| 30 | 51 | 184/1 | Sir George's last breath midst flames falls through frame - end on portrait of Bardolph CS flames f/g. n.g. action | 13" | 32 | 16 | M |
| 30 | 51 | 184/2 | a/b - OK | 44" | 34 | 16 | S |
| 30 | 51 | 185/1 | MS Christian back to normal falls into frame L-R - dead midst flames. 3 attempts - n.g. smoke too heavy | 54" | 32 | 16 | M |
| | | | & again - OK | 17" | | | |
| 5 | 14 | 186/1 | Retake of shoot 35/1. Looking down corridor - Stopes follows by Emily in from R to cam and behind cam L. Dialogue Stopes "It does seem you're better Master. Yes, he does seem to be getting better - perhaps he's growing out of it, whatever it is." | 28" | 33 | 17 | S |

| SCENE NO | PAGE NO | SHOT NO | DESCRIPTION | DUR: | FR NO | SR NO | S/M |
|----------|---------|---------|-------------|------|-------|-------|-----|
| 18 | 36 | 187/1 | Retake of shot 36/2. Looking down corridor - Stopes & Christian struggling around corridor b/g to cam, and oov L.<br>Dialogue Stopes "You do what your father said, just do as you're told". Christian: "Damn you Stopes, just wait until I'm the Master". Stopes: sardonic laugh.<br>n.g. voices too low | 13" | 33 | 17 | S |
| 18 | 36 | 187/2 | a/b n.g. struggle | 13" | 33 | 17 | S |
| 18 | 36 | 187/3 | n.g. for camera | 14" | 33 | 17 | S |
| 18 | 36 | 187/4 | a/b OK | | | | |
| 9 | 20 | 188/1 | Emily's bedroom. Hold on CS table. Emily's hand reaches for brush - track out and tilt up to see Emily on bed brushing hair - reaches for cup - decides it's too cold - then thinks it a bit strange - puts brush down and exits oov L.<br>n.g. for sound | 52" | 33 | 17 | S |
| 9 | 20 | 188/2 | a/b - OK | 1.03 | 33 | 17 | S |
| 9 | 20 | 189/1 | C/I CU Emily - decides not to have cocoa hears music - thinks it charming, then strange - moves from bed oov L. | 46" | 34 | 17 | S |
| 9 | 20 | 190/1 | H/A Cam. looking down corridor to arch. Emily in from behind cam. R walks down corridor looks slightly back and continues oov R. | 27" | 34 | 17 | S |
| 9 | 20 | 191/1 | Side angle banisters staircase Emily in from L, down stairs - pause then R-L track L as she continues to bottom looks and moves forward.<br>n.g. batteries down | 6" | 34 | 17 | S |
| 9 | 20 | 191/2 | a/b - n.g. action | 25" | 34 | 17 | S |

| SCENE NO | PAGE NO | SHOT NO | DESCRIPTION | DUR: | FR NO | SR NO | S/M |
|----------|---------|---------|-------------|------|-------|-------|-----|
| 9 | 20 | 191/3 | a/b - OK | 27" | 34 | 17 | S |
| 9 | 20 | 192/1 | CU Emily at bottom of stairs listening. exits frame R. | 10" | 34 | 17 | M |
| | | | & again - OK | 25" | | | |
| 9 | 20 | 193/1 EB | MCU Emily looking slightly alarmed | 11" | 34 | 17 | M |
| | | | & again moves oov. L | 15" | | | |
| 9 | 20 | 194/1 | BCU Emily's feet down steps pan with them R-L and oov L. | 10" | 34 | 17 | M |
| | | | & again | 10" | | | |
| 10 | 21 | 195/1 | W/A Looking into drawing room. Christian back to cam. playing piano. Emily R shoulder back to cam. enters L f/g - track with her as she goes towards him - CS her hand on his hair - he turns reveal Christian as hideous werewolf! not bad | 45" | 34 | 17 | S |
| 10 | 21 | 195/2 | A/B OK | 43" | 34 | 17 | S |
| 10 | 21 | 196/1 | Reverse Emily MCU by curtain of drawing room - thinks quite charming music - walks to cam. and oov R. | 15" | 34 | 17 | s |
| 24 | 44 | | W/T clock chiming - first attempt n.g. 3/4 hour | 32" | | | |
| | | | Final attempt O.K. 1/4 hour | 26" | | | |
| 25 | 45 | 197/1 | Side angle banisters - CU Emily's boots down stairs L-R, then R-L cam panning with her | 20" | 34 | 17 | S |
| 30 | 51 | 198/1 | Portraits - ancient Granny D'Aubigny with lightening FX - n.b. hair in gate & again - several attempts. CS & wider | | 34 | 17 | M |
| 30 | 51 | 199/1 | Portrait - Puritan D'Aubigny - CS & wider Lightening FX | | 34 | 17 | M |

| SCENE NO | PAGE NO | SHOT NO | DESCRIPTION | DUR: | FR NO | SR NO | S/M |
|----------|---------|---------|-------------|------|-------|-------|-----|
| 28 | 48 | 200/1 | Werewolf change! o/s Christian back to cam. - mirror b/g - Christian as half werewolf - turns to cam. holds hand to face - camera locked off - transformation sequence | | 34 | 17 | M |
| 28 | 48 | 201/1 | Full length Christian lying on bed restless - tilt down and pan R on his feet as he moves from bed - feet oov R - end on nodding rocking horse n.g. size 8 props on foot! | 25" | 35 | 17 | S |
| 28 | 48 | 201/2 | a/b - n.g. action | 14" | 35 | 17 | S |
| | 48 | 201/3 | a/b - BEST | 28" | 35 | 17 | S |
| 28 | 48 | 202/1 | W/A Christian on bed restless - track in to MCU Christian rolls oov R. | 37" | 35 | 17 | S |
| 8 | 19 | 203/1 | MS Christian asleep from side angle. Stopes into b/g from R - gives him foul mixture - much choking and spluttering | 25" | 35 | 17 | S |
| 22A | 42 | 204/1 | Tilt down from dressing table - across fort L rocking horse nodding - tilt up to MLS Christian asleep - wakes up suddenly - thinks about his past (brother etc.) | 14" | 35 | 17 | S |
| 22A | 42 | 204/2 | n.g. lampstand in shot | 32" | 35 | 17 | S |
| 22A | 42 | 204/3 | n.g. rocking horse nodding too violent | 33" | 35 | 17 | S |
| 22A | 42 | 204/4 | n.g. for camera | 12" | 35 | 17 | S |
| 22A | 42 | 204/5 | a/b - BEST | 32" | 35 | 17 | M |

# Post-production effects

In most areas of concern to the director there is little difference between working on film or videotape, as the rules of visual grammar and the techniques of visual communication apply to both. There are advantages and disadvantages with either medium, but these are largely matters of equipment, and are not of importance to the director.

This is not true of post-production effects. In this area film and tape differ enormously, and the situation is further confused by the fact that video effects can be seen and judged at the time of their creation (which film effects cannot). Films for television increasingly add their effects after the show print stage as the film is transferred to video. Some feature films (e.g. *Back To The Future II*) have made use of video effects which have then been converted back on to film by a sophisticated version of the old tele-recording method. Despite what the critics said, the effects in that film compared very poorly with the rest of the picture, where the images came directly from the original negative.

If a director expects to work in both film and video, then he would be wise to know at least something of how effects are obtained on film and why they cost so much. If a film is going to be seen in the cinema as well as on TV, then its post-production effects must be generated on film. This is also logical if the film is to be televised on different transmission systems, as the video effects would otherwise have to be remade to all the various tape standards.

To understand film effects, it is necessary to be aware of the basic film process, and film cutting-room practice. When you shoot a film, the film in the camera is developed to a negative. A print is made from this negative; this print is referred to as a 'rush print' or 'rushes'. Rush prints are printed at one light throughout the roll, with no colour grading. The director thus needs to appreciate that if one shot on a rush point looks too dark or too light there is no cause for alarm. The shot will probably be perfectly OK in the final print, when each shot is printed at its own individual best light. If you are worried about possible print quality, then the film editor can ask the laboratory to examine the negative to make sure it will print satisfactorily, and, if you are still unsure, you can ask for a

corrected rush print of the roll in question. A corrected rush print supplies each shot printed with optimum exposure, i.e., as it will appear in the final film.

Over the days, weeks and months, you work with the film editor to cut the film to your satisfaction. At the end of the process you have a finalized cutting copy which is much scratched and marked by its journey through the editing machinery. It is joined together with sticky tape, and is hardly a feast for the eyes.

## NEG CUTTING

After the final sound mix the film editor sends the cutting copy to a 'neg cutter' and arranges for the laboratory to deliver the negative there. Working in clinically clean conditions the neg cutter cuts the negative to exactly match the cutting copy. He does this with reference to the numbers that are printed every sixteen frames along the edge of the negative. They are printed photographically onto the rush print, and as every roll of negative has its own individual code there is no danger of a mismatch. These numbers are called 'key numbers'.

Once the negative has been cut to match the cutting copy, it is sent back to the laboratory for a print. Before this print is made, the negative is examined shot by shot by a grader. The grader judges how much exposure is required to obtain the best quality from each shot, and what colour correction is needed for each shot. The grader is an extremely important link in the production chain. If shots taken on different days and different weather conditions have been edited together in one sequence, the grader has his work cut out to make it look like a continuous piece of photography. The first print from the newly-cut negative is called the first answer print. This is because the laboratories require an answer from the film editor and the director that everything is satisfactory. If there is anything wrong with the print – perhaps one shot might be inexplicably all green – the editor tells the grader and they try for a second print. The grading information is kept on a computer tape or floppy disc, and this is easily updated with the necessary corrections. Usually the second print is perfect.

If the film contains scenes of a particular mood, it is much better for the editor or director to visit the laboratory and watch the first answer print through, along with the grader. This is not done often enough in television; but if the director can spare the time the results are always well worth while. The computer records of the final grading are stored with the negative, so any subsequent reprints are guaranteed to be the same. The final accepted print is known as the show print.

## SHOW PRINTS AND TRANSMISSION

The electronics of the television image require the film image to be lower in contrast than looks best in the cinema. For this reason, there are two types of show print stock available, low contrast for TV, and high contrast for projection. A laboratory receiving an order for a show print from a television company will automatically print it on low contrast stock, unless instructed otherwise.

Nowadays, all films are transmitted from tape. The show print is transferred to tape in advance of transmission. Even if there are no video effects to be included at this stage, this process allows the film image another series of shot-by-shot correction to make it ideally suitable for electronic reproduction. As this process ('digigrade' in BBC terminology) allows for colour and exposure correction, it is very common nowadays for the production to accept the first print from the laboratory and make any further adjustments at the digigrade. Obviously, this does not apply to film intended for projection.

## OPTICALS

Until the early sixties all films were neg-cut on one single reel. When sound in film was introduced in the late twenties, the American Academy Of Motion Pictures designed the Academy frame. This made space for the sound track, but also incorporated another important innovation, a wide frame bar which permitted invisible negative joins. The industry continues with the standard on 35 mm up to the present day. When a post-production effect was required on film (known as an optical), then the various elements from the original footage had to be rephotographed and combined in the optical printer. A crude but useful analogy for an optical printer is a projector lens pointed down a camera lens. If you bear in mind that there must be negative for every effect in the final show print, the following will make better sense.

For many years picture mixes, wipes, superimpositions, telescope masks etc., were all made in the optical printer. For a picture mix the negatives of the shots to be mixed together were sent to the optical house and (in the days of black and white) a fine-grain positive print was made from each of them. The fine grain of Shot A was laced in the projector side of the optical printer, and raw negative stock in the camera side. Using cues supplied by the key numbers indicated on the original negative by the film editor, the fine-grain shot was run through locked in synchronization with the camera side of the printer. At the appropriate point, the projector lamp was faded out. The negative in the camera side was wound back to the start and the projector side of the printer re-laced with the fine grain of Shot B. At the point where Shot A was faded out, Shot B was faded in. When the negative in the optical camera was developed, it contained an image in which Shot A mixed to Shot B. A print was struck

off the negative to be cut into the cutting copy, and the optical negative was kept safe until it was needed by the negative cutter.

For many years this method of producing an optical negative by way of an intermediate fine-grain positive was the only procedure available. Indeed, when I started work in the cutting rooms at Ealing Film Studios in the mid-sixties, the first thing an apprentice assistant editor had to learn was how to order mixes using the key number references needed for the fine-grain stock. Things were to change, as television used more and more 16 mm film. The reason for the first change was that the wide frame bar on 35 mm film facilitated invisible neg joins. The negative was cut on a single reel, like the cutting copy, and there was no problem. 16 mm, however, has a very thin frame line, and a negative that was cut on a single reel had very noticeable neg joins. These appeared as bright white lines at every cut on the show print, and this effect was unacceptable.

## CHEQUERBOARD NEG CUTTING

The solution to the problem was the 'chequerboard' neg cut, which has become standard practice on 16 mm film. A chequerboard neg cut has the negative for each reel of cutting copy made up into two reels of negative. For the first shot of the film, the negative is on Roll A with equivalent black spacing on Roll B. At the first picture cut, the negative is joined to Roll B and the black spacing to Roll A. This procedure goes on to the end of the reel until the final cut negative is on two reels with alternative negative and black spacing on each. The advantage of this elaborate procedure is that the neg join is made into the dead area of the incoming black spacing, so the negative join becomes invisible – just as it would be on 35 mm. This was the original reason for the invention of the process, but another advantage was realized very quickly. If the negative is on two separate reels which are combined in the printer to make a single reel of show print, then mixes can be made in one step at the show print stage. All that is needed is for the film editor to mark the cutting copy with the appropriate marks to indicate the length of the mix, and the neg cutter overlaps the negatives on Rolls A and B at the point where mixes are required. The printer making the show print is cued by the grader to cross-fade from Roll A to Roll B at the mix points and an otherwise complex and expensive process is immediately made cheap and simple. All film mixes are now made in this fashion; a simple mark on the cutting copy is all that is needed. However, it is *only* mixes that can be made from the chequerboard negative. Other optical tricks such as wipes and title superimpositions still require an intermediate optical stage. The fine grain of the black and white era is called an interpositive, if you are working in colour.

## INTERNEGATIVES

Any intermediate stage involves an extra generation, with consequent loss of quality. It was for this reason that the 'colour reversal interneg' was developed in the early seventies. It was realized that for many optical effects such as freeze frame, reverse printing and changes of speed, there would be huge advantages in being able to make a negative directly from the original negative in one process. A 'reversal' interneg in fact. This is how it works. Assume you want a freeze frame. The negative of the original footage is laced in the projector side of the optical printer, and colour reversal interneg stock (CRI) in the camera side. The original negative is run in synchronization with the CRI until it comes to the frame that requires freezing. Then the original negative stops, but CRI continues to film, receiving the stopped frame over and over again. The CRI is processed to its negative image, and so in one step the optical department have achieved the freeze frame required. It is not difficult to imagine that, by running the original negative at different speeds forwards or backwards, a host of other effects are available.

So, quite suddenly in the early seventies a whole area of optical effects became much simpler and cheaper. But not every effect can be achieved so simply. Even directors who only want a nodding acquaintance with the complexity of film opticals should appreciate that many effects still require the full procedure involving a colour interpositive. These are always effects that require one solid image to be combined with another. Titles against a moving background are a good example. To understand this you need to remember that film works in terms of negatives and positives, and that an area of white on the positive (which lets a lot of light through) is black on the negative and, therefore, lets no light through. It is, therefore, much easier to print another image into a white area of a shot than into a black area.

## OPTICAL TRICKERY

One of the best doubling tricks I ever achieved made use of this. On screen, the audience saw Dick Emery as a British officer standing next to a large mirror. In the mirror we could see the reflection of a German officer (also clearly Dick). In the foreground, back to camera, we could also see the officer, whose reflection was in the mirror. The trick was easy to shoot and not very expensive to achieve. In reality, Dick, dressed as an English officer, stood by the mirror, and his double, dressed as the German Officer, stood back to camera. The mirror frame was fitted with white cardboard. This was heavily lit by the cameraman, so it would be a full black on the negative. It was, therefore, a comparatively easy process for the optical department to print into the mirror a shot of Dick as the German officer to make the apparent reflection. This shot had been specially framed by us to be in exact register. The important lesson

learned here is that if you get a half-good idea, you need to consult the experts. I would have instinctively fitted the mirror with black card! Fortunately I asked the optical department for advice before the shoot and they told me that as they would be combining negatives, they wanted the mirror fitted with white card (black on the negative). Ever since then, I've always consulted an optical department before trying an adventurous bit of film trickery. Basically, you need to know what the optical department requires, and make sure you shoot the original footage according to their needs.

The business of blacks being white on the negative (and vice versa) can give unfortunate effects on the A and B chequerboard mixes described above. In the old-fashioned mix method, mixes always behaved as you would imagine them, because the mix was achieved via a fine-grain positive. Now 99 per cent of all A and B mixes work well; but they work best if you are mixing images of similar density. If you are mixing from the wagons rolling across the prairie to the camp fire at night, you are in for a surprise. An A and B mix will let the black sky through first (as it is clear film on the negatives) and the camp fire through last (because it is black on the negative). This is the reverse of what appears logical; it also looks ugly. These day-scene-to-night-scene mixes are the one disadvantage of A and B mixes.

After reading the above, you will probably be relieved to learn that on video you can see the effects as they are generated, and no longer have to wait several days or weeks until the optical department deliver what you hope will be the correct result. Video effects are now so sophisticated that a number of film-makers have been tempted to create the special effects on video, and then have a film negative made for inclusion in their neg cut. As I mentioned above, 'Back To The Future II' took this (in my opinion) disastrous step. Video transferred to film always looks poor in comparison with images originated on film, and one of the worse aspects of 'Back To The Future II' is that you could tell that an effects sequence was coming up as soon as a low-quality shot hit the screen. Film opticals themselves never have the same quality as the original footage. This is why it is always best to dupe the optical footage right from the start of the shot, even if it is several expensive feet before the actual effect occurs. We've all seen low-budget feature films on TV where this hasn't been done. Just before a mix or wipe the picture changes quality, (in colour, often violently) and then the mix/wipe occurs. As the purpose of a mix is to supply a smooth transition from one scene to another, this cost-cutting lack of 'duping through' was self-defeating. Incidentally, this fault is only seen in films made before the A and B mix process was introduced.

My colleague Rodney Greenberg tells me that on his recent concert recordings in high-definition TV, there is a problem in the middle of every mix, which is at present something inherent in the system – perhaps nothing changes.

# VIDEO EFFECTS

If your programme is intended for television or home video, then you are best advised to generate the post-production video effects on tape. If you shot on tape, then this is automatic, but if you shot on film, it is still worth considering. A lot of films made for television have their flashy opening titles made on film, but the end credits are frequently done on tape. As long as the film is to be viewed on television, i.e. played as a tape, then my 'Back To The Future II' objections don't apply.

Video effects are numerous. The latest equipment can make pictures twist and metamorphose in a way that would be endlessly time-consuming and expensive if executed on film. The obvious point to bear in mind is that bernaise sauce, however good, won't make a gourmet dish out of a pot noodle. Although visual tricks are suddenly available as never before, they should nevertheless be used with discretion.

If you are editing on tape, then there is a tremendous advantage in the immediate availability of mixes, freeze frames, wipes and title supers. Any requirement to combine images will need a three-machine edit suite. An image from Machine One is combined in the vision mixer with an image from Machine Two, and the mixed signal recorded on Machine Three. The medium-range editing suite most often has a Grass Valley mixer which allows a range of effects, but should you want the images to turn somersaults and vanish up their own trouser legs, then you will need a more sophisticated suite armed with the latest digital acronym (Charisma, Harry etc.). These devices are booked by the hour and are expensive.

# EFFECTS SPECIFIC TO FILM

For all the brilliance of video trickeries, there are still two very useful effects that are better achieved on film, namely under- and overcranking, and reverse printing. They work best on film because they are less detectable and thus serve the directors intention better.

## Under- and overcranking

Film is projected at a constant speed. Nowadays this is 24 frames per second (fps) (25 on television in countries with 50 Hz mains supply). If film runs through the camera slower than 24 fps, say 12, it will still be shown at 24 fps, so the projected picture will seem twice as fast. If the film is shot at 75 fps it will still be shown at 24 fps and so appear at a third of its normal speed, i.e. in slow motion. It is the physical character of the film image that allows for under- and overcranking to work so well. The slow-motion camera actually records more information at 75 fps than at a mere 24 fps. Video slow motion is achieved by slowing down the original

information – it is the equivalent of filming at 24 frames per second, and then having the optical department print every frame three times. You get slow motion, but without the fluid look of real slow motion originally photographed at 75 fps. It is thus possible on film or video to change the speed, make it faster or slower, after the original shooting; but on film you have the opportunity to under- or overcrank at the actual time of shooting. This is not only cheaper, it is far superior. You should be aware, however, that only some 16 mm cameras can overcrank. The Arriflex will run at up to 75 fps, which gives a good slow motion, but some Aaton cameras still in use will not run faster than 32 fps. If you are working on film and you want to change the speed of the action by under- or overcranking, it is as well to shoot some tests before deciding on the frame speed you need. When wishing to create the silent-movie look, most cameramen suggest much too low a speed, for example 16 fps, which will make the action look ridiculous: 19–20 fps is usually slow enough. Remember that if you are undercranking to make action such as a chase look more exciting, you have to be very careful not to overdo it, and give the game away. Action is very sensitive to overcranking, and good examples of this fact can be seen in Errol Flynn swashbucklers when they are shown on British TV. The fights (shot at 21 fps) look believable in the cinema, shown as they are at 24 fps, but on TV at 25 fps they are pushed over the edge, and have a whiff of farce about them. The small percentage difference between 24 and 25 fps really does make a serious difference, and I mention it to reinforce the point that undercranking can produce unpredictable effects and is well worth a trial to determine the best frame speed for your particular circumstance.

Overcranking above 75 frames per second requires a specialist camera, and is usually reserved for scientific analysis. Explosions benefit from overcranking, and all model shots require a high framing rate. The problem is that the faster the film travels through the camera, the less exposure it receives, so shooting at 150 or even 300 frames per second requires wide apertures and a lot of additional light. One trick worth bearing in mind for model shots is to film at 75 or 100 fps (which still allows for a reasonable exposure), and then get the optical department to print every frame twice. The resulting CRI will have the apparent speed of 150/200 fps. The shot will not have required an enormous amount of extra light, and because the original negative was already overcranked, the 'step printing' to 200 fps will still provide smooth action. (Step printing, i.e. every frame twice, or three times, from an original of 25 fps, does not look smooth; it looks just like slow-motion video and is, therefore, a pointless expense).

Undercranking halfway into a shot is a very useful trick, again achievable seamlessly on film. Imagine a two-shot of two duellists. There is dialogue before they start their swordplay. Obviously you cannot undercrank this shot because of the dialogue, but the result is that the swordplay looks too slow. Of course you could cut almost immediately to some fight footage that had been slightly undercranked, but there is

another solution. The optical department could supply you with a CRI negative that was printed at normal speed at the start of the fight, but from the sword play onwards was step-printed, missing out every second frame. This would give an edge to the action that was missing from the original version. Remember that if you tried to alter the camera's speed when you actually filmed the scene, there would be a change in the exposure as the camera slowed down, and this would be difficult, if not impossible to disguise by pulling aperture.

*Reverse printing*

Reverse printing is the other useful trick that is more effectively achieved on film. The arrow just misses the heroine as it 'thunks' into the tree by her head. The hero rolls out of the way as the axe crashes past camera. These desperate deeds and many like them are safely and easily achieved by reverse printing. The arrow is pulled out of the tree on a piece of fish line, and the actress performs her looks of shock and relief backwards. When the shot is printed forwards, it looks genuinely dangerous, and you don't notice the fish line because you don't expect to see it at the wrong end of the arrow! Reverse printing is quickly and easily achieved on film, and is much better left to the optical department. It is possible to achieve the effect by mounting the camera upside-down, and then cutting the shot the right way up in the cutting copy. This assumes that you are using double-perforated negative stock. Altogether it is a lot of messing about, so the wise director shoots the reverse action as normal, and hands the negative to the optical department for a reverse-printed CRI. The cost is comparatively small because reverse shots are usually quite short. It is a good idea to keep reverse printing in the back of your mind, as it can solve problems that at a first read of the script seem insoluble.

I once directed a comedy which centred around a fantastically powerful hair restorer. One scene had a bald man seated in front of a group of academics. The mad doctor then poured a few drops of the restorer on the man's head, and it immediately started to grow hair; at least, that was what the writer wanted. We achieved this intention by using reverse printing. A model of the back of the man's head was made with hairs that could be pulled back inside it. When the shot was printed backwards, a bald head suddenly sprouted a profusion of wispy hair. It was a startling – even revolting – effect, but it got a big laugh.

## ADVANTAGES OF VIDEO

Even the most dyed-in-the-wool film enthusiast has to admit that apart from undercranking, overcranking and reverse printing, all visual tricks are more speedily and easily achieved on video than on film. The ability to

freeze frames, use shots for a second time, and superimpose video graphics, is the bread and butter of corporate video production, and would be desperately uneconomic to attempt on film. Remember that on film if you do need to use a shot twice you can't just print up a shot from the original negative for the second time. You need a negative of that shot, so in fact you make a copy negative (CRI) from the negative of the required shot, and then edit in a print from the copy (dupe) negative. No such problem exists on video – the shots can be repeated from the master original. In the same way as it is wise to check with an optical house before you shoot a complicated effects sequence on film; it is also wise to plan to check with the facility house as to whether your video-effects ideas are achievable. Nowadays, almost anything is achievable if you have all the latest video computer hardware; but not all editing suites are so lavishly equipped. If you are paying a modest amount for your on-line edit, some of the more spectacular trickery may not be available.

The standard suite will have a vision mixer control in addition to the edit control. This will enable a range of useful effects, but again nothing in the pop-video scale. The range of effects you have a right to expect from the standard video edit suite are:

1 Freeze frame
2 Posterization
3 Credit superimposition with a choice of fonts
4 The ability to colourize these letters
5 Picture mixes and wipes
6 The ability to quarter-frame the image
7 The ability to inlay one shot into another.

After that basic but very useful range, additional effects may require the use of additional bolt-on goodies, with consequent additional cost. All the video effects described above assume a three-machine editing suite. Two play-in machines and one record machine are required for any effect involving the combination of two picture sources (mixes, wipes, inlays etc.). If the images you wish to mix together are on the same tape or cassette, then one of them will have to be lifted on to another tape/cassette in order that it can be played in from the second machine. On Betacam D3 and 1 in tape this is not much of a problem, as you don't lose much quality by dropping a generation. If you are working on a non-broadcast standard (like low-band U-Matic) you will notice the difference. In such cases, the wise director ensures that the shots to be mixed are originated on different cassettes. Frankly, if you've got a lot of shots to mix together, it is as well for them all to be on separate cassettes, whatever the standard you are working on. Using the original will always give you the best quality, and you will save time by not having to copy off a load of shots.

If a sequence is likely to contain mixes, the director is best advised to hold shots long enough to allow for the time it takes for one image to mix to another. If you are taking shots of stained glass windows, or

architectural detail, you may well feel that you might want to mix rather than cut, when it comes to the edit. If a shot involved a move (panning from one window to another for example) hold the shot at either end of the pan to allow for a mix in and a mix out. The more difficult routine is to remember when a shot in a drama is likely to be the end shot of a sequence, which may be used as part of a mix to the next scene. Again, you need to hold the shot 'long' before you say 'cut'. A slow count to five is sufficient. Generally, there is no advantage in saying 'cut' too soon at the end of any shot, as to do so will limit the post-production opportunities in both sound and vision. When the action has played to a satisfactory close, count slowly to three before you say 'cut', even if you have no intention of mixing. If there isn't enough footage to allow for the mix or fadeout that you desire and you are therefore in difficulties, you might consider freezing the frame to allow for the effect. This is possible on both film and video, but is much more easily achieved on video. It is not an ideal solution, as a freeze is noticeable even if it occurs well into a picture mix. Video freezes look strange because the visual noise on the picture freezes with the action. Even so, one maverick use of the freeze is to use it on a static establishing shot if the camera was hand-held, and the shot consequently wobbly. As long as there is nothing in the frame that you would expect to move, this can look preferable to an otherwise unsteady shot.

Half-frame and quarter-frame facilities available from the Grass Valley mixer are very much part of the corporate or instructional video scenario. Again, it is best to know at the time of shooting which images are going to be combined in this fashion. They can then be framed appropriately. An image to be quarter-framed needs to be bold if it is not to look insignificant when reduced to one-quarter of the screen area. Obviously, big close-ups will work best.

## TITLES AND GRAPHICS

The corporate video usually has a fulsome requirement for on-screen graphics. The 'points to remember' on which the client insists must be spelt out, literally spelt out, on the screen. For example:

- Look your client in the eye

- Speak positively about the product

- Never appear desperate

It is rare for a corporate video not to reach such a visual nadir at some point. The video freeze can at least go some way to alleviate the situation. If the exhortations written on screen are backed by a freeze frame from an appropriate scene, they look less aggressive: and if that freeze frame is

posterized, or combined with a stippled background, or both, the effect can be almost pleasing. As to the colour of letters for titles and subtitles, both film and video offer a wide choice, but yellow or gold is undoubtedly the favourite. It is a colour that reads well against the majority of backgrounds, and also looks clear if reproduced on a black and white monitor. Red is a colour to avoid if you are working on video, as it doesn't read at all well on black and white, and worse still bleeds very easily after a generation or two. Red works well on film, but because of the problems associated with video, it should be used only on a film primarily intended for cinema projection. As far as coloured letters on a plain background are concerned, gold against blue works very well on both film and video.

The more elaborate video effects such as Harry and Charisma are expensive. If your budget is restricted, the wisest plan would be to assemble your on-line leaving room for the effects and then to add them all at one fell swoop. In that way you maximize the use you get for your money. Elaborate video effects are now so much a part of everyday viewing that there is a danger that the audience will be less impressed with the effects than the director or producer. The more disciplined the use of such effects, the more effective they become. If every shot change has the images spinning into space in the shape of a teacup, telephone or tank (dependent – of course – on whether the sponsor was Liptons, BT or the Ministry of Defence), then these transitions quickly lose their potency. If, however, one effect comes as a dramatic punctuation after a sequence of straight cuts then it *will* make an impact.

*ADO effects*

Most facility houses' on-line suites have an ADO effects box as part of their package. This uses analogue technology to achieve a wide range of effects. As it comes as part of the editing suite package, a director working on a small budget may choose to use only ADO effects. However, the digital systems are necessary if a truly three-dimensional animation is required. It is these digital effects that are best generated at a separate session, and then dropped into your final cut.

Whatever the medium, film, tape or 'systems still to be invented', it is an invaluable habit to have frequent reviews of the edit for when you are cutting a programme together. This seems to happen more often on film than on tape, probably because the pressure of time in a cutting-room usually seems less than those in a video suite. This may be simply because film cutting-rooms are booked by the day or the week, whereas video editing is charged for by the hour. Whatever the reason, it is all too easy to judge video editing cut by cut, rather than sequence by sequence. This in itself can result in a competent but wooden look in the final cut. Rhythm and pace are concepts that are almost impossible to memorize as you plod from one cut to the next. The greatest favour a director can grant himself is

to make frequent excursions back into the edited story, and check that all is well. I would guess that whatever developments occur over the next fifty years, this will always be true.

# Music

## HISTORY

Music as an accompaniment to moving pictures is as old as the cinema itself. In 1897, when the Lumière brothers commenced exhibiting their films to the public, they hired a saxophone quartet to play along. When Britain's first cinema opened in 1901, a 16-piece orchestra was engaged. This was the Mohawk Hall in Islington, and the Fonobian Orchestra was conducted by a Mr W. Neale. Ten years later, Sir Edward German was paid 50 guineas for music to accompany the film 'Henry VIII'.

The stereotype we carry of silent movies being viewed to the sound of a jangling piano is very far from the truth. It is true that in the twenties the small bioscopes could only run to a piano, but the city-dwelling cinema-goer would have been disappointed if the film were to be accompanied by anything less than a small orchestra. It is odd to realize that at the height of the silent era the Hollywood studios all had large music departments. As well as providing the music on the set, which was supposed to help the actors find their moods, these departments also prepared the scores for the cinema orchestra to play. When the cans of films were delivered to a cinema a reputable distributor would also supply a set of band parts.

Shortly before she died, I had the good fortune to speak to Mrs L. Bridgement. She had been a cellist in the silent era at a cinema in Leicester. She told me that she had been paid an extra 1s 6d a week for operating the 'stoll'. This was a pedal that moved an indicator on each musician's stand and told them when to cut to the next piece of music. The synchronization of live music with intercut sequences of love scenes and chases owed everything to musicians such as Mrs Bridgemont watching the screen and zealously operating the stoll. I also learned that cinema orchestras frequently played popular songs as part of their accompaniment, and when they did so the audience would often sing along. I include this as a point of interest. I had no trouble in accepting her confession that the bands seldom played the music supplied by the film companies, as this was often too difficult or arranged for a different ensemble. Most bands preferred to busk. Busk or not, I doubt if many

silent-moviegoers were short-changed. The music supplied by the studios was usually a pretty rough canter through the classics with scant regard for the original composers' orchestration – and some fearsome segues to attempt a match with the picture.

If you look at some really early talkies (c. 1930–34), you can get a good idea of what some of these scores were like, as the accompanying music is the work of the same hacks that were knocking them out in the twenties. A film called 'The Black Cat', starring Boris Karloff and Bela Lugosi, and made by Universal Pictures in 1934, is a good example. The film has nothing to do with the Edgar Alan Poe story, and the music score has nothing to do with anything that is happening on the screen. Huge chunks of Brahms's Second Symphony are delivered to such bizarre effect that you honestly do begin to wonder if the orchestra is perhaps in the next room. At one point, when the hero and heroine decide to leave the ghostly castle, a pastiche of Tchaikovsky's 'Romeo and Juliet' is played, sounding so inappropriate as to beggar belief. One explanation of these inappropriate accompaniments is, of course, that the infant talkie was seriously lacking in sound effects. The early optical sound recording systems could only manage a mix of three soundtracks, and the music was therefore expected to fill in a lot of holes. Even the excellent early gangster films of James Cagney have some noticeable economies of realism in their final sound mixes. Car effects and gun shots are present as their absence would be just too obvious, but a lot of the lesser effects (footsteps, door catches etc.) are absent, and their absence is disguised by the music.

Now, whatever else they were, the Hollywood moguls weren't fools. They quickly realized that this sort of thing simply wasn't good enough. RKO in 1931 and Warner Brothers in 1935 hired the two most talented composers to arrive in Hollywood. The Austrian, Max Steiner, and the Czech, Eric Wolfgang Korngold, had both left behind careers of huge promise in their native countries, but were to gain even more fame creating the Hollywood sound. More than any other composers, these two men brought a previously undreamed-of understanding to the writing of film music. Korngold's first job was to adapt Mendelsohn's music for 'A Midsummer Night's Dream' for Max Rheinhart's version of the play. This was made for Warner Brothers in 1935. In some ways, this score was very much in the bad old tradition, but when Korngold was given his head in late 1935 with 'Captain Blood', and even more impressively with 'The Adventures Of Robin Hood' in 1936, he set a standard which is still a yardstick of successful screen musical composition.

Korngold's musical style had its roots in Wagner through Richard Strauss. He approached the writing of a film score in a very operatic fashion. One could argue that he regarded the action set pieces as arias, and the dialogue scenes as recitative. 'The Adventures Of Robin Hood' is a masterpiece of film scoring, and as it is frequently on television, it is well worth recording and analysing the musical effects. The music is often

very loud, but it is always complementary to the pictures. The quiet sections that murmur behind the dialogue are scored for smaller resources, but they are never dull. These are two very important points for the user of film music to understand. When Disgusted of Tunbridge Wells writes to complain about the blaring background music that destroyed his enjoyment of an otherwise etc., etc., in fact he is not complaining about the level of the music on the track. He is complaining that his attention was distracted by the music, and that was in fact the reason it seemed too loud: it only seemed loud because it was inappropriate. Had it fitted the mood and the action, then there would have been no complaint. The classic Tom and Jerry cartoons are a good example of this. The best of the series have no dialogue at all, and very few effects apart from the odd scream of pain from Tom. 95 per cent of the soundtrack is the music, but Scott Bradley's scores are so well-matched to the images that it is impossible to separate the pictures from the music.

The second essential for good film music, the other quality that Korngold perfectly understood, is that even when it is quiet, and held under dialogue, it must never be so harmonically and thematically dull as to distract the audience by its lack of invention. Seventies cop thrillers like 'Starsky And Hutch' and a host of lesser horror films have this fault in excelsis. The sequence is supposedly tense as our hero searches the deserted car park for the killer, or our heroine unwisely ventures into the forbidden east wing. If all the orchestra can provide at this point is a series of uncharismatic staccato poops from the brass, interspersed with a bass clarinet descending in a diminished seventh, the director can reasonably argue that he has not been well served by the composer. So why does it happen, and where does the director of film television or corporate work find the music for his production?

## FINDING MUSIC

The first obvious source is from discs, commercial or mood. The most important thing to say about using commercial discs is that they are heavily protected by copyright, and permission for their use is entirely at the discretion of the recording company. There will be some records for which you simply won't get clearance. Classic jazz of the fifties and sixties featuring artists like Charlie Parker, Dizzy Gillespie and Charles Mingus is particularly difficult to clear and are best not contemplated; sad, but true. The copyright clearance problem also means that if you want to use a well-known symphony or a film then only a limited number of performances will be available. You are unlikely to get clearance on the very latest digital recording of Mozart's 40th, but that is not too much of a problem as it is a much-recorded work, and there is likely to be an older recording available that is possible to clear. As far as themes are concerned, you will have much more luck with 'cover versions' of the original sound track recordings. As television becomes 100 per cent

stereo, this will prove an increasing problem, as most of the recordings that are easily cleared are old mono re-issues.

It is as well to know that one factor that influences clearances, and the fees you may be charged, is the size of the intended audience. A small documentary destined for one transmission in the United Kingdom, with no plans for foreign sales, will have a much easier time negotiating copyright clearance than a major drama aimed at a world-wide audience. Even so, the director of the small documentary must be aware that the music track alone could make the film unsaleable if there were to be a sudden unforeseen interest from a foreign television company. The makers of short items for magazine programmes and late-night current affairs programmes can be pretty sure that their films will only ever receive one UK transmission, so they can afford to be cavalier in their attitude, but other programme-makers really ought to think very carefully before consigning their production to limbo simply because of the music they have included.

Aside from these very practical considerations, there is an artistic point to consider. The use of great music has dangers of its own. A piece of well-known, well-loved music is rich in associations for everybody who hears it – but they are never going to be the same associations. You could trigger a whole host of complex reactions in your audience and inadvertently distract them from the argument of your film. If Mozart's clarinet concerto starts up under commentary, and this promotes a discussion in the drawing rooms of the country as to whether it is Mozart or Weber or Schubert's Unfinished Symphony, then the music isn't working for you. There have been many films that have made effective use of music originally written for the concert hall. 'Brief Encounter', with Rachmaninov's Piano Concerto No. 2 is an obvious example. Even so, it is as well to remember that music that was composed to be listened to in its own right is unlikely to be ideal as an accompaniment to a film.

## MOOD DISCS

The purpose of the mood disc companies is to solve all the problems associated with the use of commercial discs. In the 1960s there were only about two mood discs worth a listen: one was called 'Indian Attack', and the other one wasn't. That has certainly changed. There is now a huge range of music available, well recorded, well performed and intelligently composed. The sheer quantity of music available nowadays is something of a problem in itself. The director has to wade through huge piles of records, many of them with impenetrable titles such as 'Heart Attack' or 'Stain At The Bottom Of The Stairs'. The process always requires a great deal of patience before the musical nugget you are seeking finally reveals itself. There is a lot of good mood music, but there also is a lot of junk, and patience is essential. You should not be surprised if something entitled 'Underwater World' turns out to be ideal music for a séance.

The copyright problems of commercial recordings do not apply to mood music discs. The companies make their money by selling you the right to use their music in your productions. On completion of the production, you fill in a license form with the titles and durations of the music used, and return it to the mood music company. They then send you a bill. This can sometimes come as a shock, for though the fees for use of music in a corporate video may be modest, world rights on a piece which involves a large orchestra could cost several thousand pounds.

The strengths and weaknesses of mood music can be neatly demonstrated. The theme music for 'Mastermind' is from a mood disc; so is the title music for the 'News At Ten'. 'All Creatures Great And Small', 'Channel Four News', 'Grange Hill' and 'Give Us A Clue' are from mood discs; but there is a risk attached. You will have gathered that some effective music is available; but, of course, 'Mastermind' or 'News At Ten' have no proprietorial rights over the music – so if 'Spitting Image' wants to take the mickey out of 'News At Ten' or 'Mastermind', the music is equally available to them. I mentioned 'Grange Hill' and 'Give Us A Clue' simply because, when they started transmission in the same week in 1978, they had both coincidentally chosen the same piece of mood music as a title theme. Therefore, lack of exclusivity is a problem. You could find that two weeks before the transmission of your uniquely sensitive documentary, the music you chose with such care is associated in everyone's mind with a toilet roll commercial. Another problem with mood music is that although some discs come with theme and variations, it is very unlikely that you will find sufficient 'moods' of one particular theme to supply the full range of musical expression required for a series. All too often, the mood composer feels obliged to add a distant trumpet or tinkling glockenspiel to the repeated section, and this ruins an otherwise suitable track. The danger of working blind is that the composer often thinks that he is not giving full value unless the orchestration gets busier as the piece progresses. The result is a piece of music that stands on its own, and not a piece of *incidental* music.

These are points to consider if you decide to plump for mood music. There is good work there to be used, but the more time you allow for research the better your results will be. Much as I would extol the advantages of employing a composer to supply a specially-composed scene, there is no doubt that there is a very real advantage in having your music available to you at the start of the editing process. Mood discs provide this facility, and the wise director takes full advantage of the fact by selecting the music well in advance of the edit.

## WORKING WITH A COMPOSER

The way to ensure that your production has music which is suitable and individual is to employ a composer. Many producers shy away from the

idea, imagining that the cost is going to be enormous. This needn't be the case if a few simple procedures are followed.

The first task is to find a composer, and the best way is to ask colleagues who have recently used one for a recommendation. Alternatively, make a note of the names of composers whose music you like, and whose work you know from the television. If you then contact the producer of the programme that you liked, you will be able to gain the telephone number of the composer or his agent.

Composers get paid by the minute for this type of commission. This is important. Don't imagine that some sort of taximeter is set in motion as soon as you speak to the composer. The greatest mistake is to wait until the last minute, two days before the dub, and then phone up a composer in panic. The music score for your film will be as good as the composer's waste paper basket is full. The sooner he gets to work on your project the better. You pay for the minutes of music composed, so there is no advantage in delaying the contract until the last minute. However, if you commission fifteen minutes of music, and use only five, you will still pay for fifteen.

The sooner the composer is hired and working the better. The more time he has to consider the main title theme the better; as soon as a composer knows the content of a play or documentary, that is the first and most important piece of composition to consider. The subject of the film is enough information at this early stage. For example most TV films have 25–30 seconds of opening music, and end credits that run 50 seconds with an option on 1 minute 10 seconds. As soon as he is engaged, the composer will start to work on framing a suitable and, with luck, memorable theme for your production.

Cole Porter once said that the only inspiration he ever needed was a phone call from a producer. So don't be too flattered if the composer jumps at the chance to write the music for your film. But at that very first discussion, spell out your music budget. When the composer knows how much you have to spend, he can immediately evaluate the size of the ensemble that you can afford. A film about Edwardian gardens might easily be scored for small resources – flute and piano, clarinet, flute and piano, or flute and harp – but a documentary about the rise of the Third Reich plainly requires a fuller and more aggressive sound, so a modest music budget would be a test of the composer's ingenuity. Even in this case, though, a pipe organ (real or sampled), two trumpets and percussion might well provide the fullness of sound required for such a subject.

The ingenuity of fitting musical requirements to budgets is something that comes with experience, as is the knowledge of how to contract the musicians in such a way that all the union regulations are adhered to, but the production still gets maximum value for money. The experienced composer will be happy, indeed happiest, to act as musical director for the recording sessions, but if you choose to use a composer who is new to film, then it might well save money in the long run to employ an

experienced musical director to conduct the band and advise as to the contracting of musicians.

Television companies have very different individual agreements with the Musician's Union, and these agreed terms require close scrutiny. One company may pay very little extra money if the first music session also includes the title music for the series, other companies may pay 100 per cent of the fee again. If the composer is unaware of such matters you could be landed with a bill that was twice as big as expected. If you record the music for more than one episode of a programme in one session (say music for episodes 1, 2 and 3), you will pay the musicians a larger fee, but this is much less than three times one session fee. It is, therefore, a wise plan to work out a strategy of recording with your composer, so that a series of ten films involves no more than four music sessions. Such strategy is another good reason for involving the composer as early as possible in the production.

Ideally, then, the director should contact a composer as early in the production as possible, certainly no later than the commencement of the editing. The composer should be given a budget within which to work, and should be told the general outline of the film. As soon as you have any sort of a rough cut, bring the composer in to see this, to talk with you and the editor (assuming you are working on film). At this early stage you can discuss where music is required in the sequences already assembled, and perhaps you will have some idea of further musical requirements, e.g. a duel in Episode Three, a horse chase in Episode Five. All this is useful information for the composer, because even if there are no timings available yet, it provides a spur to sketch out a few suitable themes. You will have to pay for the composer's time to bring him into these meetings, but I believe it is very much worth while. It is far better for the composer to feel part of the creative team than to sit at home watching a none-too-brilliant VHS copy of the programme.

At this initial viewing, there may be some sequences which you are confident will not change, and so the composer can steal a march and go home with some final timings. The composer may suggest that one particular sequence really provides a lot of opportunity for music, and if this hadn't occurred to you, that will be something to discuss. The composer and editor working as colleagues can often be of great use to each other. If a sequence has some particularly good sound effects, the editor might suggest that this sequence is better without music, or on the other hand, if a sequence has sound problems the editor might request music to paper over the cracks. Such conversations do take place, and a good film composer regards the composition as a part of the whole production process, not a creative entity in itself. You have every right to expect a demo tape of the theme the composer has in mind, and nowadays the amount of electronic toys available means that this should be something rather fuller than the tune picked out on the piano.

You need to be confident in the music even before you hear it. It is all too easy to edit a documentary so tightly that there is very little room for

the music to assert itself. This is the one danger in working with a composer that does not occur when you are using mood discs. If the music is available from the start of the editing process, then it will be only natural to allow the music a ten- or fifteen-second burst before the commentary comes in. There may even be a music sequence of some fifty seconds or so. This will hold because of the music. The danger when the music has yet to be written is that an anxious director and inexperienced editor won't allow that fifty second breather, because without music it all seems too long. Then the poor composer is given too little opportunity to make a proper contribution. Films and documentaries especially need these 'breathers', so have faith and leave room in the construction of the piece for the music to have its full effect.

On a series you might decide to record a piece of music in an early session which you know you will need in Episode Ten. If the composer is asked to write fifty seconds of music for the sea battle or whatever, then it will be there available for the editor to cut to, and you have the best of the two worlds of mood and specially composed music.

So the diary of events for the composer, once he has agreed to work on your production, is:

1 To start thinking and sketching as soon after the initial conversation as possible
2 To visit and see a rough cut, getting as much of an idea of the production as possible, maybe come away with a few fine timings
3 Return to see the fine cut, and take a list of exact timings. This may be done at home on VHS. Composers vary in their choice. On a series, these visits need not be one per episode: three episodes at a time is preferable.
4 Composer works writing music to fit the pictures. The score must then be copied ready for the session: copying alone takes a minimum of twenty-four hours.
5 The composer conducts the session, sometimes to picture, sometimes not. This varies, dependent on your budget, the composer's wishes, and the complexity of the music.
6 The composer returns to advise the editing department on the fitting of the music. Remember, the more time there is between numbers 1 and 5 on the list, the better your music will be. Obviously, the time between numbers 3 and 5 should be as long as possible. No composer can give of his best if you phone up on a Friday and are dubbing the following Tuesday!

## SHOOTING MUSIC

Shooting music with a single camera is a specialist area that the director of drama or documentary will be confronted with at some point in his career, so it is as well to be reasonably versed in the various procedures.

Attention to small technical procedures can greatly reduce the time wasted on location.

An elaborate music sequence will certainly involve playback. On film you will require two recording machines, one to play back, and the other to record a guide track. If the music to be used is from a disc or a pre-recorded studio session, then this must be transferred to a quarter-inch tape which is pre-pulsed to hold synchronization. Ensure the music has a count-in at the front, otherwise a clean start to the dance or mime will be difficult. This is often forgotten, and is one of those omissions that can cause irritation at the shoot.

On location the camera is switched to become a slave to the recorder, so the playback master is controlling the synchronization. On video you will need an additional recorder to the camcorder, and this recorder will play back the music from a pre-time-coded master. As you film the sequence the process is straightforward enough. You run the film camera and the guide track recorder (or on video the camcorder). The film is slated in the usual way, then you cue the music. The second recorder plays back the music and the artists dance or mime. The editor makes use of the guide track to learn what sections or shots fit to the particular bars of the music. There may be several shots, wide and close, that cover the same section of music, and only the guide track will reveal this.

It is sensible to allow the recordist time to mark up the master tape in various sections. This will save time and film as it is pointless starting the playback tape from the beginning once you are halfway into the music. Usually three sections are enough. The count-in is not needed once there is some music before the section you intend to film, as the artists can listen to a few bars and then pick up the rhythm/words. It is starting out of silence that is difficult, hence the need for a count-in at the front.

This process is repeated for all the shots. At the edit the film editor cuts the picture to match a magnetic film master, which was transferred synchronously with the master quarter-inch tape. On video, the time-coded music master is transferred to the edit tape so that the pictures can be painted into music.

The items for the production to remember are:

- Playback requires two recorders (or one recorder/player and one camcorder)

- A count-in must precede the music

- Film playback requires a pulsed quarter-inch master and a synchronous magnetic film master (only the quarter-inch is required on location).

Only certain transfer suites are equipped to provide playback masters, so check in advance. A safety playback master for location is a good idea in case of a 'rip-up'. If you are filming a live performance which you

intend to play back, with the shots mimed to playback, the same procedures hold basically true. You should go for a complete and uninterrupted recording of the work in sound and picture, and then use this as your master playback sound. Again, two recorders are useful, and if you have a camcorder, then the additional recorder is obviously essential.

Imagine that we wish to film a master playback shot of a pianist and a singer. What should this shot be? All too often the fact that it is the sound master produces a knee-jerk reaction in the director, so he asks for a two-shot of the singer and the piano (the visual equivalent of the traditional master shot). In fact, this is not the best plan. A close-up of the singer would be more sensible, because this master is the only shot that will be in sync; everything else will be mimed. The sync will show up much more in the close-up than the wide shot, so don't go for a wide shot just because it is a sound master you are shooting. The sync will be much less noticeable in the wide, so miming will be less critical. Don't forget the count in – the same difficulties of a clean and accurate start apply.

If you are really stuck, there is no doubt that a busked system of playback will work for short periods – 20–30 seconds. A good-quality cassette player will hold sync amazingly well if you want actors to dance on set in time with the music, it may well be all you need. However, real dance or singing can't be managed by this method. If you film dance to playback, then you cannot simultaneously shoot the sync sound effects. You may need a post-sync session to provide the feet noises, door effects or any other sounds that you would expect to hear. Tap-dancing is a prize example, because if the music is loud enough for the dancers to hear, then it will be too loud for the recordist to be able to record a clean 'tap' track. The tap noise will be badly coloured by the playback music, and the whole thing will sound messy. It is a sobering thought to realize that all Fred Astaire's tap routines were post-synched in the dubbing theatre with the great man wearing headphones and dancing on the spot.

Sometimes it is necessary to film a band or an orchestra with no playback at all: for example, a garden party with a brass band, or a section in a documentary about the school orchestra. This is never easy, but there are some helpful tips. First, make sure that you have a complete recording of at least one piece. Don't cut the recorder even if the cameraman goes in to grab close-ups. Start and end with a wide shot – but remember that the end of one piece looks much like another if it is loud and you cut to it on the last chord. Once you have a complete soundtrack, try to persuade the band to play the same piece again, and this time go for shots of the conductor and appropriate solo passages. If you have a good musical memory you can stand by the cameraman and prompt him to 'get onto the cornets as they are about to play a fanfare' etc. Shoot everything sync.

If the band co-operates and repeats a piece, you should get enough shots, but even if it won't or can't, then you can still take a host of close shots as they play another piece of music, and cut these into your original master. A piece of music that is of similar time signature and tempo is

obviously best (another march?). Close-ups of faces blowing, focus pulls from tubas to trombones, the drummer framed so we can't quite make out the rhythm he is playing, close-ups of the conductor – all these are useful shots which can be cut into the parts of your music master shot that are unusable because the camera was re-framing. The best of all, of course, is the audience and, at a garden party or fête, shots of children conducting along. The final trick is to make a music edit in the master recording to reduce it by about half. This neatly provides you with twice as many visuals, and if the music has repeated sections, the pictures from one section will do very well for another.

# Grips and tracking

The director whose shooting has long been confined to the tripod longs for the ability and budget to shoot with a dolly: to track, to jib or even to crane. It is always concerns about budget that convince documentary makers that they don't really need a grip, with all the wonderful camera mounts they bring in their van. This is a pity, because of all the technicians on the crew, the grip and the various basic tracking devices only cost about £180 per day (1992 prices). The quality that some good tracking shots adds to any film is amazing, and always well worth the cost. Some shots are so much better achieved with a track that they end up taking less time than the series of set-ups that a static camera would require. The tracking shot, used well, can thus save both time and money.

## THE DOLLY

The various pieces of equipment used to track the camera are many and varied but the most common basic single camera dollies (tracking devices) are the 'Elemac' and the 'Panther'. Both of these devices come on tracks like small-gauge railway lines, or, on a smooth floor, their wheels can be changed and they can roll without rails. They are sufficiently strong for the cameraman and the assistant to ride along if necessary. The camera is mounted on top of a stout pillar of variable height. The pillar joins the base of the dolly, which has the wheels mounted on a diagonal cross. This cross allows the wheel base to push in so that the device can go through narrow doors. The cross will expand and lock when the dolly is riding on its rails. The Elemac is now superseded by the Panther, as although both have a variable central column camera mount, only the Panther can vary its height while filming. The Elemac requires the best height for the shot to be decided before the shot, and this height cannot be varied while the camera is operating.

The grips bring 30 ft of track with them. This breaks down into five-foot lengths. They also carry two pieces of curved track. When the director and the cameraman have decided on the track, the grip works out how to

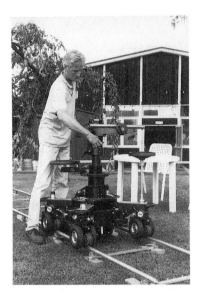

**Figure 10.1** A standard dolly fitted with a jib arm.

achieve it. He lays a sufficient length of track and then levels it out using wooden wedges and checking with a spirit level. Once the tracks are firm and level the dolly is lifted on to the tracks and, if all is well, it should be able to glide smoothly and silently up and down the length of rails. Obviously some surfaces are easier to lay the tracks on than others. A car park is considerably easier than a ploughed field. The field is possible – but it will take more time to lay the tracks. A wise director gives advance warning of any tracking shots so that the grips can commence laying the tracks while the unit carries on with a simple shot that can be achieved on a tripod.

It is better to plan a tracking shot as the third shot of the day rather than the first. You can then discuss the track with the grip or the cameraman when you arrive on location, then shoot some simple shots and be ready for the tracking shots at about the time the grips has got everything set up.

A common mistake when a director first plans to do a tracking shot is to conceive only shots which track with the action. Following two people as they walk along the pavement or the station platform is fair, but hardly inspiring. It also contains the great danger of seeing the tracks in the background of shot as the camera progresses to the end.

Tracking with action doesn't expand the aspect of the frame: that is why it looks unadventurous. Counter-tracking is preferable. If the action is going from left to right and the camera tracks right to left the scene is expanded, and the action is enhanced. Imagine that there is a grand piano in a room with its keyboard facing screen left; behind the right hand end of the piano there is a door. The pianist enters and crosses to the piano and plays. If we start on a close-up of the door and track left with the pianist, the shot is tracking with the action and the result will look dull. If,

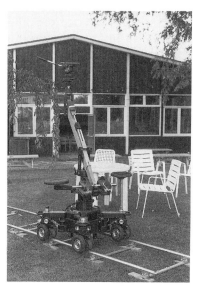

**Figure 10.2** A jib arm.

however, the shot starts with the camera looking over the piano, the door is in the back of the shot so we see the pianist enter; as he moves left to the keyboard we track on a diagonal right and finish looking at the actor down the length of the piano, this shot will have much more style. Diagonal tracks are the bread and butter of good camera moves; but novice directors take a while to come to terms with this fact. Laying straight tracks diagonally to the action is the main reason the curved lengths of rail are seldom used. When directors first start they tend to imagine that a straight track must be very limiting. Nothing could be further from the truth.

## THE JIB

The jib is one of the more useful pieces of equipment that a grip brings along. It is basically a counterbalanced arm; the camera is fitted to one end and there are balancing weights at the other. The centre of the jib is fixed to a column, often the column of the Elemac. The whole thing functions like a see-saw with the added ability that it can swivel on its central column mount. The jib allows a very fluid movement. An actor can rise from a chair and walk a short distance, and the camera can follow him all the way at eye level and in the same size of shot. The camera 'jibs up' as he rises, and then the cameraman follows his move as the jib swivels on its central column. The jib is entirely mechanical. It is just a solid counter-weighted arm. The operation is achieved by the cameraman moving the camera. But as the camera is held in perfect balance this is an effortless procedure. The column to which the jib is fitted can either be a simple

pedestal of variable height, or it can be mounted on the central column of the dolly. The simple pedestal was at one time called a bazooka from its appearance. However, after an unfortunate experience at London Airport when a customs official was told that a particular equipment case contained a bazooka the name was smartly changed to 'camera pedestal'. The pedestal takes up less floor space than the tripod and is strong enough to take the jib.

Using a standard jib the camera can go from a lens height of approx. 18 in (0.5 m) from the floor up to about 6 ft (2 m). If the jib is fitted to the Elemac then a limited amount of jibbing and tracking is possible, but beware! Some cameramen are better at this than others, and some refuse to attempt it. To track and jib you really need the latest Panther Dolly, which can be ordered with various customized electrically-assisted jibs.

All the equipment described so far is cleverly designed but extremely heavy, to ensure the camera is rock-solid even if it is fitted with a longfocus lens. A lot of fluid camera work can be achieved by a skilled use of a hand-held camera, but the camera must be fitted with a wide-angle lens if there is to be any hope of success. The grips' various camera mounts allow this fluidity to be achieved without any compromise in the choice of lens, and without any fatigue on the part of the camera operator.

In recent years various devices have arrived on the market which attempt to lighten tracking equipment and allow a cameraman to transport a lightweight dolly in the boot of the camera car. The purpose behind these gadgets is to avoid the necessity of having a grip on the shoot. Whilst one or two of these inventions are ingenious and may serve an occasional purpose, in general they are a waste of time. The whole point of tracking equipment is its solidity, so any lightweight compromise is pointless. A piece of lightweight equipment that will only work on a smooth floor is no better than the much-used wheelchair; any device which forces the director to use a wide-angle lens is no better than hand-holding. Economizing on a grip is false economy. Any director who has had much exposure to that range of tracking equipment which 'weighs one-and-a-half pounds and fits into a briefcase' will realize why the grip and his specialized equipment continues to be one of the most respected and vital technicians on a serious drama shoot.

The steadicam is an interesting device that has been around for about fifteen years. It allows the cameraman to walk upstairs or from room to room, following the action with the apparent ease of a conventional track. Basically the camera mount is steadied by gyroscopic damping. The whole device is worn by the cameraman. If film is used then the camera is fitted with a video finder so the cameraman views the scene from a small monitor and does not have to keep his eye to the viewfinder. Panning, tilting and focusing are remotely operated by switches built into the grips which the cameraman holds. The steadicam is a clever and useful piece of equipment but it does take time to set up and it requires an experienced operator. It is not a time-saving way of achieving a track, but rather a specialized way of achieving a track that would otherwise be impossible.

It takes time to fit the camera to the device and each cameraman has to be 'fitted' to the gear. It takes a good deal of strength to operate a steadicam. Recently the makers have brought out a lighter device for use on 16 mm and video. This will doubtless prove popular, as it appears to be easier to use than the original version. This, though fine for 16 mm and video, was in fact made to cope with the weight of 35 mm cameras, and is consequently a rugged and heavy device.

## CRANES

Cranes come in all shapes and sizes but none of them are small. If you want the camera to swoop down on the fleeing hero and heroine and track with them for some distance, you will need a crane. All cranes are a type of giant elemac, counterbalanced not just for the weight of the camera but also for the weight of the operator, director and (often) focus puller who will all be riding with it. Cranes can run on rails and on the more sophisticated models the jib arm swivels from the central mount. They require two, sometimes three operators: a key grip and one or two other grips. The up-and-down movement and swing of the jib are controlled by one man, and the tracking movement by the other two. Cranes pack down into quite small trailers and usually arrive on location as a trailer towed by a Land Rover. They take time to set up, so it is sensible to schedule the crane shot just after lunch. The crane can be set

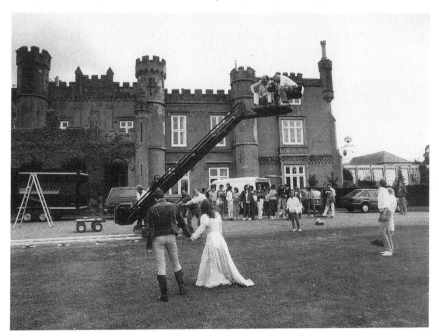

**Figure 10.3** A large crane on location at Wall Hall, Herts. The author directs alongside Lighting Director Tony Mayne.

up during the morning, checked and rehearsed before lunch, then shot immediately after lunch. With luck you will get away with one day's hire!

Using a device on one day for the various specialist shots is common practice; and as long as things don't look too repetitious in the finished film it plainly makes economic sense. Even the small documentary shoot will benefit from using a grip and dolly for one day, or whatever the budget allows. It makes sense to expand your crew on the days when you need those extra facilities. For instance a three-day shoot about the local art gallery may well have a three-man crew for the two days of interviews and general exteriors. You can expand this to five including an additional lighting electrician and a grips on the day set aside for the museum interiors. A piece to camera or a tracking interview scheduled for that day would also add some very real production value to the documentary.

The advent of video viewfinders for film cameras as used on the steadicam has also engendered a revolution in camera crane design. At one time the giant cranes (maximum height upwards of sixty feet) were colossal. If they were to carry the operator, director and focus puller in safety, they had to be. The trouble was that they were used so infrequently that they become uneconomic to maintain. A crane has to be steady, smooth and silent. Cranes are complicated pieces of engineering, and as the largest ones need hydraulic assistance they are a minefield of seals and servo pumps. Round about 1980 it was realized that a video finder and remote controls for panning, tilting and focus meant that there was now no need for three men to go up with the camera. A whole new age arrived, starting with the 'Luma Crane'. Freed from the weight and safety restrictions, the camera alone could now soar with an ease that would have once been thought impossible. Now the operator on the ground can control everything with either a joystick or a remote version of the Moy head dual handle pan and tilt mechanism that is used on all feature films. The camera output (video) or viewfinder output (film) is seen on a TV monitor. Kenneth MacMillan's photography of the battles in Kenneth Brannath's version of Henry V was achieved by using such a device.

## SPECIAL MOUNTS

The grips can be expected to rig mounts for the camera in all sorts of unusual places, sometimes improvising with parts from his regular kit, more often by supplying specially-built camera mounts. Mounts for the bonnets of cars or the side of cars are commonplace. Mounting on the side of a motor-bike or even looking back at the pilot of a Tiger Moth, all are possible. The car mounts take a full-sized camera, as they are most frequently used for dialogue scenes. The motorbike mounts take a small cassette-loading 'gun camera'. These miniature cameras can also be worn as part of a helmet and used on motor-bikes, on skis or in free-fall parachute jumps.

Helicopter mounts for cameras usually come from the same specialist who supplies the actual helicopter. They are gyroscopically stabilized in a similar manner to the steadicam. Helicopter filming is potentially very dangerous and all the safety requirements must be strictly adhered to. Helicopter shots have two big problems. One is keeping the shadow of the helicopter out of frame; the other is the very obvious downdraught that can be seen flattening grass or blowing actors' hair about when the helicopter is low. I well remember editing a helicopter sequence of a sailing barge race in which the downdraught nearly capsized one of the barges. The director thought that the crew of the barge was waving a greeting – the lip-readers in the audience knew better!

# Filming action

It has always been a mystery to me why directors always seem so ready to delegate the direction of action sequences to someone else. Of course elaborate action requires the close co-operation of the stunt co-ordinator and the director; a smaller shoot requires the director and the stunt artist to collaborate. But to call in a specialist to direct the item for you seems to be to subscribe to the belief that the filming of action is a specialist skill. It is certainly one that all self-respecting directors should achieve. William Wyler, director of 'Ben Hur', never made too much of the fact that the famous chariot race was directed not by himself, but by the veteran stunt man Yakima Canut.

A chase is about the most standard piece of action that can confront a director. It is very easy to do badly, but by no means difficult to do well. For a chase to excite us there must be a clear logic to it and a sense of geography; but the first rule is that as much of the action as possible should be towards the camera. The camera always cuts ahead so that there are a minimum of passing shots. I don't believe that continuity of action – left to right or right across the screen – is mandatory. A chase whose action is constantly in one direction becomes very boring to watch. However, I would agree that all changes of direction must be clear to the audience. There is an old and well-tried device for a chase: first, a shot where the car or horse or stage coach comes head-on to camera and leaves frame right. The shot is then repeated, but this time with the subject leaving frame left. If there is a need to change direction at the edit it is a simple matter to do so by using either one or the other of those shots. A much better way is to have a shot where the subject enters from one side and exits from the *same* side. This is much more exciting visually. It is usually possible to find a stretch of winding road so that the vehicle can enter at the top left of frame, weave down the road, and exit bottom left. Leaving frame by the same side as you entered is a useful shot to have in the directorial locker. All too often, when directing a sequence, you realize that the action finished with an exit frame right and now you need to do another shot when the action starts with an entrance frame right. A buffer shot as described above is the solution. In period drama in

particular, the need to exclude anachronistic detail will often limit the choice of camera position, and this in turn can limit the range of exits and entrances. Ideally, you should visit each location and prepare a story board for the chase to suit what is available.

Any good chase should contain some geographical points of reference, so that the audience can estimate whether the pursuers are catching up with the fugitives or if the fugitives are escaping. A good chase will keep the audience guessing until the end.

Consider the following scenario for a typical chase:

The captain of the smugglers has been cornered in the top room of the inn. He bolts the door and goes to the window. The revenue men rush up the stairs and start to shoulder the door.

SHOTS REQUIRED:
1
  SHOT LOOKING DOWN STAIRS
  HERO RUNS UP THE STAIRS
  CAMERA PANS WITH HIM TO DOOR OF ROOM
  (MAJORITY OF ACTION TOWARDS CAMERA)

2  INTERIOR ROOM CAM CLOSE TO DOOR. HERO ENTERS INTO MCU
   HE BOLTS THE DOOR AND LOOKS ROUND IN DESPERATION
   HE SEES THE WINDOW

3  HERO'S POV OF WINDOW

4  REVENUE MEN UP THE STAIRS (SAME SET-UP AS SHOT ONE)

5  HERO BY WINDOW LOOKING DOWN INTO COURTYARD

6  HIS POV OF THE COURTYARD (TAKEN WITH A WIDE-ANGLE LENS TO
   EXAGGERATE THE DROP)

7  REVENUE MEN START TO SHOULDER THE DOOR

8  HERO REACTS MCU

9  CLOSE UP OF BOLT NEARLY GIVING WAY
   (THIS SET-UP TO BE USED SEVERAL TIMES)

10  HERO MAKES UP HIS MIND & JUMPS UP INTO THE WINDOW FRAME

11  MORE OF THE BOLT GIVING WAY

12  HERO STILL PLUCKING UP COURAGE

13  MORE DOOR SHOULDERING – THIS TIME IT GIVES WAY
    (AS PER SHOT 7)

14  EXTERIOR LOW ANGLE LOOKING UP AT WINDOW (WIDE- ANGLE LENS TO
    EXAGGERATE). HERO JUMPS. LANDS & RUSHES TO HIS HORSE

To achieve this in one shot is tricky but possible. The jump would be performed by an identically-dressed stunt man who would need to land on stunt boxes or an air-bag. These would be just out of shot at the bottom

of the frame. The actor playing the hero jumps up into frame after the stunt fall, and if the shot is carefully planned this will appear convincing.

> 15 BETWEEN THE HERO AND THE ESCAPE STANDS A REVENUE MAN GUARDING THE HORSES. HE DRAWS HIS SWORD AND RUNS TOWARDS THE HERO (TOWARDS CAMERA). THE HERO SIDESTEPS, TRIPS HIM AND FINISHES HIM OFF WITH WHATEVER IS TO HAND (A PITCHFORK)?

On a low-budget film this guard could be the same person who doubled for the hero in the jump.

This incident highlights the sorts of problem that confront the action director. It would be best if the hero still had his sword with him to deal with the guard but this would be a dangerous prop in the jump. It would therefore be preferable for the hero to lose his sword before the leap from the window. Best of all would be for the hero to realize this danger himself and throw the sword out of the window ahead of him – this suggests the height of the fall. The sword would hit the solid ground and distract the audience from the concealed precautions taken to soften the stunt artist's landing. The clatter of the falling sword attracts the attention of the guard, who is subsequently killed by the pitchfork.

Shot list would now read

13  REVENUE MEN SHOULDERING DOOR

14  HERO THROWS DOWN HIS SWORD

15  LOW ANGLE AS SWORD FALLS TOWARDS CAMERA AND CLATTERS ON THE STONE FLOOR OF THE COURTYARD

16  GUARD BY HORSES HEARS THE CLATTER, LOOKS UP

17  (POV GUARD) SEES THE HERO ABOUT TO JUMP

18  RESUME 13 SHOULDERING THE DOOR – IT BREAKS

19  MCU THE HERO IN THE WINDOW. HE JUMPS

20  LOW ANGLE STUNT SHOT OF THE LEAP WITH THE SUBSTITUTION AT THE END

21  GUARD RUSHES TO CAMERA (TAKEN FROM OVER HERO'S SHOULDER) HERO SIDESTEPS AND TRIPS GUARD

22  GUARD FALLS ON FLOOR, FROM HERO'S POV

23  HERO GRABS PITCH FORK AND PLUNGES IT OUT OF FRAME – HE LOOKS UP TO SEE

24  REVENUE MEN AT WINDOW AIMING MUSKETS (MEDIUM WIDE SHOT)

25  HERO TURNS AND RUNS MCU

26  MCU MUSKET MAN FIRES

27  HERO RUNS PAST TREE OR WALL – BULLET JUST MISSES HIM (we will discuss this effect later)

28  HORSES IN FOREGROUND. HERO RUNS TOWARDS CAMERA – HE CUTS MOST OF THE HORSES LOOSE

29 REVENUE MEN RUNNING OUT OF THE INN DOOR. IF THEY RUN THROUGH CHICKENS OR GEESE THIS WILL ADD TO THE SENSE OF CONFUSION AND EXCITEMENT

30 HERO MOUNTS HORSE AND RIDES OFF (LEFT TO RIGHT)

31 TRACKING SHOT WITH HERO ON HORSE. HE LOOKS BACK TO SEE

32 REVENUE MEN FRANTICALLY TRYING TO ROUND UP THE HORSES – THIS DELAY IN THE PURSUERS JOINING THE CHASE WILL MAKE IT BELIEVABLE THAT THE HERO HAS A CHANCE TO ESCAPE.

The reader will note that it has taken us 32 shots, some of which are quite elaborate, to get as far as this, and the chase has only just begun. The essential point is that action cannot be skimped – it takes time. It requires a very detailed shot list and a great deal of preparation and rehearsal on location.

A dialogue scene may not suffer too badly for the want of a couple of close-ups, but an action sequence will. Notice too that the shot list so far contains some exciting action but nothing much happens in each shot. It is only when edited together that the events seem to crowd in on each other. Confining the action to one piece of action per set-up simplifies the shooting and makes things as safe as possible for the actors. So, back to the chase.

SHOT LIST FOR THE CHASE CONTINUED

33 RESUME SHOT 30. CAMERA TRACKING WITH HERO IN M/S AS HE RIDES LEFT TO RIGHT. HE SMILES TO HIMSELF AT THE CHAOS OF THE REVENUE MEN ROUNDING UP THEIR HORSES.

34 3 OR 4 REVENUE MEN MANAGE TO MOUNT AND RIDE OFF IN PURSUIT LEAVING FRAME RIGHT.

35 LONG SHOT HERO RIDES TOWARDS CAMERA. FOREGROUND IS A SIGNPOST 'LULWORTH 3 MILES'. THIS POINTS OUT OF SCREEN LEFT. SO HERO EXITS FRAME LEFT

– The direction of the chase has changed and the audience has a geographical point of reference.

36 TRACKING SHOT WITH HERO RIDING RIGHT TO LEFT.

37 REVENUE MEN STRAIGHT TOWARDS CAMERA UP TO LULWORTH SIGN. THEY EXIT FRAME LEFT (SAME AS THE HERO)

38 HERO'S HORSE JUMPS HEDGE (RIGHT TO LEFT)

39 TRACKING SHOP WITH GROUP OF REVENUE MEN (RIGHT TO LEFT)

40 REVENUE MEN JUMP HEDGE (RIGHT TO LEFT)

41 WIDE SHOT AGAINST THE SKY. HERO ENTERS SCREEN RIGHT AND GALLOPS LEFT DOWN WINDING ROAD WHICH SNAKES BACK TO THE RIGHT AS IT APPROACHES CAMERA – THE REVENUE MEN ENTER THE SAME SHOT ABOUT 6 SECONDS AFTER THE HERO

42  MCU TRACKING WITH THE HERO RIDING TOWARDS CAMERA

43  MCU GROUP OF REVENUE MEN RIDING TOWARDS CAMERA. THE LEADING REVENUE MAN DRAWS HIS PISTOL

44  REVENUE MAN'S POINT OF VIEW OF HERO (IE FROM BEHIND RIDING AWAY FROM CAMERA)

45  RESUME 41 – REVENUE MAN FIRES

46  MCU HERO REACTS AS MUSKET BALL HITS HIM. HE STARTS TO FALL FROM SHOT (SAME SET UP AS SHOT 40)

47  HERO'S HORSE STRAIGHT TOWARDS LOW CAMERA. THE HORSE FALLS WITH THE HERO LANDING UP CLOSE TO CAMERA.

48  LOW ANGLE HERO'S POINT OF VIEW. THE REVENUE MEN RIDE INTO FRAME FROM THE RIGHT LOOKING DOWN AT THE FALLEN HERO.

49  THEIR POINT OF VIEW OF THE HERO ON THE GROUND.

This is certainly the shot list for an elaborate chase, but only by working in such detail can the sequence be brought to the screen effectively. The list immediately reveals what set-ups are used more than once, so that although they might not be all part of the same slate they can be filmed one after the other. For example, Shot 40. The MCU tracking shot of the hero riding towards camera might be Slate 140. The shot where he reacts to the musket ball (Shot 44) would be Slate 141.

It is extremely unlikely that the actual geography of the terrain will be the same as the screen geography. The ideal place for the hedge jump may be some miles away from the location chosen for the 'Lulworth Sign'. It might well be reached well before the sign. All that matters is the screen geography. The only way to be confident about creating a totally artificial screen geography is to shot-list each sequence in detail.

The chase as described would involve a number of specialists. The leap from the window requires a stunt man doubling for the hero. A doubling stunt always works best if it starts hard on an action cut. It is also helpful if the hero is wearing something eye-catching, as this will take the attention of the audience. If he can wear a hat so much the better. A red cloak and a big hat with a feather will always disguise a doubling stunt. A grey suit would present a much greater problem, and would demand a stunt man of the same build and hair type as the actor.

Television's small screen allows you to take much greater liberties with the matching of doubles. The stunt man, Stuart Fell, regularly doubled for both Ronnie Corbett and Ronnie Barker, though he doesn't resemble either of them. Of course the 'Two Ronnies' series had bizarre situations involving eye-catching costumes. That is why the doubling worked so well. The other important stunt involved in our chase sequence is the one which involves the horse's fall. There are a number of splendid horses that are trained to rear up or to fall over at a given signal for their rider. The stallion Snow is such a horse. I've had the pleasure of working with him several times and he is a real star and knows it. If a horse like Snow was the hero's horse in our chase then most of the problems would be

solved. The hero would need to be doubled again for the horse stunt, this time by a stunt rider (usually the horse's owner). A properly-trained horse will refuse to perform the stunt if it thinks it is dangerous, so the production team must find a suitable location with soft earth. If the horse approves, he'll perform.

In the bad old days a very cruel device, called a running W, was used to make horses fall on cue. It was basically a wire which pulled the horse's front legs up so the poor animal crashed down in a heap. (They have long been banned in America and the UK.) Having met Snow, I honestly believe that he enjoys his work. Like most film horses he knows exactly what 'action' means. If you're using experienced film horses and you need them to stand still for a shot, don't say 'action': use another word such as 'cue', otherwise the horse will move off out of shot before you know it.

Our hero has been doubled twice and of course he could be doubled for the hedge jump and all the galloping wide shots. It would be much better, however, if he were a sufficiently good horseman to cope with the basic riding scenes.

The bullet near-misses are achieved by the visual effects department. Small charges of high explosive are concealed in the bark of the tree and detonated electrically as the hero passes. This is a job for the expert. The director can help by confining the shot as much as possible. This will enhance the effect and simplify concealment of the necessary wires.

I have included a brief mention of stuntmen, doubling and visual effects in order to prime the novice director with the sort of thought patterns that are necessary when planning an action sequence. Let's now consider the separate elements that are common to all such sequences.

## STUNT ARTISTS

Stunt artists come in all shapes and sizes, male and female. They specialize. In the chase it is highly unlikely that the high fall would be performed by the man who did the horse stunts. Some stuntmen specialize in driving, crashing motor-bikes, cars, etc. The more elaborate crashes involve careful preparation of the vehicle, stripping the interior of anything likely to cause injury or to catch fire. The stunt will be performed with a minimum of petrol in the tank. Sometimes the vehicle is fitted with hydraulic rams underneath. When these are fired the car will turn over or even somersault. Ramps may be concealed on the road to lift the vehicle up as it grinds to a halt. Obviously the director needs to consult with the stunt co-ordinator and the director of photography, and have the camera positioned in such a way that the devices remain hidden and the stunt looks as dangerous and spectacular as possible.

## STUNTS AND SAFETY

Stuntmen get paid to take risks; but remember, they command high fees because they know how to perform these feats without getting hurt. The successful stunt is the one that looks great and injures no-one. *Never* book the local daredevil who'll do the stunt for half the price of a registered stunt artist. Producers who have made the mistake have frequently ended with a death on their hands. Never believe the 'I do my own stunts' nonsense that publicity departments put out about stars. If in our horse chase there was any doubt at all that the actor couldn't manage to jump the hedge then the shot should be achieved using the stunt rider as a double. The expert rider will easily perform the jump, whereas if your star gets injured the production will be expensively postponed. The tragic death of that kind and talented actor, Roy Kinnear, was a case in point. Roy suffered a fatal injury when his horse stumbled. A stuntman wouldn't have fallen from the horse, let alone fallen badly and injured himself. Even more tragic was the fact that the accident happened in a wide shot, so a double would never have been noticed. Apparently Roy wanted to ride himself. In such cases the director must be strong and overrule the actor, for everyone's benefit. The perverse thing about accidents is that it is often the simple shots, rather than those that are perceived as dangerous, that lead to injury.

Stunts are priced according to their complexity and danger. You usually pay per take, so it is as well to cover elaborate stunts with two cameras. Re-setting alone will be costly, time-consuming and sometimes (as in 'The Bridge Over the River Kwai') impossible. Physical stunts such as climbing up rigging, scrambles up or down cliffs, etc., will get worse as the stuntman gets tired. From his point of view the first take will invariably be best. In such circumstances talk the shot through carefully with the camera operator and shoot even the rehearsal. Remember that a tired stuntman will not look convincing and is much more likely to sustain an injury.

### Fire stunts

Fire stunts are potentially very dangerous. If you require a man to become a human torch then very special gear is required. The man is completely clad in a fireproof suit and breathes from a small oxygen cylinder. His 'face' is a rubber mask. Nothing of the real man is exposed to the flames. Lesser but effective fire stunts are possible if the stuntman wears a protective back plate under his clothes and the clothes are partially smeared with petrol jelly. As long as the wind is light and the flames are blown away from him, as they will be if he runs forward, then the stunt is relatively low-risk, but you must still always seek the advice of the stunt co-ordinator.

*Fights*

Any fights or scuffles will involve stuntmen. In the chase all the revenue men will be best played by stuntmen except the chief revenue man who will be an actor, maybe a star. If this is so, then perhaps *he* will need a double for the chase as well.

If there is no real stunt work as such, just a lot of running about, then you may get away with using extras. This is risky, as they can be difficult to motivate. The burlier type of male dancer is often a very good bet for the sort of action that requires energy and co-ordination but no actual stunting. Most drama schools teach fencing and stage fighting so you should be able to find actors, even stars, who look convincing in screen action. Some actors are undoubtedly better at action than others. Unless it is imperative that you use a particular actor, then obviously you will choose a cast that is best able to cope with the action requirements. One word of warning: beware the type of gung-ho fool who will ignore every rehearsed move of a fight and go berserk when the director says 'action'.

**Figure 13.1** George Baker learning a swordfight on location at St Donat's castle.

Errol Flynn had a particular aversion to such stupid mavericks and this is hardly surprising because whatever his other attributes, he was a great swashbuckler and an expert screen swordsman. However even he was doubled in some of the most difficult swordplay.

It's not just actors who may need doubles in an action sequence.

Horses such as Snow are very expensive to hire by the day, and a high-spirited stallion is not easy for a comparatively inexperienced rider to control. It would be difficult to keep such an animal still for the period of time it takes to shoot a dialogue scene. Performing horses often have docile look-alikes – the sort of horse that would hardly blink if a firework went off underneath it. Of course it is a boon for the action director to have one horse calm for the dialogue scenes or for any scenes where there is a lot of noise, and another, high-spirited beast, for the gallops and fast getaways – on screen apparently the same animal.

## WORKING WITH ANIMALS

Some animals take well to filming, and a number of specialist firms will supply screen-educated beasts of almost every species. Dogs are easily trained, and you should have little difficulty in finding a well-behaved, well-trained, intelligent animal. If the script does not require a specific breed, so much the better. You can book the best dog available.

Beware of chimps: they look adorable but are often vicious. All animals must be accompanied by a trainer or handler, and if you have children in the cast or someone in the crew who is dotty about animals, make sure they know the risks involved.

There is no such thing as a trained cat, though several people have made a small fortune claiming there is. It's strange that whilst lions, cheetahs and even tigers can be trained to work on screen, their small domestic relatives seem oblivious to all requests to perform on cue. Some may be a bit more reliable than others; some just fall asleep. This in itself is no bad thing as they can always be made to react on cue by the use of a squirt from a high pressure air hose!

Problems can sometimes be solved by the simplest means. Suppose a dog is on a leash and must walk with an actor towards camera. If the dog's owner is by the camera then the dog will look happy and confident. If the owner is by the actor at the start of the shot and just ducks out of frame before 'action' then the dog will naturally pull back towards its owner. Food bribes are essential to all animal filming. The Disney Dog which turns its head intelligently as it listens to the conversation is in fact following a tit-bit which is being held just out of frame.

Snakes, crocodiles and other large reptiles present their own special problems. Expert advice and handling is as important as ever; the director can help by working quickly. Cold-blooded animals become sleepy if their body temperature is low. As they warm up under the lights they also liven up, so set them in position at the last moment, and ensure they don't get warm too quickly.

**Figure 13.2** Horse-drawn vehicles have no reverse gear!

Horse-drawn vehicles have no reverse gear. This sometimes takes film makers by surprise. A coach-and-four needs a considerable amount of room to turn round and a shot of a coach travelling towards camera will absorb time between takes as the vehicle gets into position. Make sure there is good turning space at either end of the road that you are using. All galloping shots (with or without coaches) are safest and look best if the horses are travelling uphill. A slight incline towards camera is thus the favourite location. The effect of horses galloping down a steep slope is usually achieved by judicious camera tilt. It is false economy to use hacks from the local riding school ridden by once-a-week horsemen. If you need horse soldiers you will have to hire professional cavalry. It will cost money but you won't waste time. It is rumoured that the BBC's production 'By the Sword Divided' suffered from producer economy in this vital respect. In one shot Cromwell's coach was supposed to be accompanied by mounted troopers. Some horses were frightened by the coach and pulled out of frame; others simply turned round and tried to throw their riders. As a result the shot was somewhat less redolent of pageantry than the director had hoped.

## SPECIAL EFFECTS

Explosives, flames, floods, monsters and moonmen are the province of the special effects men. In television they are sometimes called visual effects. Once again their talent requires the understanding and co-operation of the director and the director of photography. Bullet near-misses have been described above, but bullet hits are equally possible. The actor wears a protective plate attached to which is a strong plastic container (often a contraceptive) in which some offal and stage blood surrounds a small explosive charge. When the charge is detonated, a hole is blown in the actor's shirt and the blood and offal makes a convincing mess. The director can help by limiting the size of the shot and also its length. Our chase is a good example. The bullet hit is complicated by the actor's being on a galloping horse. If the bullet hit is filmed in big close-up and is only on the screen for a brief moment then the actor could in fact be static for the effect, just bouncing a little to give the impression he was still at the gallop. The detonation of the trick charge would then be much less troublesome.

Explosives that apparently go off dangerously close to actors can be made to seem closer than they are by the judicious use of a long-focus lens. The rubble and shrapnel will be harmless lightweight material such as burnt cork. Heavy objects such as cannon wheels might be replicated in lightweight fibreglass. Nevertheless, the explosive charge is dangerous and the long-focus lens will be helpful.

'Fire forks', which supply butane flames to areas of the set in a fire scene can be much exaggerated by a long-focus lens. A flame fork just under the

**Figure 13.3** Fire forks foreground and background for Stopes last line in 'Bright Wolf'.

lens and another in the body of the set will be compressed together by long-focus foreshortening and will create a convincing conflagration. The use of a half-silvered mirror of the type used for front-projection effects can set an actor apparently in the heart of a fire. The camera points directly at the actor on the set through the mirror set at 45° to the lens, and flames from the flame fork, at right angles to the camera direction, are reflected in the mirror. As the mirror is half-silvered, the image on the film combines the actor and the flames in a terrifyingly realistic fashion. Dialogue in fire scenes will usually need to be replaced by post-synchronization, as the synch track will be full of hiss from the butane burners.

The most impressive stunts and special effects are usually a combination of talent from every department, ie camera, sound, stunt artist, special effects designer, editor and, of course, director. Simple tricks still have their place. A cross-bow bolt fired from a close-up bowman cutting to a reverse-printed cross bow bolt being pulled out of an actor's jerkin will always look effective, especially if it is accompanied by an appropriate sound effect. Sound makes a very important contribution to effective action. Punches, bullets and sword clashes all benefit from enhancement by the sound editor – the audience has been conditioned by years of exposure to Hollywood Westerns, and if the noise of a punch doesn't sound as good as it did in 'Stagecoach' then it won't do.

Fights are usually left to the fight arranger and again the director must realize that blows and swordplay will only look really good from one angle. If there are two heroes involved in the fracas then separate these at an early stage. If hero A's fight looks weak at a certain point then you can cut to hero B's progress. If they are both on screen you're stuck with it. If a fight ends in a stunt such as a high fall or a leap from a bridge, construct the sequence in such a way that you can cut to the stunt hard on the action. Nothing looks worse than the slight hesitation or repositioning that often occurs just before a stuntman launches himself. In the excitement of the shoot this may go unnoticed but it is noticeable on film. If a stuntman has to do a whole fight routine and then perform a stunt at the end of it there is much more of a risk that something will go wrong, whereas if you can cut in close as the hero delivers a fearsome punch and this cuts hard to the stunt fall, the sequence will have an important punctuation and the stuntman has to consider only his fall. He can get into exactly the right position, and if there is any hesitation you can edit it out.

## THE ARMOURER

Sharp-edged weapons and firearms are supplied by an armourer who has a Home Office licence to allow him to work with prohibited weapons. The more that your filming can take place on private property the easier the production will be. Police authorities may request that the weapons be

locked in the local station every night. Remember that even a gun firing a blank can cause injury and that some automatic weapons (such as the AK47) fire blanks in a very dangerous fashion. Establish what is safe for camera before you start to rehearse the sequence.

Dismay can occur on location if the actors aren't given some warning of just how loud certain guns can be (a tommy gun is deafening). Don't rehearse the scene without firing the weapon and then go straight for a take: always have a demonstration to prepare everyone for the noise they can expect. The crew should be equipped with ear defenders, and if the cast can wear them without its being obvious, so much the better.

A number of weapons are available; in convincing rubber mock up – this can make things much easier and safer for the actors. No-one really wants to jump over a wall with a metal machine-gun if they can create the same effect holding a rubber one.

# CHAPTER 14

# Wrinkles

As far as has been possible I've tried to develop the various pieces of information in the book logically. However, in such a complex business as single-screen direction there are bound to be a number of hints and artful devices that a director learns only with experience. They inevitably form a bit of a rag-bag, so this final chapter may seem something of a lucky dip. As like Miss Jean Brodie, the following is an attempt 'to put old heads on young shoulders'.

## INTERVIEWS

Even the basic interview can be helped by some allowable deception. Most books on direction, including this one, will recommend the various shots required and emphasize the fact that it is best for the cameraman to change shot size during the question. Few, if any, will advise you to start an interview with a short roll of film (or videocassette) in the camera. A number of directors do this, especially if the interviewee is nervous. It is very off-putting for the interviewee if the director says 'cut' after only a couple of minutes and then has a chat and tries to get a better performance from the interviewee on take two. The interviewee gets embarrassed and wonders what the crew is thinking. The chances are then that the second take will be even worse. If the camera has a full roll the director is sometimes tempted to let it churn through although he knows that most or all of it is destined for the cutting-room floor. There are very few interviewees, good or bad, that don't benefit from a word of advice shortly after the actual start of the interview so a short roll provides the perfect answer. It is the cameraman who says 'cut, I'm sorry we've run out'. The crew then appears to the interviewee to be vulnerable rather than threatening. The director can then have a chat to get the train of thought back on the rails and the second take will usually be a vast improvement. A more sophisticated version of this ruse is to have a full roll or a new cassette, and employ a secret signal to the camera. Then if the

interview is going well you continue to the end of the roll. If you need to cut, you signal, and the camera 'runs out'.

## THE DUTCH TAKE

Most interviews nowadays are on tape and the stock cost is of no great concern. When film was the only medium available stock cost was a very real constraint. That is how the 'Dutch take' came about. When the director was confronted with a person who was so boring as to defy belief, but who for reasons of diplomacy had to be interviewed, it was not uncommon to pretend that the interview was being filmed when in fact it wasn't. A further sophistication was to cut the camera much earlier than was apparent to the interviewee and continue in sound only. The sound-only interview still has its place, especially when the interviewee is nervous. It is much easier to forget a microphone than a camera, so the sound-only interview may well be more relaxed. Of course you will need some talking-head shots to establish the person; after that, the sound-only interview will be used as voice-over. If someone has a stammer or cough, using the interview sound as voice-over will enable you to clean up the track considerably; but you must leave in some hesitations, otherwise the effect will be unrealistic. As a voice-over your contributor will appear coherent and urbane, whilst on screen he suddenly becomes a shambling wreck.

I learnt the short-roll trick from my friend and colleague, the ecological film maker John Thornicroft. Another device of his that I recommend is to play dumb. You often require an interviewee to explain a point more thoroughly. Rather than saying 'I'm sorry, we'll have to do that again, could you make it a bit clearer this time?' John puts the onus on himself. 'I'm sorry, I didn't quite understand that, do you mean . . .' He then pretends to have got the wrong end of the stick. The interviewee takes pity on the stupid director and comes up with a simpler explanation. Again it is a question of shifting the vulnerability from the contributor to the film-maker.

A trick of my own is to interview people whilst they are engaged in some activity. People chatting about themselves whilst going about their daily routine will be much less self-conscious than a 'stuffed dummy' in front of the camera. A modification of this device can be useful with actors. If an actor has difficulty with a long speech it is often helpful if he has business to do whilst performing that speech. Somehow the brain then has enough to think about without wasting energy worrying about forgetting the lines.

## AUTOCUE

Nowadays presenters seldom forget their lines – indeed they don't have

to remember them, thanks to 'autocue', 'portaprompt', and other wonders that reflect the words in a half-silvered mirror in front of the camera lens. If you are using this equipment there are a number of tips:

1 Send your script off to be typed on to the autocue computer in advance. This is especially important if there are many pages of text involved.
2 Use a static camera. It *is* possible to pan and track with autocue on the front of the camera but is very difficult and time-consuming.
3 Check reflections. If the presenter is wearing glasses make absolutely sure that the words are not visible as reflections in his spectacle lenses. Also check for reflections in any glass objects in the background (such as picture frames or glass-fronted cabinets).
4 Most important of all: check the height of the autocue. Some presenters are brilliant at reading it, others not so good; but no-one is convincing if their natural eye line to camera is altered by looking up or down to read the words. Fine adjustment is necessary: take the time to get it right. Look at the monitor with this thought in mind and satisfy yourself that all is well. This can only be judged by looking at a monitor (on video) or through the finder (on film).

## REFLECTIONS

Reflections can be a time-consuming nuisance on any set: lights reflected in picture glass or glass cabinets, even the whole crew visible in a mirror or a shiny metal object such as a domed silver salver. The reflection in pictures can usually be disposed of by altering the angle between the picture and the wall. This is easily achieved by crushing a polystyrene cup and wedging it behind the picture frame. Dulling spray can also help. It is available in aerosol cans, and is useful on gloss-painted doors and suchlike. I've never found it very good on glass as it tends to smear and become obvious.

The problem of the mirror in the background or the silver salver is a devil if you don't know the simple cure. That is to paint the offending surface with washing-up liquid. Delicately applied so as to leave no streaks, the effect is miraculous. The object still appears bright and reflective on screen but it is impossible to discern any reflection in it. Cleaning off is no problem either – a couple of wipes with a cloth and all is back to normal.

If you are filming through a glass window into an unlit interior, you confront a different type of reflection problem. You want to kill the reflection but still see through the glass. The answer in such a case is a polarizing filter, which can be adjusted to cut out, or at least minimize, reflections from the glass.

## MASKING OUT BACKGROUNDS

An old grey blanket is a good method of disguising bright or bulky objects that might spoil an otherwise acceptable shot. In black and white the effect is almost magical, but even in colour an anachronistic fire hydrant or brightly-painted shed can be effectively neutralized if it is covered in a couple of grey blankets. If the lens in use has a limited depth of field the trick works even better. A bright colour will register on the screen even if it is out of focus, but grey will not. Make no mistake: grey, not black, is the colour for these tricks of concealment. Greenery cut from a nearby wood will cover unwanted electric cables that would otherwise spoil an ancient wall, and in a period drama it is often possible to place a suitably-dressed extra to mask some fixed anachronism such as a post box. Washing on the line is a great standby to mask out an area of the frame. When you see washing in a period drama it is usually there to hide something undesirable on the skyline. Some of the banners adorning the walls of the Carcassonne location in 'Robin Hood, Prince of Thieves' were used to mask modern light fittings.

## DIFFICULT LOCATIONS

There are a number of locations which require special procedures or equipment, sometimes for reasons of safety, sometimes for reasons of logistics, often both. The swimming pool is a good example. Electrical safety will be a major concern, and the lights are dangerous not only from the point of view of electric shocks: they may explode if they get splashed. Your electrician must be informed if you are working in swimming pools, bathrooms, showers, etc. Almost certainly he will advise 110 v lamps or battery lights with safety covers and connections. The factor that catches most people by surprise on swimming pool shoots is known to all wearers of glasses – the lenses mist up. On a cold winter's day lenses taken into a swimming pool may take as much as 45 minutes to acclimatize; allow for this in your schedule. Leave the camera and lenses in the pool area until the lenses (including the viewfinder if it's film) have warmed up. Remember with a zoom lens it's not just a matter of wiping mist from the front and back element, all the elements inside the lens may mist up as well. There is no way you can speed up the process of acclimatization.

Any location at which a spark may cause an explosion imposes restrictions. Filming in a coalmine or a flour mill will require a clockwork-operated camera. The same is no doubt true of munitions factories. The types of lamps permitted will be restricted, but the chief concern will be the arcing that takes place with any unprotected d.c. electrical motor, hence the need for a clockwork camera. For many years the Coal Board kept a couple of faithful Newman-Sinclair cameras for the purpose. Despite their advanced years they still delivered excellent pictures.

# THE ONE-OFF TAKE

The documentary maker is occasionally confronted by the frightening prospect of only having one chance to get a sequence, and with very little time to achieve it. On a recent television documentary about the environment, various celebrities agreed to participate and prove how 'green' they were. One star was to be filmed cycling through London as her voice-over described the horrors of coping with London traffic. The location was London Bridge and on the day the traffic was so bad that the star arrived late and very anxious to get to her next engagement. The director had five minutes in which to film the sequence. Fortunately he was experienced. He described the purpose of the sequence to the cameraman, then asked the actress to go to the other side of the bridge. On 'Action' she was to cycle slowly towards camera. The cameraman was primed to use this one chance to get as many shots as possible. On the long end of the lens he filmed the actress pedalling along in close-up. He let her leave frame. Then he zoomed out wide, let her enter frame and he held this shot for several seconds. Then he zoomed in to her feet on the pedals, tilted up to her face and again let her leave frame; then he panned ahead of her and let her cycle into frame. Finally he widened out and held a shot in which she cycled into close-up, then he panned with her as she rode away. All that was needed to make a sequence from this one shot was some additional long-focus shots of cars and lorries which were taken after the busy lady was travelling to her next engagement – by car!

The lessons to be learned from the 'sequence in one shot' centre on the ability of director and cameraman to think in advance and keep a cool head. These qualities are also required in any drama situation that is likely to take a very long time to reset. A sequence of thugs vandalizing a property is a good example. The cameraman must be briefed to cut and to shout 'cut' loudly if anything goes wrong *before* the smashing takes place. This is equally true of a comic sequence in which the star is going to be soaked with a hose or drenched in whitewash. Comedians are seldom at their most co-operative before such incidents and if they suffer a needless repeat of the experience, the production suffers a loss of time and temper. The drama director has people to think 'retake' for him, but for the documentary director it is easy to forget that a retake may be necessary. A simple shot like a close-up of a pen writing a diary entry is the classic case: if you need a second take and the date is specific, you don't just need another page, you need another diary!

# FILMING FROM A TV SCREEN

Filming from television screens or computer monitors can hold surprises for the innocent. If you want to film the picture on a television screen the film camera must be synchronized with the electronic scan of the television tube. If it isn't, a broad dark horizontal line will appear on the

image and roll continuously down the screen. There are two solutions. One is to use a gadget called a 'Jensen interlock' to synchronize the film camera with the mains pulse that feeds the television. Alternatively, if your film camera has a variable speed and the viewfinder takes its image from a mirrored shutter (The Arriflex SR Camera for example) then the black line can be got rid of by simple adjustment. If it can be seen in the viewfinder then it won't appear on the film. This is because the viewfinder image appears only when the shutter is closed. Therefore if you see the black line stationary in the viewfinder the shutter must be open only when the TV screen is bright all over. The cameraman therefore adjusts the speed of the film camera until the rolling black line appears stationary in the finder. He can then turn over, confident of obtaining the best picture from the TV monitor. Of course such adjustment means that the camera is running non-sync, so a scene to be shot with a TV monitor in the background cannot use this method – the more complicated Jensen interlock would be necessary. This problem also applies to computer screens and this is important as documentaries frequently require the contributor to be seated beside his computer screen.

On video this is less of a problem because a video camera run from the mains will lock up with the TV monitor. There is still a potential snag, however. Some computers run off 60 Hz a.c. and not the British 50 Hz standard. In such cases the black line reappears. Try to avoid sync shots which contain picture information from a TV monitor. Shoot the monitor shots as close-up cutaways and exclude them from the talking-head shots. In a drama it might well be less hassle to have fake monitors, 'computer screens' lit from behind by a green bulb inside the monitor cabinet.

## THE JUMP FRAME

A much less complicated tip concerns the shooting of jump frame sequences. The jump frame is as old as the cinema. The ghost suddenly appears in the corridor simply by butt editing a locked off shot of the empty corridor with the same shot but now containing the ghost. Appearances and disappearances are easily achieved by this trick on film or tape. An added refinement is to mix the two pictures together so that the ghost materializes onto the screen. The trick is so well-known that it is surprising that directors (even cameramen) sometimes get it wrong. The reason is simple. For the visual trickery to work there must be a visual constant in both shots. Thus, if the ghost appearing in the corridor does so in long shot the trick works well, but if he is close to the camera he will occupy most of frame and exclude the corridor. Instead of looking like a sudden magical appearance the cut will seem to be a simple cut to a close up. The safe rule is always to include a foreground object that is constant on both sides of the edit.

A few years ago I learned an effective additional trick to use with jump

frames. I was shooting a fairy tale for the Golden Oldies Picture Show. Every time the handsome prince kissed the pretty sorceress she vanished. The choreographer suggested that we included glitter at the 'vanish' and it worked brilliantly. The routine was as follows. The camera was locked off on a two shot of prince and sorceress. They kissed and the prince (actor Miles England) froze. The sorceress (Lee Miles) then walked out of shot. On a count of three, two, one, Miles reanimated with an expression of amazement as simultaneously the choreographer, Antony Johns, threw a handful of fine glitter over the camera into the area where Lee had been standing. The effect on the edit was that of a very expensive special effect. The couple kiss/ edit/ and the girl vanishes in a puff of Disney dust much to the amazement of the prince.

There is a variation of the jump frame that is a stock-in-trade to film-makers. If an object passes sufficiently close to the lens to cause a blur then it is possible to cut to almost anything. Traffic again provides an example. If the camera is one side of the road shooting action on the other and a passing bus or a lorry masks out the whole frame for a moment, then an edit at this point will appear to be completely natural. If the blur caused by the passing vehicle is edited to another blur caused by another vehicle the effect is even more satisfactory as the effect is of a natural wipe from one shot to the next. It is in fact a less self-conscious version of the somewhat discredited whip pan. Some years ago I was directing a Dick Emery show on film in which Dick was playing his usual plethora of roles. Dick, as the chambermaid, was having an unseemly encounter with Dick, as the crusty colonel. I used the blur-edit technique for a simple but effective trick. The shot was a tightish two-shot over the colonel's shoulder looking towards the chambermaid. Obviously the colonel for the shot had to be Dick's double, as he was back to camera and the maid was Dick himself. I directed the shot so that the maid advanced on the colonel, grabbed him by the lapels and swung him round. They then changed positions so the shot ended with the colonel facing camera and the maid back to camera. The change over from Dick as maid to Dick as colonel and the opposite with the double was possible because the action of the swing round brought both of them sufficiently close to camera to blur the lens for a brief moment and allow the edit. The effect on screen was that it was one continuous shot with Dick convincingly playing both parts at once. I would claim little credit for this idea as it has been used in various guises by film-makers for many years. The famous eternal track-out in Hitchcock's film 'Frenzy' is the example always quoted. In the film two complicated crane shots, one on the sound stage and one on location, are linked into one continuous and seemingly impossible long crane shot by introducing two extras who pass close to the camera lens at the point where the two shots are joined together.

A less-acknowledged but equally clever trick is used by Hitchcock in his early sound film 'The Thirty-Nine Steps'. There is a dialogue sequence in an open-topped car. This is simply enough achieved by holding a side view of the vehicle against back projection. It is a reasonably tight side-on

shot showing the actors in the back seat. At the end of the dialogue the camera tracks in the opposite direction to the apparent direction of the car so that the lens is blurred by the car's folded hood. This then invisibly edits to a location shot in which the car drives past the camera in such a way that the hood masks the lens for a moment; the camera then pans as the car drives off into the magnificent Scottish hills. The on-screen effect is again of one shot – the camera seems to have travelled with the car for some five minutes and then let go. It is a very effective jump frame trick.

# Film in television

Film and television have had an uneasy partnership from the very earliest days of broadcasting pictures. John Logie Baird is usually credited as the inventor of television and, indeed, he was the first person to send a picture over the airwaves. However his flying-spot system which involved bands of photoelectric cells in a pitch black studio was impractical. In the earliest days of transmission the BBC was obliged to experiment with two systems: Baird's, and the EMI camera which employed a cathode-ray tube, and was the forerunner of modern camera systems. Baird had by now developed his intermediate film system, which used a film camera to shoot the scene and then sent the film through a rapid-processing bath. The negative film image could then be read by his flying-spot technology and transmitted to the viewer just 50 secs later. No such film scanning system survived, and as high-speed film processing at that time involved copious quantities of cyanide and the equipment operated at extremely high voltages, I wonder if any of the operators survived either.

The National Museum of Photography in Bradford, UK, has a replica of Baird's first non-film system, and this is worth a visit. We all know that hindsight is 20:20 vision, but one look at that strange contrivance coupled with Baird's infrequently quoted affirmation 'there is no future in the cathode ray tube' should be enough to persuade most students to reconsider Baird's contribution to the development of television. Unfortunately, he never really succeeded in his other great quest – the invention of indestructible socks.

The systems of the late 1930's were both capable of transmitting completed films; indeed when the BBC TV ceased broadcasting at the outbreak of the second world war they were transmitting a Mickey Mouse cartoon. With a sense of style that seems to have gradually evaporated from the corporation they recommenced transmission in 1946 with the very same cartoon.

Nevertheless for many years there was a clear distinction between theatre, films and television. Soon a television programme was to incorporate three cameras each observing the scene and each sending its

pictures to the vision mixing desk; the vision mixer (in the USA still referred to as the 'switcher') would then switch from, say, a wide shot on camera one to a close up on camera three at the instigation of the director. An early television play would thus have something of the appearance of film in that it would be viewed as a series of wide shots and close-ups. Of course the events took place in real time; the play was being performed as you watched. Up until the mid-1950s, a repeat of a play was exactly that: the actors came into the studio and performed the play all over again. These technical restraints had very practical consequences. BBC Television Studios were located in central London and plays were mainly transmitted on a Sunday when actors from the West End were free to perform for the infant medium.

A major technical limitation of the early system was that picture cuts were impossible. Instead a picture mix was always required when the vision mixer changed from camera to camera. The tele-recording of the Coronation in 1953 shows clear evidence of this. The Coronation stimulated the boffins at Alexandra Palace into making many useful developments. A sense of history and archive, which also seems to have faded with the decades, pushed forward experiments to make possible the recording of television pictures. Thus tele-recording emerged in 1953–4. At that time the technique consisted simply of a modified film camera aimed at a modified television monitor. The transmission of the live programme was then recorded on film and this film could be retransmitted when the repeat was required. The early recordings were poor (the picture on the monitor was bad enough anyway) and film stocks were still insensitive and grainy. Nevertheless tele-recording continued to develop, and gradually it became unnecessary to recall the actors to the studio when a repeat was scheduled. Instead, the tele-recording was run. Once television programmes were recorded on film it became possible for a film editor to edit them; but it took a long while for this particular penny to drop. For years programmes were recorded live on transmission and repeated in exactly the same form as the original broadcast.

Television dramas in the early fifties could be said to be somewhat constipated endeavours. It is possible that viewers in their forties found nothing untoward in the real-time shackles of those early plays. Remember that the early talkies were filmed with three or four film cameras around the set, each in its own soundproof booth and each linked to the one optical sound recorder. Early talkies therefore had many of the same restrictions as early television plays, though they had much superior picture quality. Tele-recording improved dramatically between 1955 and 1965. When I joined the BBC Ealing Film Studios in 1965 the tele-recording editing department was the largest single editing area at the studio. Tens of thousands of feet were delivered each week (and several thousand got lost). Anecdotes surrounding editing machines that developed a sudden penchant for chewing whole programmes into shreds still abound among the technicians who remember those distant days. 35 mm tele-recordings of drama or major music programmes (such

as Jazz 625) had remarkably good picture quality considering the primitive technique of filming a television screen that was used. Sound was no problem, as this was recorded direct on to a synchronous 35 mm magnetic track with a back-up (for dire emergency only) recorded on the optical soundtrack area of the picture film.

Just before the advent of colour transmissions in the UK, tele-recordings was riding high. Technical developments had managed to produce consistently acceptable recordings from the process, and it had become standard practice for tele-recording to be cut and dubbed like film. Directors soon became used to shooting retakes of scenes, or bits of scenes, for inclusion at the tele-recording editing stage. In drama productions it was usual for location exteriors to be shot 35 mm black-and-white on film. This caused a confusion of styles that was seemingly inseparable from any television drama production. Long scenes tele-recorded in the electronic studio and firmly set in real time would be interspersed with scenes shot on 35 mm film. Unlike the studio chunks these film sequences allowed the director and editor full range of the creative use of time. What was more, the 35 mm film always had a picture quality vastly superior to that of its poor relation, the tele-recording. Sometimes, as a desperate measure, the film itself was tele-recorded to downgrade it and achieve a more homogenous overall picture quality.

At the end of the black-and-white era of British television in the mid-1960s, film held a powerful position as a programme-making tool. Documentaries were increasingly shot on 16 mm film, and emulsions were developed to aid the television film maker in the quest for more sensitive film stock with improved definition. Drama sequences continued to be shot on 35 mm film, and some prestigious drama programmes like Ken Russell's 'Delius' and Jonathan Miller's 'Alice in Wonderland' were made entirely on 35 mm film. At the same time, however, drama documentary film makers such as Ken Loach began using 16 mm, preferring its lightweight equipment and low stock costs. Ironically, this latter advantage was often offset by a vastly increased shooting ratio. (The present day switch from 'expensive 16 mm Eastman-color' to 'dirt-cheap Betacam cassettes' has witnessed a repeat of this same phenomenon.)

In 1966, video recorders which used tape 2 in wide became available from the Ampex company. Video recording was soon to revolutionize television production, though the change was not immediate. The original system made editing extremely difficult. The machines were not designed with editing in mind. Like the original tele-recording, the idea was to record studio output for retransmission at a later date. This limited the creative use of video for many years after its introduction.

As long as television remained in black and white, videotape presented an alternative to tele-recording and film rather than a threat. The introduction of colour was to change that. The tele-recording process had improved dramatically over the years, and the editing flexibility which it

had in common with film systems allowed it to retain considerable support amongst directors even after the introduction of Ampex video. Once colour arrived tele-recording was doomed. Camera film stocks in 1966 lacked the sensitivity and exposure latitude to cope with the requirements for filming a picture from a colour television monitor. A black-and-white tele-recording might have looked passable against the Ampex alternative but in colour there was no argument: Ampex won hands down.

As British television emerged into the colour era, the situation was thus as follows: prestigious plays were produced in colour, with studio interiors directed for a multi-camera electronic recording on Ampex tape. Exterior or location film sequences for such productions were shot on 35 mm Eastmancolor. A few smaller-scale film dramas were shot entirely on 16 mm Eastmancolor. Some documentaries were shot on 16 mm Eastmancolor, but for a while many documentaries continued to be made in 16 mm black and white.

It is interesting to recall that the BBC's most prestigious drama series of all time, The Forsyte Saga, was made in black and white, with studio tele-recording and black-and-white 35 mm location film sequences, a year after the official introduction of colour. Cost had much to do with this but the possibilities of tele-recording, editing and dubbing played their part in that decision.

For many years post-production sound on videotape remained in the dark ages. When the engineers decided to develop a system for video sound dubbing they unfortunately chose to ignore forty years of film development, and lumbered videotape with the 'sypher suite'. This had much more in common with the practices of an amateur ciné club than it did with a professional dubbing theatre. It was at least two years before sypher sound staff rediscovered the use of dubbing cue sheets.

Shortly after the introduction of colour, the BBC decided to abandon 35 mm. It was claimed that on transmission 16 mm was indistinguishable from the larger format. At the time this was untrue: the real reason for the change was simply to economize. The vast increase in the use of 16 mm film, however, encouraged Eastman Kodak to improve its film emulsions. They were so successful in this that present-day 16 mm looks better than 35 mm did in 1966. In fact, Eastmancolor emulsion improved so dramatically that by the late 1970s there was no point in shooting epics on 70 mm. Major movies were shot on 35 mm negative and only released on 70 mm for cinema projection. The huge amounts of 16 mm shot for British TV in the 1970s and early 80s also had its impact on camera design, lens manufacture and editing equipment. 16 mm, once the sole domain of amateurs, became as sophisticated as its 35 mm big brother. In many ways the smaller gauge had advantages. The cameras were already small, and became smaller; the gauge was much easier to handle in the cutting-room, too, once editors had become used to it. Although the frame rate of 16 mm is the same as that of 35 mm (24–25 fps) those actual frames are smaller, so the lateral speed of the film through the mechanism is much

slower. Consequently the chances of a cutting room rip-up are much reduced.

In the seventies and early eighties television production continued much as before. Dramas and drama series and serials were still entrenched in the electronic studio with their location work now entirely shot on 16 mm Eastmancolor. The definition of the new stock was a much better match for the studio scenes, but television lighting directors were slow to adapt their techniques to match the more pleasing contrast ratios of film. In all fairness this was sometimes technically impossible, but in most cases there was seldom much desire to oblige. Electronic studio work was still stuck in real time. Drama directors increasingly preferred to use film, and thought of every possible excuse to work on location. The resource management at the BBC did its best to discourage this, and so strange dramas would appear with 10 minutes of electronic studio and 40 minutes on 16 mm film. The Corporation then wondered why it had trouble selling these strange hybrids to the USA. As the resource tail increasingly wagged the production dog, plays appeared shot by outside broadcast units well versed in cup finals. Some series scored a jackpot and had elements of all three: electronic studio, electronic outside broadcast and 16 mm film.

In the midst of this mishmash of styles sat the situation comedy or 'sitcom'. It had always had peculiar difficulties. The pieces were performed to an audience, so they were played chronologically – however inconvenient this might be. As many of the sets as possible faced the audience seating. There was always much concern for the studio audience and logistic hoops were constantly jumped through so that the studio audience were surprised by the tag of the scene, or the show. Location scenes, as ever, were shot on film well before the studio run of the series. The audience saw these film scenes on monitors which were strung over the audience seating. Their laughs were all important and this presented (and still presents) a huge problem for the sound mixer. The sound from the excerpts need to be loud enough to be heard but not so loud that it is picked up by the mic's set to record the audiences' hysterics. This continuing concern for the studio audience, at the expense of the viewer at home, is the main reason why so many situation comedies look antiquated.

The rise of single-camera video has now made a huge impact on the use of film in television. Today's audiences now receive their programmes as follows: drama plays, series or soap operas made in the electronic studio with location work shot on single or twin video cameras; low budget single-camera productions on single-camera video; prestigious dramas or series on film. Films made for television are mostly shot on 16 mm, though there is a move back to 35 mm. Documentaries are increasingly moving to video, though again prestigious series with a good chance of overseas sales are still made on 16 mm.

The multi-camera studio which was once the most fundamental force in television is on the wane. Only soap operas and sitcoms use multi-camera

studios for drama and these are now increasingly the domain of current affairs programmes and the ubiquitous quiz shows. Film holds on as super-16 mm and is future-proof – good enough for high-definition transmission and of the correct width-to-height ratio for the new shape TV screens.

A purist might argue that one hardly ever watches television in its original form any more. The news is live and so are some current affairs programmes, sporting events and the occasional concert. For the rest of the time the box in the corner merely churns out a variety of material produced in a plethora of different ways. The advent of VHS, convenient though that clever invention is, has further diminished the domestic status of television – you don't even have to stay at home any more. Perhaps it's simply nostalgia, but I honestly feel that apart from all the arguments about falling standards, television has lost its charisma. It no longer has artistic individuality. It has become merely an apparatus.

# Conclusion

Recently a Saturday matinée on television screened an ancient British film 'Sons of the Sea'. This was made in 1939 and the most interesting thing about it was the credit 'Made in Dufaycolour'. Dufaycolour was a complicated system which involved coating black-and-white film with a matrix of tiny colour filters – red, blue and green. The processed film projected through this integral coating of filter produced colour. If 'Sons of the Sea' was anything to go by it wasn't bad at all. It had a charming posterizing effect that was redolent of the thirties. I then got to wondering if this was a subjective response on my behalf – I love old films and odd techniques; maybe someone else would just have thought it was awful colour.

Over the years the film industry has embraced every technical advance from sound to colour, from 3-D to wide screen. The complexity of three-strip Technicolor is such that it seems a miracle that the process worked at all. The original system was rated at 5 ASA (ISO5 in modern terms) and the amount of light required was phenomenal. Yet Technicolor reigned supreme for twenty-five years. When the Kodak company produced Eastmancolor in 1952 the film industry was transformed overnight. Eastmancolor could be used in any camera and was a single colour negative – much more simple to use. Early Eastmancolor was, frankly, nothing like as good as Technicolor but it was convenient. It took only three years for it to knock Technicolor off its pedestal. In 1955, 112 films were made on Eastmancolor, but only 90 in Technicolor. Nowadays Eastmancolor is superb; but in 1955 it was not. Television and film industries have always had an inclination to embrace new technology well before it is fully developed. The switch to single-camera videotape which started in the early eighties was a prize example. The fact that the original video systems were so inflexible by comparison with film did much to divide the camp. Film-lovers became entrenched and wouldn't touch video with a bargepole, while video enthusiasts made outrageous claims for the new technology. (No doubt some technicians in the fifties convinced themselves that early Eastmancolor was everything they'd ever wanted.)

Things are beginning to settle down. At last the engineers are listening to programme-makers' needs, and designing editing equipment accordingly. Random-access editing systems have arrived and will doubtless improve beyond our wildest dreams over the next few years. Nevertheless, some people wear a wry smile as they remember a time when the appalling video systems of the eighties were hailed as 'perfect'. It seems that film production will retreat into the cinema and the prestigious end of the television market, but film still has much going for it. Present-day Eastmancolor gives a beautiful big bright picture which video has yet to match: super-16 mm easily meets the demands of high-definition television. A 16 mm film camera is a lot more useful as a production tool than a high-definition television camera, which is currently half the size of a sofa. But film is expensive, as any silver-based chemistry is bound to be. It is at a high stage of development, and so it should be, after all: it has been around for a hundred years. Portable video has so far had a life of a mere 15 years. Gradual exposure to the possibilities of production on Betacam D3 or D5, or whatever, has swayed even dyed-in-the-wool old buffers like me that video is a brilliant production medium. It is good already, and, like Eastmancolor, it will get better. I know that if I were directing a period drama I would prefer to shoot it on film. I know that if I were going to some far corner of the earth I'd be safer on film (and I'd have a clockwork camera and some 100 ft rolls so I could carry on shooting if there was no power or if the main camera got eaten by a boa constrictor) but I also know that a TV comedy or contemporary documentary would be more easily achieved on tape and if some firm wanted a corporate video, then effects, titles, and speed of delivery would absolutely mandate the use of tape – probably Betacam.

Perhaps I love film because I was brought up on it, because when I was a teenager I made 8 mm films and longed to make 16 mm films. Perhaps in twenty years time some television director will regret the passing of videotape for the same odd nostalgic reasons. I don't know – what I do believe, however, is that the techniques described in this book will remain valid. Those techniques involve the grammar of the visual language. Film or video are merely the paper on which the words are printed.

# Index

NOTE: Numbers in **bold** refer to the major coverage of a subject; *italics* refer to illustrations.